british asian style
fashion & textiles/ past & present

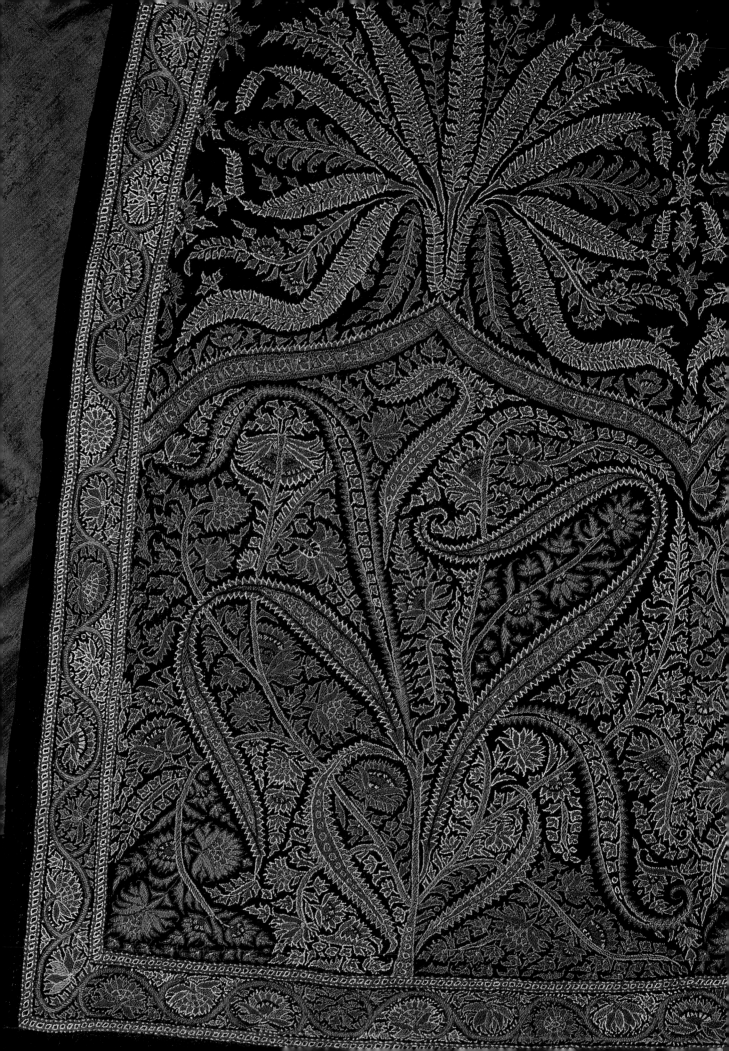

british asian style

fashion & textiles/ past & present

edited by christopher breward,
philip crang & rosemary crill

v&a publishing

First published by V&A Publishing, 2010
V&A Publishing
Victoria and Albert Museum
South Kensington
London SW7 2RL

Paperback edition
ISBN 9781 85177 619 1

Library of Congress Control Number 2010923042

10 9 8 7 6 5 4 3 2 1
2014 2013 2012 2011 2010

A catalogue record for this book is available from
the British Library.

Designer: David Bothwell

New photography by Richard Davis
V&A photography by V&A Photographic Studio

Front cover illustration:
From the Empire Line series by Gavin Fernandes,
plate 76
Back cover illustration and frontispiece: Cloak,
embroidered goat-hair (*pashmina*), plate 100

Printed in Hong Kong

V&A Publishing
Victoria and Albert Museum
South Kensington
London SW7 2RL
www.vandabooks.com

contents

introduction
by christopher breward

1
Sikh man, on his mobile phone at
Liverpool Street Station, London, wearing
a Burberry trench coat and 1970s vintage
heels with a turquoise turban
Wayne Tippetts

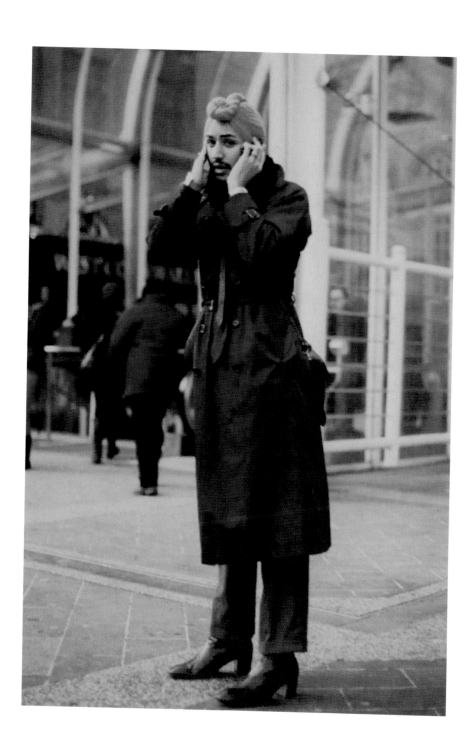

2
Right: Niraj Chag, musician and composer,
Stratford Theatre, London, 2009
Jaskirt Dhaliwal, from the series British
Asian Musicians

3
Far right: Neeta, singer and songwriter,
Camden, London, 2009
Jaskirt Dhaliwal, from the series British
Asian Musicians

4
Below: Police constable Brij Rajanwal on
duty, London, 1984

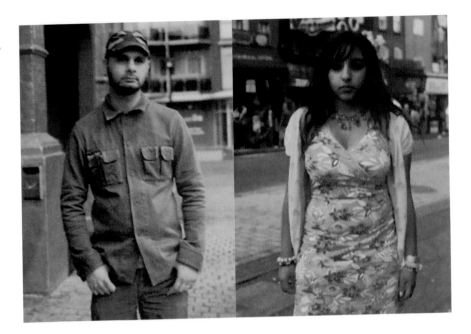

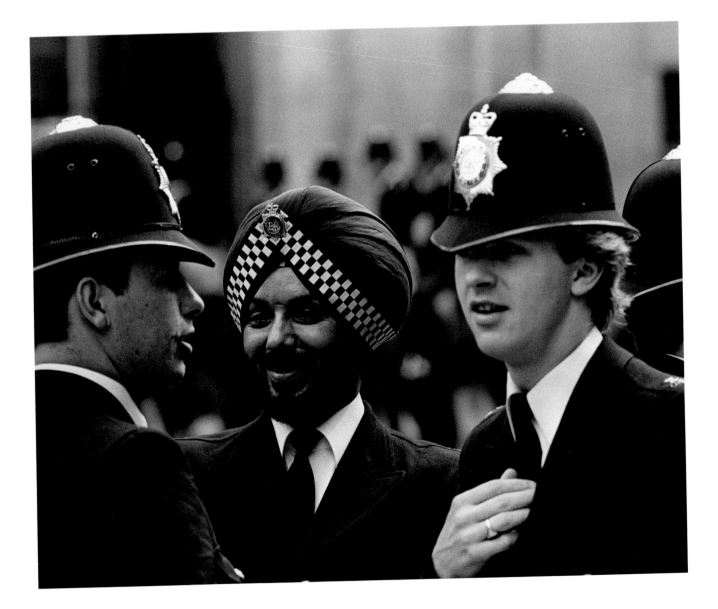

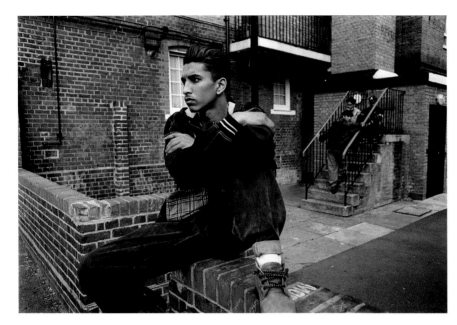

5
'I can't see it, my future on the street anymore', Masum Ahmed, Shadwell, London, 1993
Anthony Lam, from the series Notes from the Street

British fashion has long been enriched by the presence of South Asian textiles (textiles produced in India and Pakistan), from the fashionable chintzes of the seventeenth and eighteenth centuries, through the *boteh* or Paisley patterns that fed the shawl craze of the nineteenth century to the incorporation of traditional embroideries and dress styles by the counter culture of the 1960s and 70s. Similarly the clothing of South Asian people who have travelled to and settled in Britain over the same period, but most especially during the late twentieth century, has contributed to an everyday cosmopolitanism in which local, national and transnational identities have become particularly nuanced through the language of dress. A recent generation of British Asian fashion designers, stylists, photographers, musicians, film-makers and media entrepreneurs, often educated in British art and design colleges, have responded in exciting ways to these influences, recasting the traditions of both British and South Asian styles in a unique manner that has sometimes been re-interpreted for the mainstream under the banners 'Asian Kool' and 'Indo-Chic'.[1]

This book is the first to consider the ways in which these intertwined histories, of engagement through production, commerce, aesthetics, retail, display and migration, in colonial and post-colonial times, have contributed to a vibrant and under-represented aspect of Britain's cultural heritage and contemporary creative environment. With some notable exceptions, the literatures of textile manufacturing, trade and consumption in South Asia and Europe, and studies of contemporary fashion cultures in local and global contexts have tended to develop separately.[2] This is reflected in somewhat disconnected approaches towards periodization (the colonial and the post-colonial), disciplinary framing (fashion studies, textile history and Asian studies), which have also sometimes been reflected in the physical arena of museum collections and displays. It is appropriate then that the V&A, with its deep history of collecting across the fields of textiles and dress, both Asian and European, and its engagement with contemporary

fashion production, the creative industries and the many communities which constitute its visitors, should seek to marry its diverse coverage through a project such as this. We are grateful to the Diasporas, Migration and Identity Programme funded by the Arts and Humanities Research Council, which enabled curators at the V&A to work with colleagues from the Geography Department at Royal Holloway, University of London on a project titled 'Fashioning Diaspora Space'. This book is one outcome of the research, collaborative events and discussions that emerged from this partnership.

We have been deliberately eclectic in our choice of contributions, looking to fashion and textile historians, cultural geographers and ethnographers, alongside curators, photographers and an artist to provide various concise perspectives on the nature of British Asian style, past and present. The content does not follow a chronological narrative, but rather engages with various themes that trace connections between Britain and South Asia, fashion and textiles, the museum and the street. In the first section, 'Textiles', we establish the material threads that have bound Britain to India and Pakistan, through histories of exchange, through contemporary production routes and via the memories attached to cloth. In 'Styles' our aim has been to highlight the articulation of distinctive British/Asian 'looks', which relate to religious identity, the everyday processes of dressing, the professional practices of designers, media representations, and experimental play with South Asian influences and elements by several influential segments of British society. Finally in 'Spaces' the intention is to investigate the enduring presence of South Asian textiles in British shops and in the Museum itself, reminding us of their ubiquity in all aspects of British culture.

British Asian Style is by no means intended as the last word on this intriguing aspect of textile and dress history, but we hope it inspires all those with an interest in a centuries-old story of exchange, travel, competition and creativity.

textiles

the golden age of the indian textile trade
by rosemary crill

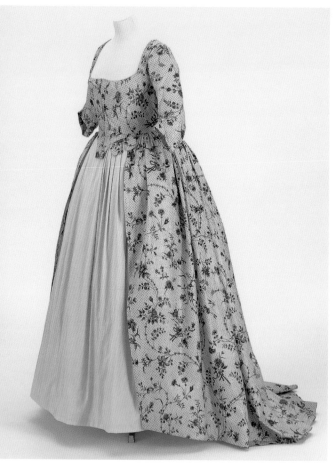

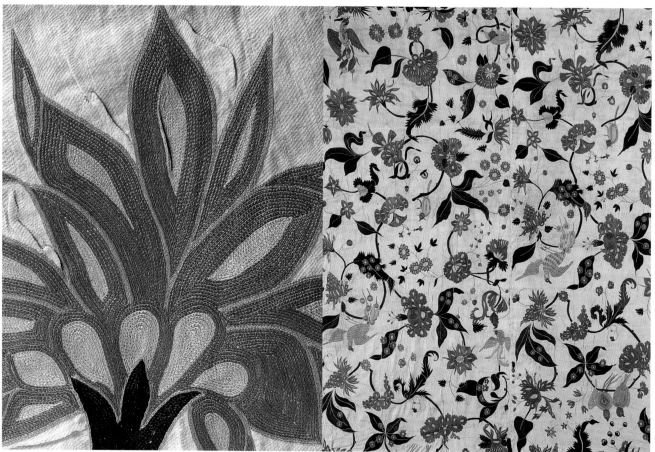

6
Previous page: Chintz hanging (detail)
Cotton, resist- and mordant-dyed
Coromandel Coast, India, late 17th century
V&A: IS.121–1950

7
Opposite, above and right: Chintz dress with
gold spots and detail
Coromandel Coast, India; made up in
England, *c*.1780
V&A: T.217–1992

8
Opposite, below and right: Embroidered
hanging and detail
Cotton, with chainstitch embroidery in silk
thread
Gujarat, India, *c*.1680–1700
V&A: IS.155–1953

India had been sending cloth to distant markets long before any Europeans arrived on her shores. Classical written sources record that silk and cotton textiles were being traded from India across the Indian Ocean to the Mediterranean in the first centuries of the Christian era, and also in the opposite direction to Southeast Asia and even China, in a global maritime trade led at that time by Arab merchants. In the medieval period the overland Silk Route brought Italian, Chinese and Islamic textiles to India. It is hardly surprising, then, that when the Portuguese established themselves in the subcontinent in 1510, in the wake of Vasco da Gama's discovery (aided by Arab navigators) of the sea route to India in 1498, fine textiles were already a significant part of the international trade in which the Europeans were keen to participate.

The establishment of the British East India Company in 1600 brought about a massive increase in trade with India. At first only interested in joining the lucrative spice trade, the Company soon started to take notice of the many types of textile that might also 'vent well' in Britain. Indian textiles had been used primarily as bartering tools for the acquisition of spices in the Moluccas (now in modern-day Indonesia) where they were highly prized, but the textile trade with Britain was soon to become the most profitable component of the Company's operations, and by 1664 accounted for some 70 per cent of the Company's total trade, rising to 83 per cent over the next 20 years.[1] Millions of pieces of cloth were sent to Britain from India, either for re-export to other parts of the world such as West Africa or the Middle East, or increasingly for direct sale to British consumers.

The allure of cotton
The main attraction of Indian cloth to the British public was that it was mostly made of cotton, as opposed to the linen or wool that had been the mainstays of most people's dress until then. Silk, mainly from Bengal, was a less desirable commodity, as it was considered inferior to European silk, and was used mainly for petticoats and linings, and small articles like handkerchiefs. Cotton had been very little used in Britain before it started to arrive from India in the sixteenth century (small quantities were traded even before the foundation of the East India Company). Its appeal lay in the fact that it was light, easily washable and, very significantly, colourful for Indian cottons were dyed with fast colours in new, vibrant designs (pl.6). Most of the textiles used in Britain had woven (or sometimes embroidered) patterns, and textile printing and dyeing were only known at a very rudimentary level. The Indian dyers, by contrast, had mastered the techniques of mordant dyeing and the use of wax resists, enabling complex and multi-coloured patterns to be produced on cotton. Fine chainstitch embroideries were also produced in India for the Western market, sometimes replicating the designs of the dyed fabrics (pl.8). While the bulk of the Indian cottons traded to Britain by the East India Company were plain (or at most striped or 'sprigged' with small designs) and intended for utilitarian purposes, it was the floral chintzes that took Britain (as well as Holland, India's other major European trading partner) by storm.

Much has been written about the impact of these glorious, brilliantly patterned cotton textiles on British society.[2] Technically, they signalled a break with the predominance of woven patterns. Aesthetically, they fed into a new taste for exotic designs, which emerged from the opening up of the world for trading. From the mid-seventeenth century, Chinese, Indian and Japanese motifs all blended indiscriminately into a hybrid style that came to be known as Chinoiserie and which permeated architecture, interior design, furnishing fabric and dress. Chintz – itself a hybrid Indian-Dutch-English term for mordant-dyed cotton cloth – became almost ubiquitous, although expensive French or Italian silk never lost its place at the very top end of the luxury textile hierarchy. Compromises would be reached in which a cotton chintz fabric might be used for the outer side of a dress to show the wearer's up-to-the-minute

awareness of fashion, while it could be lined with silk to show her spending power and recognition of the enduring primacy of expensive, rustling silk. Added luxury might also be given to a chintz dress or furnishing fabric by over-printing it with gold leaf (pl.7). In spite of these attempts to increase the status of painted cotton, it was mostly used in informal settings, both as furnishing and as dress fabric. While state beds, in which a visiting monarch might sleep, would be hung with velvet and silk, fashionable women's bedchambers or morning rooms were often decorated with chintz or embroidered Indian cotton hangings. Chintz dresses were worn by upper-class women in informal settings, like Sophie Pelham who chose to be shown feeding her chickens in a floral chintz dress (pl.12).

One of the unique aspects of the craze for chintz is the relatively wide range of social strata to which it seems to have appealed. It is perhaps the first fashion craze to be experienced by several levels of society, a feature that was not universally approved of. Cotton (in spite of the distance it had had to travel) would always be cheaper than silk and was therefore more readily available to a greater number of people. The furnishing fabric and bed hangings for which chintz was initially used were sometimes adapted for use as garments, especially by poorer consumers in Holland, from where the fashion for chintz garments spread to Britain aided by the accession of the Dutch monarchs William and Mary to the British throne in 1689. There was also a tradition of mistresses of households passing on clothing to their servants: this would no doubt have been day wear rather than anything grander, so a fashionable but informal morning dress could become the 'best' wear of a lady's maid, leading to complaints that it was no longer possible to tell the mistress and servant apart.[3] It has been suggested that the evidence for widespread use of chintz has been deliberately exaggerated, partly through the propaganda of writers paid by British weavers to attack the influx of Indian textiles into Britain.[4] Whatever the true level of ubiquity of chintz textiles, the influx was such that British

weavers of wool and linen feared for their livelihoods and forced Parliament to impose a ban on printed and painted cottons from India in 1701, and then in 1722 of those printed in Britain as well. This did not stop the craze for chintz but merely created a fevered trade in smuggled goods. Indeed, most of the surviving examples of chintz furnishings and dress date from the period of supposed prohibition, before the Acts were repealed in 1774.

A remarkable insight into a middle-class Englishwoman's use of chintz and other fabrics is provided by Barbara Johnson's collection of dress fabrics.[5] Miss Johnson was a vicar's daughter who recorded every dress she had made from 1746 until her death in 1823, along with a sample of its fabric and a selection of contemporary fashion plates. Most of the 121 textile swatches preserved in the album are of silk and are not Indian, but by the 1760s and 70s we can see a trend towards muslin, calico and gingham (all Indian fabrics), along with some English printed fabrics clearly of Indian inspiration. In 1779, for example, Miss Johnson ordered a dress of Indian chintz and pinned into her scrapbook a fragment of delicately hand-drawn floral cotton (pl.9). In 1764 a similar design was recorded, but in this case the fabric appears to be of British manufacture. By the third quarter of the eighteenth century British engineers were working to invent machines that could replicate the Indian textiles that were flooding the market. The drive to invent machines for spinning and weaving the cotton yarn imported from India, as well as those for printing the finished cloth, helped to motivate the Industrial Revolution, and these machines quickly started to imitate Indian fabrics. Consumers like Barbara Johnson were happy to buy these (cheaper) imitations while at the same time acknowledging that 'real Indian' goods were rather more desirable.

A much narrower choice of fabric would have been available to the owners of the garments documented in the Foundling Hospital in London between 1741 and 1760.[6] These poignant scraps of cloth were taken from

A Lady in the newest full Dress, and
another in the most fashionable Undress.

His Royal Highness Prince William Henry,
Their Majesty's Third Son, in his naval Uni-
form, on board the Prince George, attended
by Admiral Digby.

24 - 179

2 | 6
2
2 | 8
40 | 11 | 2
1 | 2
10
2 | 6
5
8 | 10
4 | 1 | 2
2
5
10
10

a purple and white linnen
Gown, eight yards.
Three shillings a yard.

1779

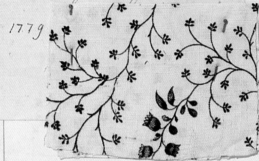

a Chintz Gown and Petticoat,
two pieces, thirty two shillings
each piece, four yards and
three quarters, ell wide

May 1779

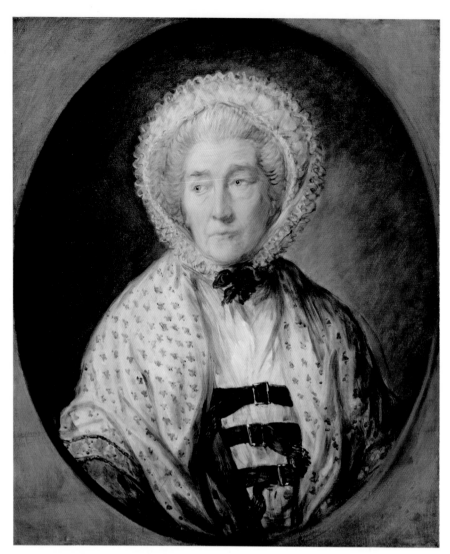

10
Left:
Mrs Hingeston Wearing a Shawl
Thomas Gainsborough (1727–1788)
Oil on canvas, 1787
Staatliche Museen zu Berlin, Gemäldegalerie

11
Below:
Mrs Hingeston's Kashmir Shawl
Woven goat hair (*pashmina*), Kashmir,
*c.*1770–80
Staatliche Museen zu Berlin, Gemäldegalerie

12
Opposite:
Sophie Pelham Feeding her Chickens
Joshua Reynolds (1723–92)
Oil on canvas, 1770
The Collection of The Earl of Yarborough,
Brocklesbury Park, Grimsby

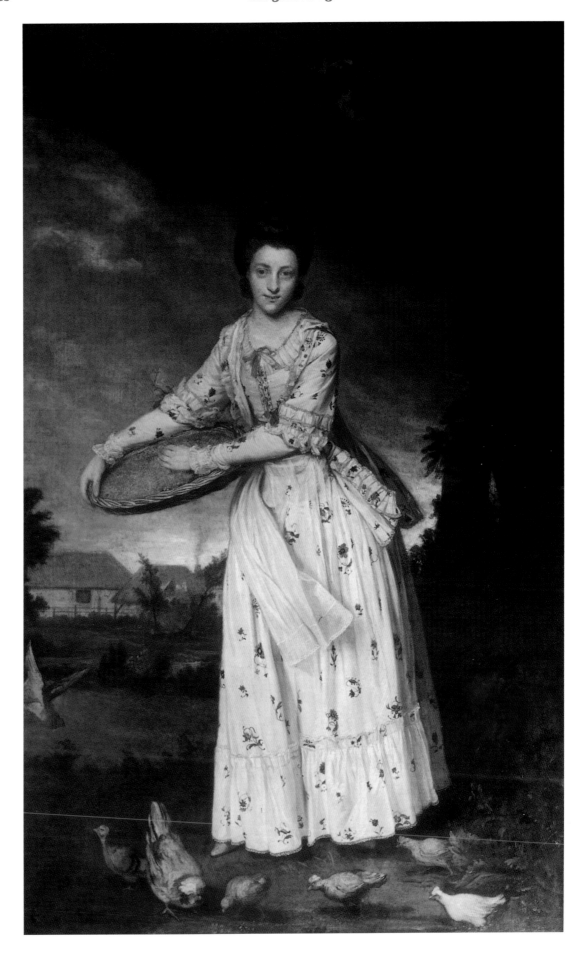

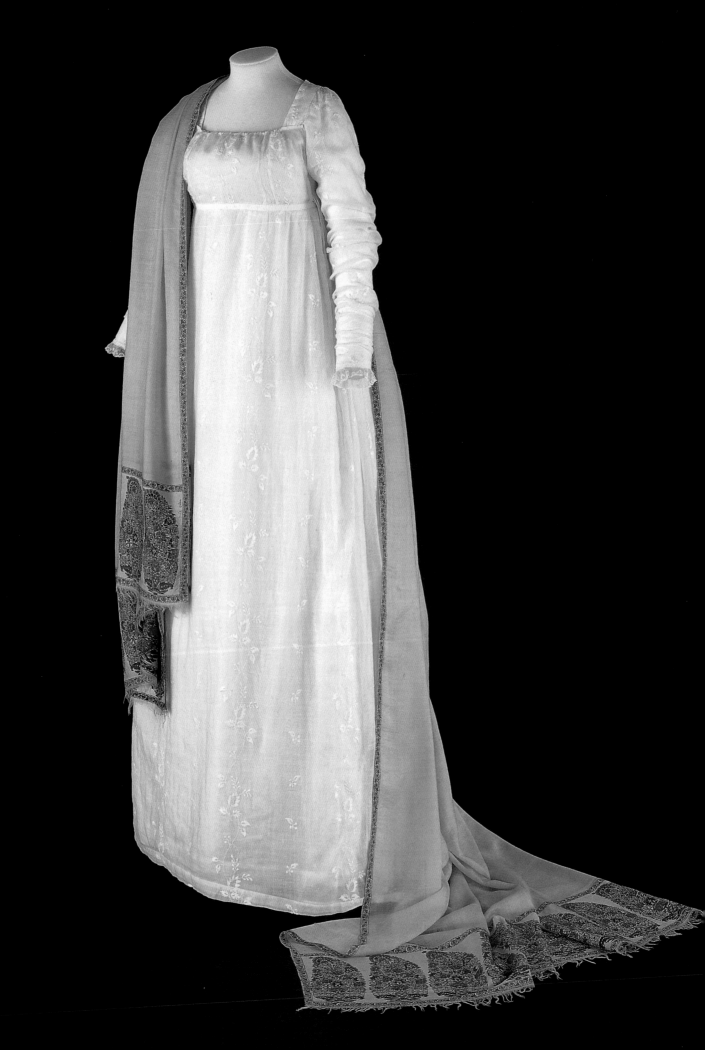

13
Opposite:
Dress
Embroidered cotton,
Bengal, India, *c.*1795
V&A: 444–1888

Shawl
Woven goat hair (*pashmina*), Kashmir,
India, *c.*1795–1800
V&A: IS.83–1988

14
Bodice
Indian muslin embroidered with flattened
silver wire, *c.*1805–10
Cheltenham Art Gallery & Museums,
Gloucestershire

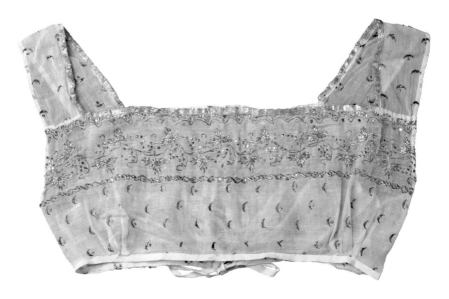

the garments in which poor or foundling children were accepted into the hospital, although they are likely to have been originally from adult dress. Although they are representative of a poorer sector of society than Barbara Johnson's samples, they also give an insight into popular fabrics of the day. While most are simple striped or checked cloths, some English floral prints are included and even a small number of genuine Indian chintzes.[7]

Indian muslin and the Neoclassical style

Innovative British textile technology was a major factor in the decline of the chintz trade, but this did not mean that Indian textiles no longer had a place in British fashion. A fresh craze emerged at the end of the eighteenth century, reaching a peak in the first decades of the nineteenth. This centred on a new, unstructured outline based on loosely draped garments like those seen in classical Greek and Roman sculptures. Originating in France, the Neoclassical style (sometimes called the Empire style) was championed by influential fashion leaders, such as the famous Mme Recamier, who were immortalized in paintings by Jacques-Louis David and his contemporaries. In Britain the style was particularly associated with Emma Hamilton, Lord Nelson's notorious mistress, who used draped garments to great effect in the theatrical 'attitudes' in which she posed in imitation of 'antique' characters such as Cleopatra or Medea. Imported Bengali muslin was ideally suited to the Neoclassical style. Muslin – plain-woven cotton using very fine yarn – had been used in Britain earlier on, mainly for small-scale accessories such as neck pieces and aprons, but became a fashionable dress fabric by about 1790. It had been highly prized in India since very early times and had been one of the favourite fabrics of the Mughal court after Bengal fell to the Mughal Emperor Akbar in 1576. Diaphanous white muslin can be seen in any number of Indian miniatures, worn by both men and women, and by both emperors and servants. As the perfect fabric for the sweltering Indian summer, white muslin was worn by British men and women in India during the eighteenth

and nineteenth centuries, although its modest charms could pall. Emily Eden, writing from India in 1837, expressed her 'dread of the eight months of white muslin that are coming up' at the beginning of the hot season.[8]

In spite of attempts to rival Indian muslin by Scottish and Lancashire mills, as well as by European manufacturers of cottons such as Hollands and lawns, nothing else could attain such a high degree of fineness and softness, features that had led the Romans to call Bengali muslins 'woven wind'. A rare survival of muslin garments worn in both India and Britain in the late eighteenth and early nineteenth centuries by members of the Whinyates family gives us an idea of the delicacy, as well as the cut, of garments of this type, which were often decorated with whitework embroidery or with thin strips of metal (pl.14). Muslins might also be embellished in India with local materials such as tussar silk or cotton (pl.13) or iridescent beetles' wing cases sewn around a hem.[9] White-on-white embroidery called *chikan* work was carried out mainly in Dacca (present-day Dhaka in Bangladesh) and later in Lucknow, for both local and Western markets. This type of embroidery was probably originally done in imitation of European whitework from Ayrshire and Dresden, but became firmly associated with India during the nineteenth century.

The Kashmir shawl

A frequent accompaniment to a softly draping Neoclassical muslin dress was a Kashmir shawl. This luxurious accessory had, like Bengali muslin, been a popular garment at the Mughal court (and elsewhere in India) for centuries, and started to be sent back to England by individual visitors from about the 1760s. Lord Clive brought 10 pairs of shawls back to England with him in 1767, the same year in which the author Laurence Sterne wrote to Eliza Draper, referring to the shawls she had brought back to England from India in 1765.[10] One of the earliest surviving Kashmir shawls is that reputedly brought back to England by Thomas Coulson, the British Resident in Dacca, in about

15

Opposite, and pages 10–11: Long shawl with
botehs (detail)
Woven goat hair (*pashmina*), Kashmir, India
c.1860
V&A: IS.119–1958

1770.[11] Shawls did not become immediately fashionable in Britain: one of the earliest English shawl wearers of whom we have direct evidence is an Ipswich vicar's wife, Mrs Hingeston, who was painted twice by Thomas Gainsborough, once in old age in 1787 (pl.10). In this painting, she is wearing a sprigged shawl of the type called a 'moon shawl' because of its central circular medallion. This 'moon' would appear on the wearer's back, and so is not visible in the painting but, amazingly, both shawl and painting have survived (pl.11). Clearly, the elderly Mrs Hingeston was not a fashion leader, but within a few years the Kashmir shawl would be one of the most desirable items in the wardrobe of a British lady.

Although the shawl was first introduced into Britain, it was popularized as a fashionable accessory in France in around 1800, and the Empress Josephine and her circle were at the forefront of its rise to fame. Josephine was reputed to have a large collection of shawls, some worth as much as 12,000 francs[12] (for comparison, a journal of the day tells us that a very pretty shawl could be purchased for 600 francs). One of the first fashionable British women to be painted wearing a Kashmir shawl was Mrs Jane Baldwin, who was shown in a portrait of 1782 by Joshua Reynolds draped in two shawls (which are likely to have been provided as props by the artist, rather than belonging to Mrs Baldwin herself).[13] Designed to accentuate the exotic beauty of the sitter, who was born in Izmir (now in Turkey), the shawls were evidently used in the painting as generic markers of an exotic and fashionable lifestyle.

The Kashmir shawl as worn in Britain was originally exactly the same object as that worn by both men and women in India: that is, it had a plain field and a border (*pallau*) at each end, which was decorated with rows of floral designs. As the shawl became increasingly popular in Europe, these floral end borders became more and more stylized, larger and more elaborate, until they spread into the field of the shawl and became its dominant

characteristic (pl.15). It was during this process of elaboration that the *boteh* or *buta* became crystallized into the curving-tipped Paisley shape that is still so familiar an element of British and Indian textile design. As with muslin and chintz, British and European manufacturers had tried, as soon as the finely woven shawls had started to arrive from Kashmir, to imitate them, but the lack of the correct fibre (*pashmina* or goat hair) meant that it was impossible to replicate their uniquely soft feel. Furthermore, the Indian shawls were woven in a twill tapestry technique that was time-consuming and impossible to mechanize, although the French came closest to imitating this with their interlocking *espoliné* technique. Between the 1780s and 1808 weavers in Norwich, Edinburgh and Paisley had started to attempt to weave shawls in the manner of the Kashmiri imports, and although the European versions bore little resemblance to the originals in anything other than the superficial appearance of the designs, they soon became hugely popular. Kashmir shawls were too expensive and labour-intensive ever to have become major imports to Britain, and had at first been brought back in small quantities by individuals. When they became widely popular, agents of British and French companies established themselves at Srinagar, the capital of Kashmir, to ensure that shawls were woven in designs that would be guaranteed to appeal to their customers. The shawls produced under these circumstances became over elaborate, with some even reputedly based on designs in British wallpaper catalogues. While these long shawls enjoyed popularity in Britain, France and America for a period in the middle of the nineteenth century, the large numbers of both Indian shawls and their European imitations meant that they were no longer seen as exclusive or desirable and fell seriously out of favour. A garment that had once been the height of fashion was, by the third quarter of the nineteenth century, reduced to a deeply unfashionable article that would only be worn by elderly ladies or used to drape the family piano or sofa (pl.16).

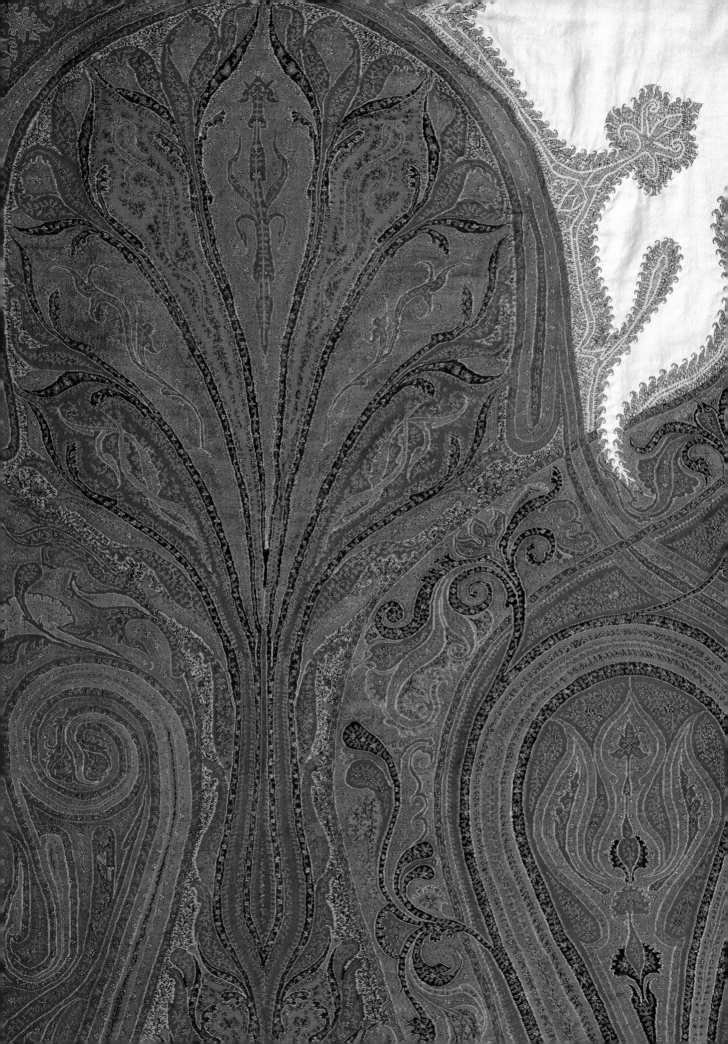

16
Salem
Sidney Curnow Vosper (1866–1942)
Watercolour on paper, 1908
Lady Lever Art Gallery, from Port Sunlight,
National Museums Liverpool

17
Reapers (detail)
George Stubbs (1724–1806)
Oil on wood, 1785
Tate Britain

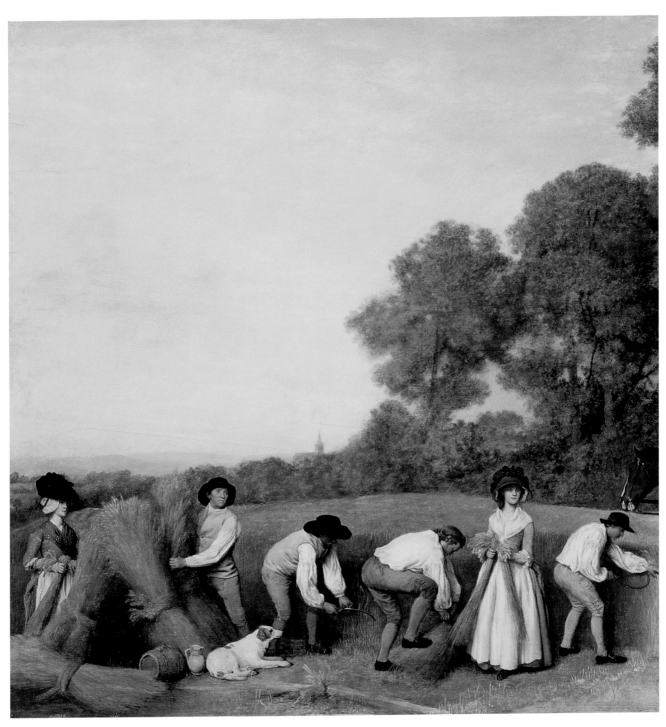

18
Dress
Indian tussar silk, Liberty & Co.,
London, 1895
V&A: T.17–1985

The Indian handkerchief

Not all Indian imports were intended for fashionable wear
by the British elite. As well as the vast quantities of everyday
cotton cloth such as *dungaree* or *bafta* (which is simply the
Persian for 'woven') that came in to Britain to be made up
into garments or other items, a popular item with British
working people in the eighteenth and nineteenth centuries
was the humble kerchief, usually worn around the neck
but also used as a headscarf or waist sash on occasion.[14]
The very name by which this type of knotted cloth is
often known today – 'bandanna' – is of Indian origin, and
specifically refers to the spotted designs originally produced
by the tie-dyeing technique (*bandhani*) with which so many
of the imported handkerchiefs were patterned (pl.21).
The distinctive spotted cloth can be seen in many English
paintings done between about 1720 and 1790, mostly worn
around the neck by agricultural labourers, sailors and their
female companions, street traders and others (pl.17). Still
popular until the demise of the East India Company in
Bengal in 1833, bandannas were also taken up by prize
fighters, who wore them not around their necks but their
waists.[15] A handkerchief of the eighteenth or nineteenth
century was much larger than the small square of cotton
we think of today (which would have been called a pocket
handkerchief) and was usually up to one metre square, a
size that comfortably allowed it to be folded diagonally and
wrapped around the neck or head. Handkerchiefs were
made mostly in silk, and were mostly manufactured in
Bengal in eastern India, an area that no longer has a tie-
dyeing tradition. (Many cotton handkerchiefs were made
in south India: these were mostly checked – hence the
'Madras check' – and were intended mainly for re-export
either to West Africa or for use by slaves on plantations in
the West Indies.) Like chintz, handkerchiefs were classed as
prohibited goods after the passing of the two Calico Acts
of 1701 and 1722, and, in their uncut form, were admitted
into Britain only for re-export. But, like chintz, there
was a thriving trade in smuggled Bengali handkerchiefs
throughout the period of prohibition, as illustrated by the

name of one popular type of handkerchief, the 'Kingsman'
– a nickname usually given to Customs officers. Printed
floral silk handkerchiefs were popular as well as the spotted
type, and both inevitably came to be imitated by British
textile printers as early as the mid-eighteenth century
(pl.19). Those produced in Spitalfields were sold side by
side with those from India. The tie-dyed spots could not be
industrially produced but a passable imitation was made by
discharge printing.

Exhibitions and exoticism

Indian textiles that had not been made with a European
market in mind first came to the attention of the British
public with the International Exhibitions of the late
nineteenth century. The Great Exhibition of 1851 was
really the first time that a significant array of Indian fabrics
had been shown in Britain without the mediation of any
trading company. While these brilliantly coloured and
superbly made textiles attracted praise from design pundits
like Owen Jones and William Morris for both their design
and technique, they did not give rise to a significant new
wave of enthusiasm for Indian styles of dress. Some British
traders known for their more adventurous attitudes to
dress – notably Liberty & Co. in London, founded in 1875
– started to stock furnishings and dress in Indian fabrics, in
styles appropriate to the fashionable Aesthetic look of the
late nineteenth century. These also appealed to adherents
of the dress reform movements, which favoured looser and
more naturally shaped garments in contrast to the more
conventional and constricting Victorian fashions (pl.18).
However, these exotic fabrics and garments tended to be
purchased and worn by members of artistic or theatrical
circles rather than the general public.

Textile producers like Thomas Wardle of Leek,
Staffordshire, designed and made fabrics based closely on
Indian textiles that he had either collected in India himself
or printed with Indian wooden printing blocks from the
South Kensington Museum (renamed the Victoria and

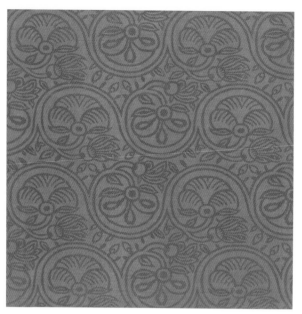

Albert Museum in 1899). These were given appropriately exotic names like 'Tanjore Lotus' (pl.20) or 'Poonah Thistle', which were applied with no particular logic to the various designs.

By the second half of the nineteenth century the trading relationship between India and Britain had shifted radically. Britain's increasing ability to produce equivalent textiles to those previously brought in from India, including the ability to spin and weave Indian raw cotton and to print designs developed especially for the Indian market, meant that Britain was now selling cloth back to India. John Forbes Watson's 18-volume 'travelling museum' of Indian textiles was put together not as an archive but to indicate to British manufacturers what type of cloth would appeal to Indian buyers: after all, as Forbes Watson rightly predicted, 'India is in a position to become a magnificent customer'.[16] This state of affairs was a key factor in the rise of the Indian Independence Movement, which was inextricably bound up with the campaign started by M. K. Gandhi (later named 'Mahatma' or 'Great Soul') for India to renounce imported cloth and use only local, handmade fabric called *khadi*. Indian nationalists were forswearing imported cloth as early as 1872, and in 1896 activists of the Swadeshi ('own country') Movement were already making bonfires of imported cloth.

The widespread appropriation by British consumers of Indian fabrics, such as muslin or chintz, had diminished by the mid-nineteenth century as new technology gave rise to local versions that dominated the market. The ready availability of these local products reduced the desire for Indian styles, although elements such as the Paisley design and floral chintzes lived on (and continue to do so) as a legacy of the heyday of Indian imported fabrics and styles.

19
Above left:
Floral handkerchief
Printed silk, Bengal, *c.*1850
V&A: IS.17–2008

20
Above right:
'Tanjore Lotus' furnishing fabric
Woven tussar silk, designed and made by
Thomas Wardle of Leek, Staffordshire,
*c.*1880
V&A: IS.45–1881

21
Opposite:
Spotted handkerchief length
Tie-dyed silk, Bengal, *c.*1880
V&A: IS.678–1883

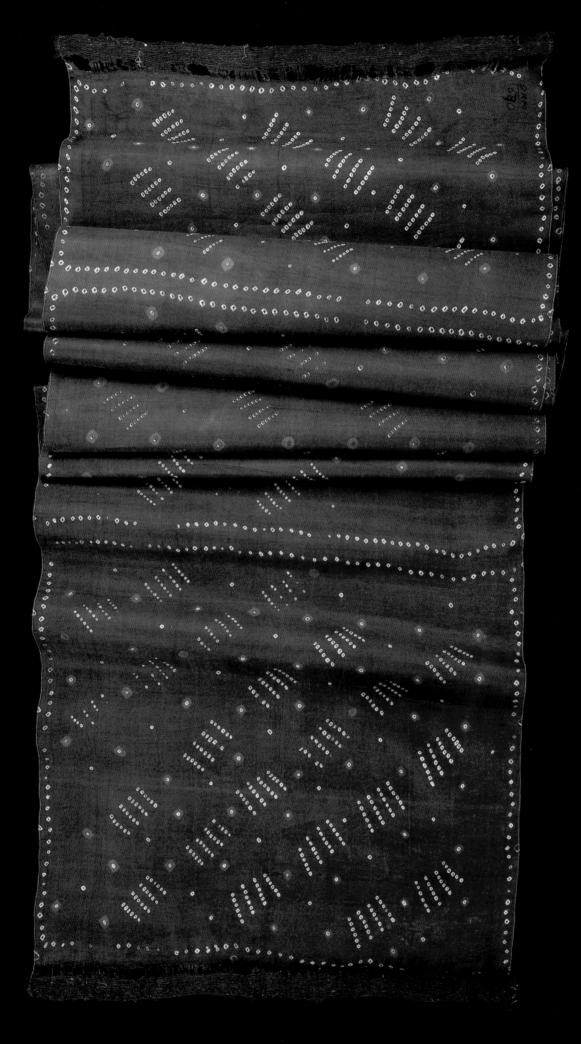

**from gujarat to topshop
south asian textiles & craft
by eiluned edwards**

22
Vagadia Rabari boy wearing a smock
Unlike Dhebarias, Vagadias have
continued to use embroidery (*jhurdi*),
Kutch, Gujarat

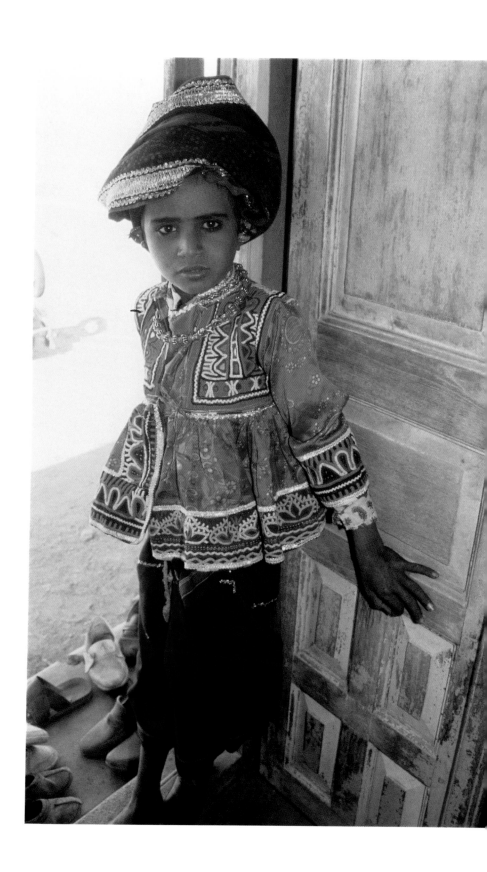

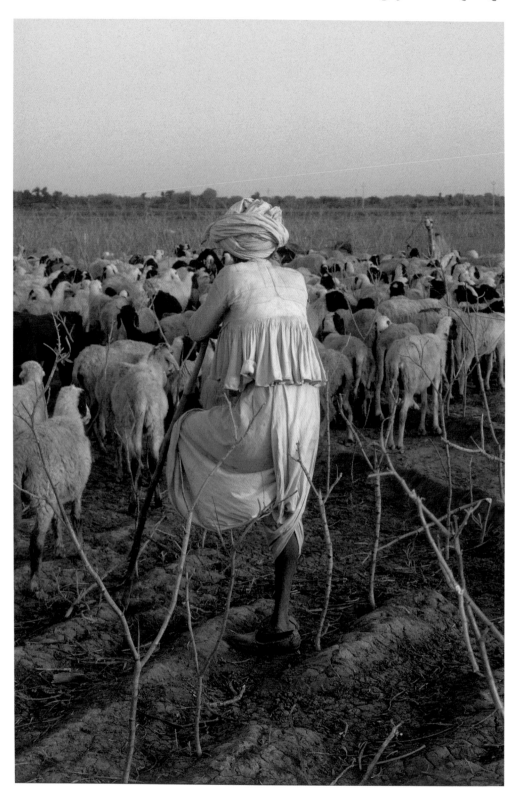

23
Opposite:
Dhebaria Rabari on migration with sheep
in south Kutch, Gujarat

The fifth Kate Moss Collection for TopShop, Spring/
Summer 2008, featured a pinstriped cotton jacket with
an asymmetric fastening and decorated with machine
embroidery, which was sold at selected London stores and
online (pl.26). According to Topshop's official website, it was
part of 'a collection of pieces that channel the bohemian
traveller, referencing Ibiza, Miami, India and beyond',
inspired by Kate Moss's own wardrobe as well as that of her
daughter Lila Grace, notably her 'oh-so-cute mini mirror
dress'.[1] The 'mini mirror dress', which was illustrated on the
website, was actually a smock worn by boys belonging to the
Rabari community (see pl.24) – pastoral nomads, herders
of sheep, goats and camels in the desert district of Kutch
in western Gujarat, India; the store's jacket was adapted
from the adult version of the garment worn by men of the
Dhebaria Rabari subgroup (pls 23, 25, 27).

Both illustrate the enduring influence of Indian textiles on
British fashion, which can be traced back to the seventeenth
and eighteenth centuries when the introduction of chintz
– painted cottons from the Coromandel Coast – to Britain
(and other parts of northern Europe) revolutionized the
fashions and furnishings of the day.[2] But in contrast to
chintz, a product that was made for sale by professional
craftspeople, the embroideries of Rabaris are made by
young women for their dowries and for close kin; use is
confined to the family (pl.29).[3]

So how did a boy's smock from Kutch end up in the very
fashionable wardrobe of a little girl living in London?
Sales of Indian dowry embroidery can be traced back
to the 1950s but in the particular instance of Dhebaria
Rabari embroidery a programme of modernization,
implemented by the community council from the early
1990s onward, accelerated its commodification after 1995.
A longer historical view of the social context of Gujarat,
however, reveals the influence of craft development policies
initiated by the government of the new nation-state after
independence in 1947.

Revised sumptuary rules

In April 1995 the governing council of the Dhebaria Rabari
community of Kutch implemented a radical amendment
to the caste rules governing dress, dowry and marriage;
they banned the making and use of embroidery.[4] Among
Dhebarias, in common with other groups in western India,
the custom of dowry, featuring an embroidered trousseau,
was part of the process of marriage and embroidered dress
was an essential part of their visual identity (pl.30). It could
be said that sight is the primary sense in India; the concept
of *darshan* (lit. 'seeing') associated with the auspicious visual
exchange that occurs when a Hindu views the image of a
deity underpins a wider emphasis on the visual, not least on
personal appearance.[5] Thus the embroidery ban signalled in
a very public way that change was afoot and the Dhebaria
council meant business.

The new ruling was unpopular among the women who
said that their dress bereft of embroidery made them
all look like widows – inauspicious according to Hindu
belief; nonetheless, it was policed with conviction. Any
transgression incurred a fine of 5,000 rupees and one
repeat offender, a man who persisted in wearing a smock
embroidered by his wife, was beaten and stripped and
his torn smock was tied to the gates of the *samaj wadi*
(community compound) in the town of Anjar to serve as
a lesson, the consequence of dissent.[6] As a result of the
ban thousands of pieces of embroidery, including items
of dress, bags, votive textiles, bolsters, quilts and animal
trappings, effectively became redundant.

Aware of the trade in dowry embroideries that had
developed since the 1950s, most families decided to sell
their embroidery and by the end of 1995 the antique
textiles market in India was awash with fine examples
of Dhebaria handiwork. The dealers were spoiled for
choice and could set their own price; heirloom pieces were
acquired for paltry sums and container loads of Dhebaria
embroidery were transported from Kutch.

24
Boy's smock with embroidery (*jhurdi*) and
detail
Formerly worn by Dhebaria Rabaris,
Kutch, Gujarat, 20th century
V&A: IS.7–2008

As one Rabari commented at the time: 'What has the
Dhebaria community got out of it? They have lost their
own gold.'[7] An established trading network took the
embroideries from Kutch to Ahmedabad, Mumbai, Goa,
Udaipur, Jaipur and Delhi – the principal centres for
dealers in embroidery and other textiles – whence they
were sold on to tourists, foreign dealers, private collectors
and museum curators. It was via this network that a Rabari
boy's smock was transformed into Lila Grace's 'mini mirror
dress' and Rabari style became an influence on the British
high street and beyond through the medium of online
shopping. But what were the particular circumstances that
led Dhebaria Rabaris to instigate the ban?

The cost of culture
'According to my calculation they [families] used to spend
seventy thousand rupees on embroidery for each girl; this
is not a small amount ... If a father has four daughters,
think what money he is spending ... Five or six of us
decided that like Gandhi who was starved and beaten
and went to jail for the independence of the country,
in a similar way to abolish this sin [dowry embroidery]
from society, we would go through the same process;
we were prepared for that ... But we have lost as well as
gained because our culture goes.'[8] These reflections on
the ban by the man who instigated it, Arjanbhai Rabari,
a respected member of the Dhebaria council, reveal the
financial burden of dowry, which left many families in
long-term debt. By banning one of its main components
– embroidery – the council was trying to release the
community from a cycle of debt and bring Dhebaria
customs into line with Indian law; dowry had been
outlawed in 1961 by the Dowry Prohibition Act although
the custom persists across Indian society and remains the
focus of intense national debate.[9] By the early 1990s many
factors, including inflation of both dowry and bride price,
had brought the Dhebaria community to crisis point and
the 'conspicuous consumption' of embroidery seemed to
symbolize all that was awry.[10]

After independence, the three main Rabari subgroups
in Kutch – Dhebaria, Vagadia and Kachhi – had started
to become sedentary; pastoral nomadism was perceived
as an archaic form of production by the government
and nomads were encouraged, if not compelled in some
instances, to settle.[11] The process was accelerated in the
1960s when the industrialization of agriculture – known
as the 'Green Revolution' – saw a changed pattern of land
use, which in effect denied Rabaris access to many of the
sources of fodder and water they had previously relied
on.[12] As nomadic pastoralism became increasingly difficult,
Rabaris sought alternative livelihoods but found themselves
excluded from many jobs because of their illiteracy and
in the towns of Kutch their distinctive dress signalled
backwardness and resistance to change.

In order to escape being perpetually marginalized in
modern India, the Dhebaria council drew up a plan of
action to target critical problems within the community;
chief among these were the lack of education and the
system of marriage. In 1993 a boarding school for
Rabari children, known as the Rabari Ashramshala, was
established in Anjar to provide continuity of education
at primary level for Rabari children, especially those
whose parents were still making the migration. The trust
set up to run the Ashramshala – the Shri Dhebar Sarva
Seva Vikas Mandal Anjar – has replicated the model and
Rabaris now run four schools in Kutch, which offer both
primary and secondary education; the number of Rabaris
with a basic education has slowly started to rise, although
girls' education remains neglected and only a minority of
women are literate.[13]

In the years since the marriage rules were revised and
embroidery banned, Dhebarias have abjured but the
impulse to decorate dress has proved irrepressible;
the women while observing the letter of the law have
subverted it by their extravagant use of braids, sequins,
lace and synthetic brocades and velvets on garments for

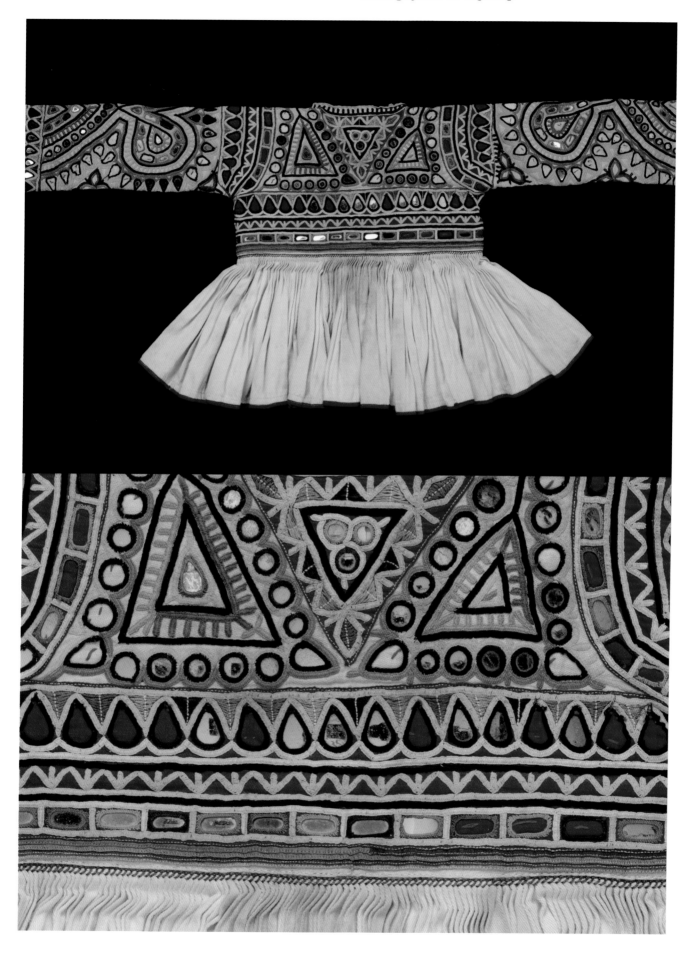

25
Elderly Dhebaria Rabaris wearing caste
dress, including a smock (*kediyun*), in Anjar,
east Kutch, Gujarat

all the family (pl.28). Their use of synthetic fabrics and
industrially-made haberdashery reflects not only the
ban on embroidery but also changing fashion; their near
neighbours – upwardly mobile communities such as Ahirs
and Kanbi Patels – have given up embroidery because it
is deemed to be old-fashioned.[14] Although many women
in Kutch no longer wear embroidery, they still produce
it, chiefly for non-governmental organizations (NGOs)
working in the craft development sector. Since its advent
in the late 1960s commercial embroidery has gradually
become an important source of income for women,
especially in the rural areas of Gujarat. The rise of
commercial embroidery based on the dowry traditions of
Rabaris, Ahirs, Kanbis, Mutwas, Jats, Nodes and a host of
other castes is an aspect of the nation-building policies of
the first independent government led by Jawaharlal Nehru;
the craft sector would provide employment compatible
with a society that was still primarily agrarian, and craft
products – distinctively Indian – would help to build the
nation's exports.

Crafting the nation

In 1952 the All India Handicrafts Board (AIHB) was
founded to co-ordinate craft development across the
subcontinent, preserving traditional artisanry and
creating new markets for craft products. The profile
of craft was raised through exhibition-cum-sales in
major cities such as Delhi, Mumbai and Kolkata, and
perceptions of embroidery and other crafts started to
change.[15] Embroidery became 'collectable' among the
urban elite, initially in India and then among foreign
visitors, many of whom first came to India on the
'hippy trail' in the 1960s and 1970s. The foundations
laid by the AIHB were consolidated in Gujarat in 1973
by the establishment of the Gujarat State Handicrafts
Development Corporation (GSHDC), tasked with
'making handicrafts marketable and preserving the
traditionality of these crafts', and an early initiative was
to link craft development to tourism.[16]

By the late 1980s Gujarat, especially Kutch, was an
essential destination on the itinerary of tours specialising
in Indian craft and textiles led by organizations such as
the Embroiderers' Guild (UK) and the Textile Museum,
Washington D.C. From the 1950s onward in Ahmedabad,
the commercial capital of Gujarat, a number of
entrepreneurs had set themselves up as dealers in antique
textiles to serve the needs of the burgeoning market for
embroidery, a few of whom would also take their clients
on village tours to meet embroiderers and to visit craft
workshops.[17] The dealers or their scouts (*pheriyo*) scoured the
villages of western India, often exchanging steel vessels as
well as cash for embroideries.[18]

For Rabaris and other communities whose lives are still
afflicted by recurring drought, the sale of a few pieces of
embroidery offered a lifeline when their animals had died
and crops had withered, as an elderly woman from Kutch
recalled: 'Selling embroidery was like winning the lottery;
we got lots of money for it without doing hard labour.
We used it for our homes and our cattle.'[19] This survival
strategy – typified by NGOs working in craft development
as 'hardship sales' or 'distress sales' – and changing fashions
in rural dress meant that much of the dowry embroidery
produced in Kutch has been sold. A good deal of it has
gone overseas as tourist mementoes or had been acquired
for museums or private collections.[20]

The exodus of hand embroidery from Gujarat had been
cause for concern as early as the 1960s but it was not until
NGOs, established somewhat later, started to combine
income generation activities with cultural preservation that
the issue was addressed, chiefly by providing women with
paid work as embroiderers. Among the organizations active
in this respect are the Shrujan Trust founded in 1968-9,
Kutch Mahila Vikas Sangathan (KMVS) established in
1989, and the Kalaraksha Trust set up in 1993, all based in
Kutch. The NGO products are based on local traditions of
dowry embroidery but have been adapted to suit the needs

26
Right:
Jacket and detail
Kate Moss for TopShop, Spring/Summer
2008
Pinstriped cotton with machine embroidery

27
Opposite:
Dhebharia Rabari smock (*kediyun*) and detail
Cotton with hand embroidery, Kutch,
Gujarat, 20th century
V&A: 15.145–2007

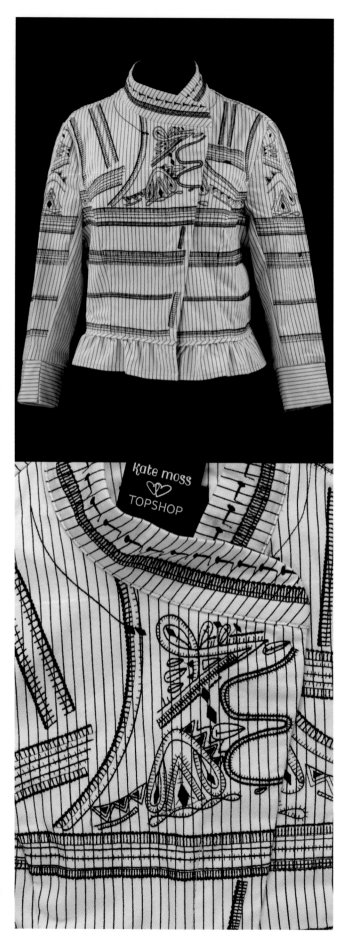

of urban consumers; the NGOs guarantee regular work,
which is organized to accommodate social conventions
such as *purdah* (seclusion of women) and women's domestic
responsibilities, notably child care and fetching water, which
can take several hours a day.

As a result of these interventions many Kutchi women
have become professional artisans and have also benefited
from training in literacy, health care and as group
managers.[21] Their professional status brings them respect,
not least because of their earning capacity, and local
perceptions of embroidery have changed from seeing it
as a domestic 'time-pass' (hobby) to an appreciation of its
considerable commercial potential (pl.29). The income
from embroidery enables the women to build *pukka*
(strong) homes, educate their children and buy health care
when they need it. In the challenging environment of
Kutch, tested by recurring drought, floods, earthquakes
and other natural disasters, and constrained by social
conventions, these are no mean achievements. In the
wider world contemporary Kutchi embroidery has been
exhibited in art galleries and museums in Europe, North
America, Australia and Japan, and also sells throughout
the West where the market for embroidered garments,
accessories and soft furnishings continues to expand.[22]
In contemporary Indian embroidery a number of
things intersect – women's development, commerce and
culture – and women from many communities, including
Dhebaria Rabaris, have lately come to see embroidery as
a serious career option.

Endnote
During a visit to Kutch in December 2008, I showed
an image of the TopShop jacket to a group of Rabari
teachers from the Ashramshala Anjar. They were amused
by the idea of British women wearing what in their eyes
was old-fashioned male dress and, converting the price into
rupees, suggested that TopShop should come to them for
the real thing at a better rate.[23]

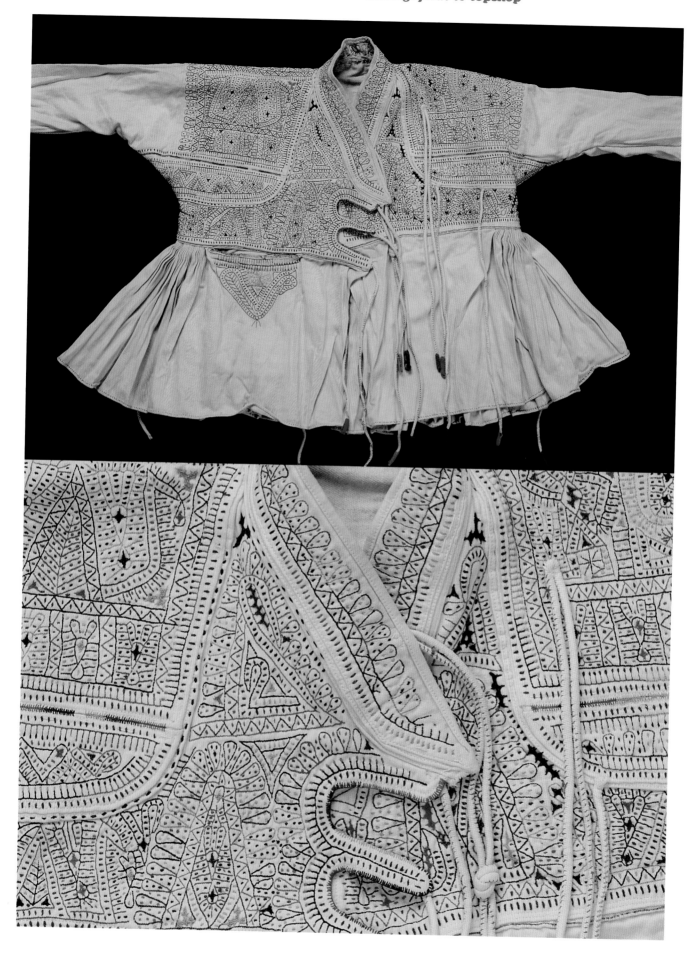

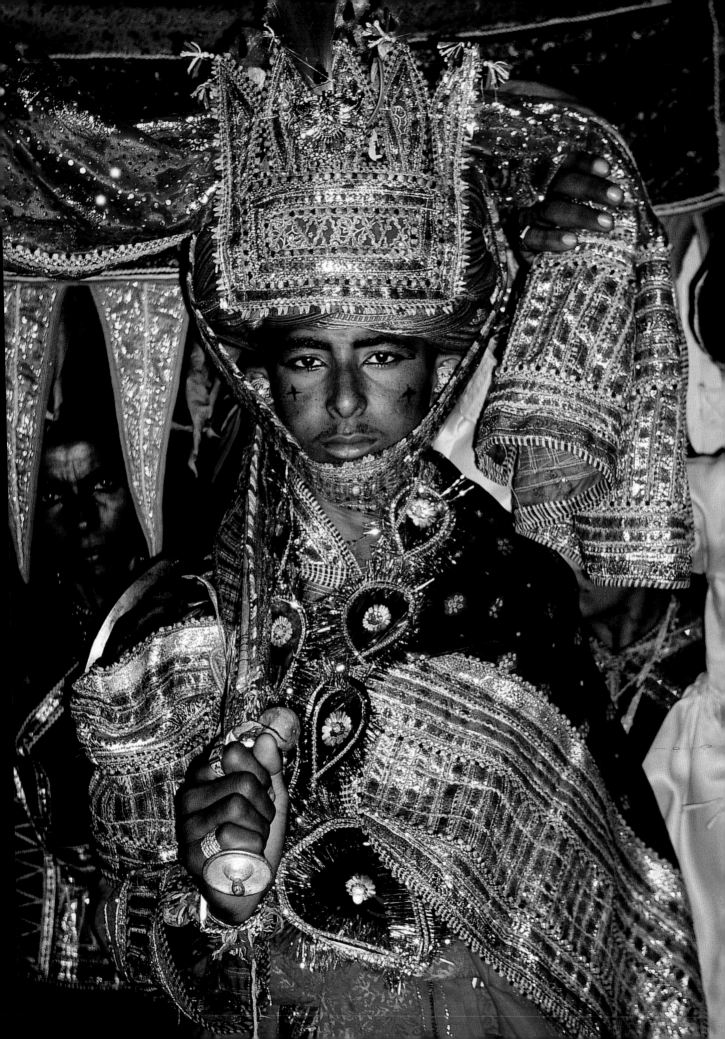

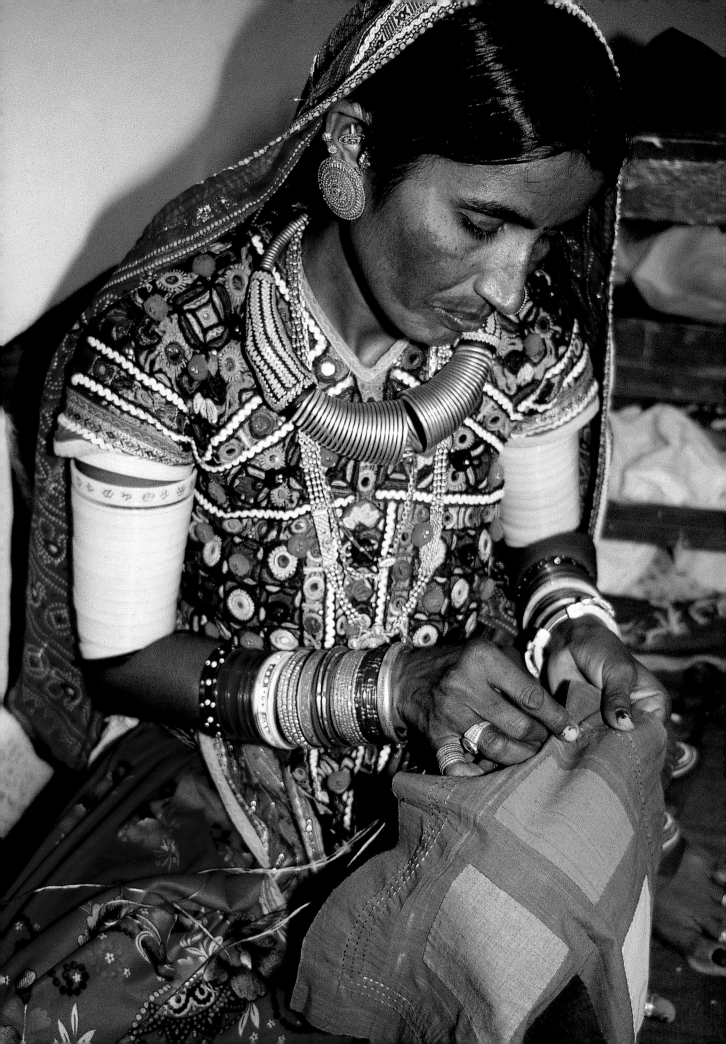

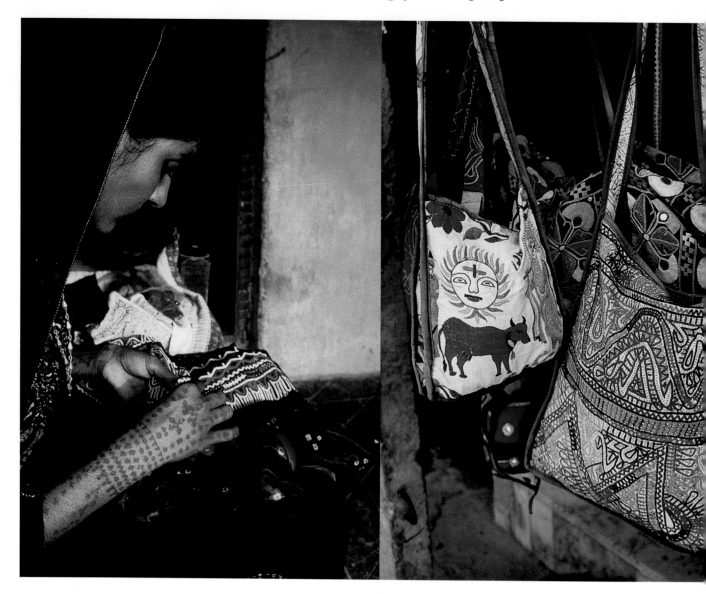

28
Previous pages, left:
Dhebaria Rabari groom in clothing
decorated with rows of machine-stitched
braid and edged with tinsel
Kutch, Gujarat

29
Previous pages, right:
Professional embroiderer from the
Megwhal community of Kutch, working
for Kutch Mahila Vikas Sangathan
(KMVS), an NGO (non-governmental
organization) based at Bhuj, Kutch

30
Above:
Dhebaria Rabari woman embroidering a
blouse for her dowry prior to the dowry
ban, 1995

31
Above:
Dhebaria Rabari embroidery 'recycled'
into a shoulder bag (right) at a tourist
emporium, Udaipur, Rajasthan

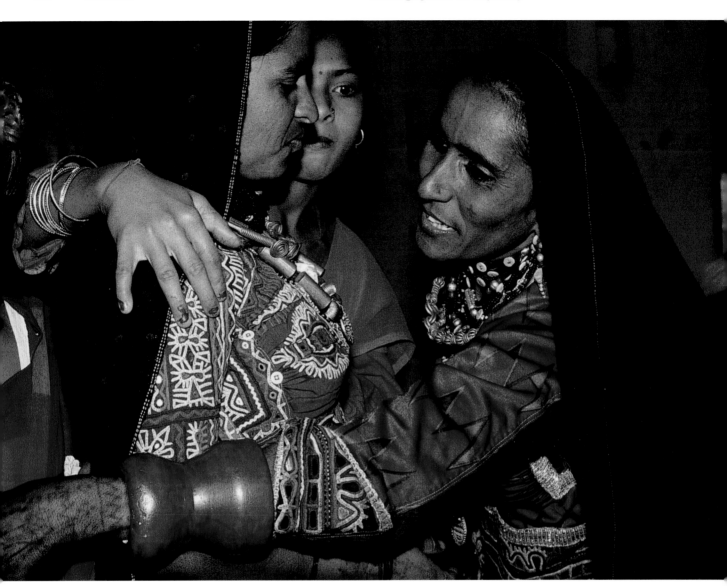

32
Above:
Vagadia Rabari women in embellished
dress celebrating the festival of
Janmashtami (the God Krishna's birthday)
Kutch, Gujarat

the british sari story & stitch
by susan roberts

33
Previous page: Headscarf worn daily by
Rowhasn Hossain, this headscarf inspired
new embroidery for the *Stitch* project, 2008
Olivia Arthur/Bridging Arts, London

34
Below: A page from Fatema Khatoon
Hossain's sketchbook
Dandelions in her back garden inspired
this design, 2007
Bridging Arts, London

35
Opposite, left to right:
Fatema Khatoon Hossain
British Sari Story competition entrant
Bridging Arts, London

36
A Sari for Harrow
Nilesh Mistry
Overall winning entry in the first *British
Sari Story* competition, 2007
Max Colson/Bridging Arts, London

37
A Sari for London
Nilesh Mistry
British Sari Story entry, 2007 with the
designer
Max Colson/Bridging Arts, London

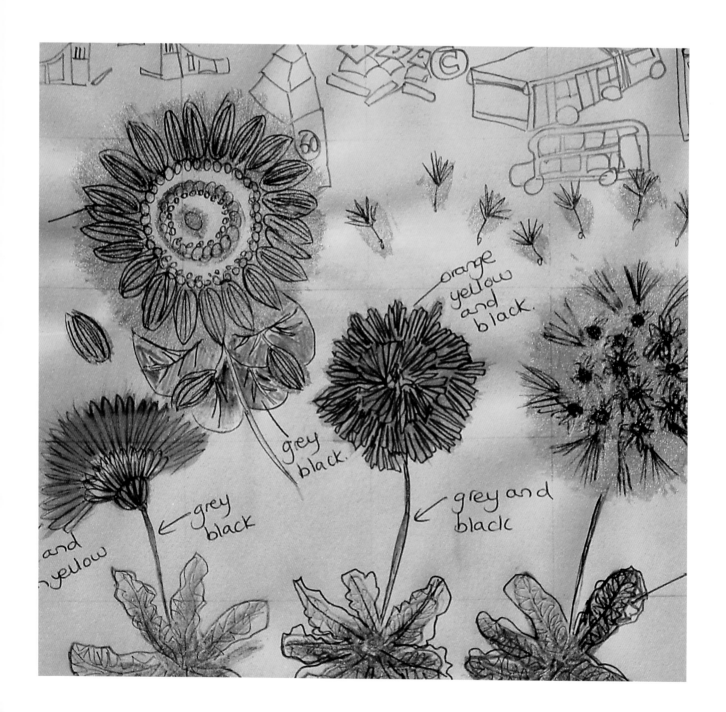

'Although I had a loving, secure family environment, I always felt that there were obstacles either created by my ethnic community or just because I was different.'
Fatema Khatoon Hossain, 2007

The sari as twenty-first-century canvas

Fatema Khatoon Hossain bared her soul when she entered the *British Sari Story* competition in 2007. She was one of dozens across the country who stepped into the unknown and engaged in a new venture to seek out British patterns for the sari. As Director of Bridging Arts, an organization tackling social issues through art and art-related activities, I was part of a team that had identified the sari as an ideal canvas for an exploration of the relationship between traditional Asian patterns and the patterns of twenty-first-century Britain. Sixty years after independence, though instantly recognizable as an icon of Asian culture, it lacked motifs and a style that reflected life in Britain today.

Bridging Arts, with Heritage Lottery funding, was keen to find patterns that reflected regional experience, in much the same way that the patterns of traditional saris from South Asia reflect regional and social experience. The initial invitation was to second and third generation British Asians to express something fundamental about their links to their heritage and to their lives in Britain. It was hoped, too, that older Asian women – and men – who lacked creative means of self-expression and other forms of expression in mainstream culture due to language difficulties would take part. But it rapidly became clear that the competition had a far wider appeal and relevance to many more, very disparate, communities in twenty-first-century Britain.

Hossain, the mother of three young children, was based in Enfield, north London. She felt it was important to speak out about her experience. With two children under three years of age and heavily pregnant, she worked in the evening between 10pm and midnight on her ideas for the *British Sari Story*. Her sketchbook was a visual journal

of 'hopes, inspirations and aspirations' – the title she gave to her sari.

Due to her upbringing, she had to push hard for recognition, acceptance and success. 'Thinking how I might represent this in my sari pattern I looked no further than my back garden at the dandelions growing there (pl.34). These are considered to be common British weeds. They also produce beautiful feathery seed heads which everyone loves blowing and making wishes at the same time! Wishes are like goals and therefore aspirations. So my dandelion plant has a central role in the sari design.'

For Hossain (pl.35), as for others who entered, the competition was an opportunity to trace lines – visual and emotional – between everyday life, memories and place. Her father, who had brought the family to Britain from Bangladesh, had encouraged his children to pursue scientific careers. Hossain worked as a medical scientist and a teacher before her first child was born. 'I had always had a desire to use creativity as a form of expression, but never had the opportunity.' She was drawn to the competition as it involved the sari. 'I felt I could say something personal.'

The contest attracted people from all backgrounds: professional artists and keen amateurs as well as people who had not engaged in any kind of artistic activity since school. The University of East London offered to print the winning designs onto new saris; Brent Council offered Brent Museum as a venue for an exhibition; sari shops loaned traditional saris to display alongside the new designs and the Victoria and Albert Museum hosted an *India Now: British Sari Story* day as part of the Mayor of London's celebrations to mark the anniversary.

Ten patterns were shortlisted. The overall winner, Nilesh Mistry, made very precise connections to place and heritage. A professional illustrator, his *Sari for Harrow* (pl.36) reflects

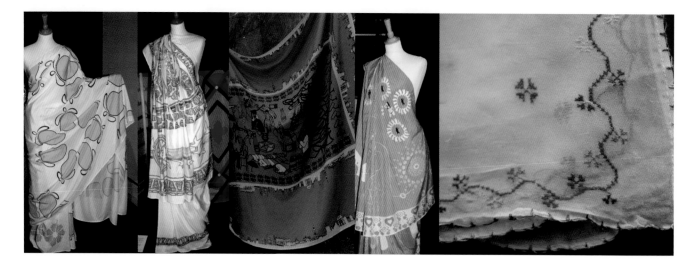

his love of traditional Asian miniatures. He was brought up in Mumbai until the age of eight, when his family moved to Britain so that his brother, a budding violinist, could study music at the Yehudi Menuhin School in Surrey.

His design reflects a residual feeling for his childhood in India as well as a strong connection to Harrow in north-west London. Tiny motifs of Harrow's coat of arms cover the body of the sari. Centred on the *pallau* (end border) is Harrow's famous hill, the public school and the church, all depicted with the air of a bygone age and apparently untouched by the modern world.

But Mistry wanted to draw out the contrast between old and new, and explore the tensions between contemporary life and these symbols of establishment Britain. Beneath the ancient coat of arms, wild roses and public schoolboys in cricket flannels and boaters, the new citizens of Harrow march along the border. 'In the "real" Harrow of today are its new citizens, including a Somali woman in a burka, a hoodie with a mobile phone, a Gujarati housewife, a Polish builder… and a mullah.'

Mistry's *Sari for London* is a blast of vibrant colours – cerise, imperial purple, scarlet and mauve – which give the London tube map a startling twist. The familiar lines with their station stop points run in parallel across the body of the sari before tangling in the *pallau* into a *rangoli* pattern, traditionally drawn at the entrances to homes as a sign of welcome to guests (pl.37).

A few miles away, in Wembley, another finalist emerged. Shilpa Rajan carved out time from caring for her small baby to create a motif that reflected an element of her life in the north London suburb. Recently married, she had moved to Britain from Canada with her parents 10 years earlier. What struck her about Ealing Road, Wembley, an artery of British Asian life lined with sari shops and food stalls, were the mango boxes that appeared on the

pavements at the first hint of summer. Rajan, who has since set up her own clothing label, drew inspiration from them to create a mango-covered *Indian Summer Sari* (pl.38).

'We know that summer has arrived once we see the mango sellers' pitches on the pavement with their big, brightly coloured umbrellas and stacks of mango boxes. Summer is here, and out come the mangoes. Every Asian household will have a box of *keri* [mango] at some point …'.

From the north came *A Sari for Yorkshire*. Ramim Nasim worked in her adult education textile class to develop a pattern that reflected her efforts to connect with life in an industrial British city after an upbringing in Hong Kong. She had moved to Bradford with her family two years earlier and faced a language barrier as well as cultural change.

Nasim created a batik pattern of fine white lines that trace the shape of raindrops and the snowflakes she had never seen before, which sparkle with sequins. Its palette is slate grey, white and black representing ice, frost and rain.

In the south-west, a non-Asian winner was Miranda Hicks with *A Cornish Sari* (pl.39). Hicks, who was studying textile design at University College Falmouth, had a long-standing interest in India and its embroidery. Inspired by formal embroidered borders, she created a *pallau* of stylized ice-cream cones, shells and seagulls on a Cornish seascape.

More than one finalist was prompted to make a subtly subversive statement through a new British sari pattern while adhering to the intricate embroidered detail of traditional saris. Samar Abbas of Wealdstone splashed his *Sari for the iPod Generation* (pl.41) with women in bikinis, guns and drugs. He deliberately chose a traditional Asian cerise pink and brilliant yellow palette but covered the fabric with tiny floral motifs and vines formed from miniature marijuana leaves. His patterns reflect the disconnect between people's material lives and their spirituality.

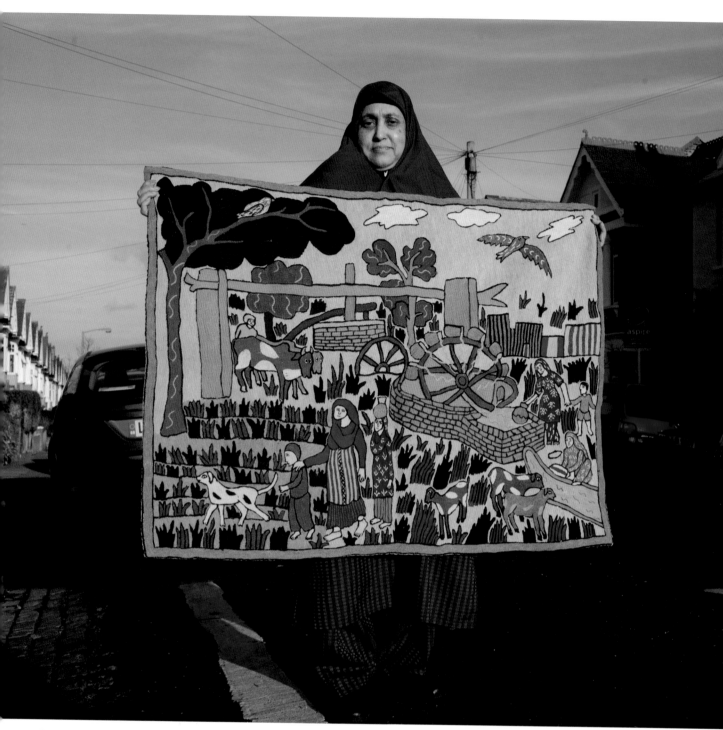

38
Opposite, left to right:
Indian Summer Sari
Shilpa Rajan
British Sari Story entry, 2007
Bridging Arts, London

39
A Cornish Sari
Miranda Hicks
British Sari Story entry, 2007
Bridging Arts, London

40
A British Sari Landscape
Pamela Rana
British Sari Story entry, 2007
Max Colson/Bridging Arts, London

41
Sari for the iPod Generation
Samar Abbas
British Sari Story entry, 2007
Bridging Arts, London

42
Headscarf
Loaned by Firoza Ahmed, the fragile
fabric inspired a trip to the V&A to view
18th-century patterns
Olivia Arthur/Bridging Arts, London

43
Above: Firoza Ahmed with a traditional
wall hanging from a village in northern
Bangladesh
From a personal collection of embroidery
loaned to the *Stitch* project, 2008
Olivia Arthur/Bridging Arts, London

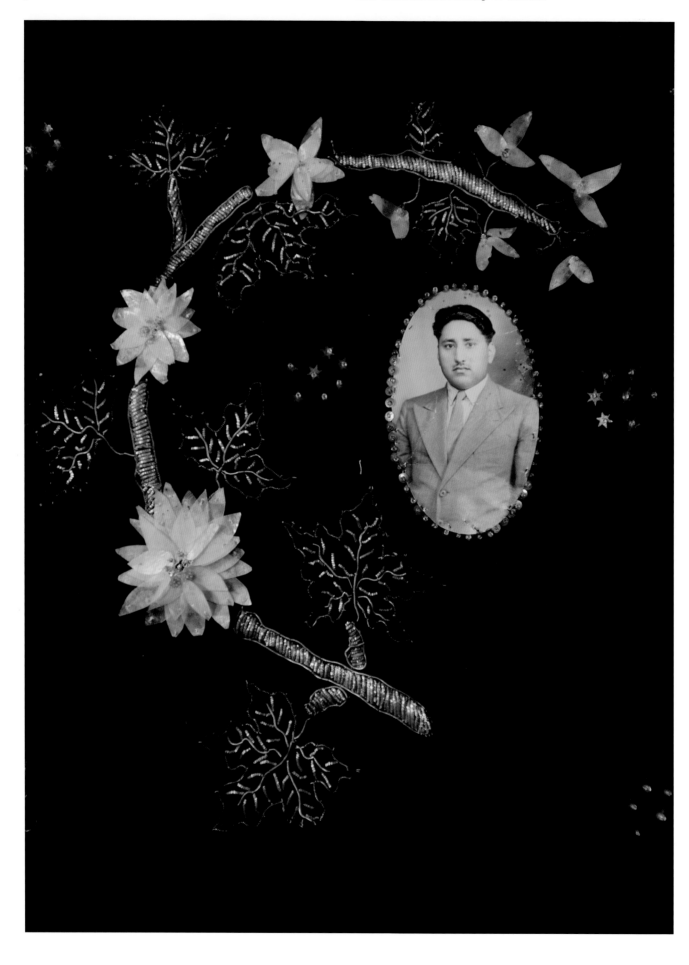

44
Rare fish-scale embroidery on black velvet
East Africa, 1940s
Loaned to the *Stitch* project by Zubaidah Shah
and Safia Qureshi, 2009
Max Colson/Bridging Arts, London

Music alienates; headphones and wires spiral in plant-like shapes away from the iPods on his sari. Scattered between them, like pollen, are meaningless words. 'In one way that is what music tells us. It's as simple as that. Women, sex, drugs and money are all just commodities.'

The detailed drawings on Pamela Rana's *British Sari Landscape* at first sight look as if they have been embroidered – an illusion that Rana had intended (pl.40). Her parents moved to Britain from the Punjab in the 1970s and she turned to her childhood for inspiration when creating the design. It features objects associated with journeys from that time and images of travel: repeating patterns of Routemaster buses, planes and heavy suitcases. Amidst them are drawings of Ghandi, striped deckchairs, and piles of samosas and slippers. The sari is edged with a skyline of buildings from London and Mumbai; the Houses of Parliament sit next to the Gateway of India. But an inner border, a chain of CCTV cameras, is contemporary and reflects Rana's view of the hostile relationship between East and West.

Rana, a graduate from the Royal College of Art, was not alone in her interest in embroidery. As *The British Sari Story* exhibition toured the country and the competition entered its second year, with the support of new partners like sari retailer RCKC, it became clear that for many women – and men – embroidery was an important element in pattern-making. It was part of the spirit of the sari and their relationship with it. Printed motifs only went so far. Emotion could be caught up in embroidery and somehow captured in the stitches that created it. At pattern workshops run throughout the competition, women often brought in saris that they had worked on themselves. This embroidery held great significance: it had been sewn with their own hands; it expressed something from their past, using skills learned often from their mothers and grandmothers; it tapped into a deep sense of history, memory and knowledge.

Embroidery as cultural exchange
Another Bridging Arts project, *Stitch*, was launched in 2008 initially to explore these connections with groups of Muslim women. During *The British Sari Story* competition, many had said they lacked the opportunity to express themselves creatively. They spoke with pride of their heritage of embroidery, but at the same time many faced a lack of understanding of this heritage.

Funded by the Heritage Lottery and Wandsworth Council, Bridging Arts worked initially in Wandsworth, south London, with groups of Muslim women from different traditions – north African, Somali, Bangladeshi, Pakistani and Indian. Key to the work was a partnership with the Royal School of Needlework and a desire to bring established British embroiderers into contact with diaspora communities with a similarly keen and long-standing connection to needlework.

At focus groups with people of varying ages and from different Islamic traditions, women – and men – brought in suitcases full of treasured embroidery: bedcovers, headscarves, shawls and wall hangings (pls 43–5). Stitches were discussed and the embroidery's background investigated. A fragile crepe headscarf (pl.42), with delicate edging reminiscent of British work on muslin, inspired a visit to the V&A and the study of eighteenth-century printed patterns from the collection (for many of the women, this was their first visit to the V&A). At the Royal School of Needlework collection in Hampton Court Palace they saw medieval goldwork and Jacobean embroidery featuring oriental designs that had come to England from Asia in the sixteenth century.

A series of classes throughout summer 2009 explored avenues opened by this work. A 10-week course studying four techniques – silk shading, goldwork, crewelwork and appliqué – refreshed embroidery skills. Exhibition packs were distributed and the women started to work independently on

45
Opposite:
Traditional *kantha* (quilt)
Northern Bangladesh, late 20th century
Loaned by Ferdous Rahman, the motifs
inspired several pieces of new embroidery
for the 2008 *Stitch* project
Olivia Arthur/Bridging Arts, London

46
Following pages, left:
Embroidered daffodils
Chhaya Biswas, 2009
Biswas studied Wordsworth's poem
Daffodils as a girl in Bangladesh but had
never seen a daffodil until she came to
Britain
Max Colson/Bridging Arts, London

47
Following pages, right:
A floral sprig
Amina Aziz, 2009
Aziz's vibrant purple and orange
chainstitch spills over the border, racing to
the edge of the fabric
Max Colson/Bridging Arts, London

their own designs, which were to be put on display alongside the traditional embroidery. Some turned to these traditional patterns for inspiration: others drew from memory.

Amina Aziz demonstrated her free spirit. She drew a first border and then chose to ignore it; she created another border and then boldly ignored that too, her embroidery creeping right to the edge of the fabric (pl.47). Farhat Shah depicted her house in Battersea, south London, with a gladioli-filled garden and a tree festooned with sequins, representing British rain.

Rare fish-scale embroidery (pl.44) on black velvet was loaned to the project by two sisters from Wandsworth: Zubaidah Shah and Safia Qureshi. It was a touching fragment from the past and had been embroidered many years earlier in east Africa for their brother, pictured in a photograph stitched to the fabric. It was the work of their 14-year-old sister who died two years later of typhoid.

The scales had been scraped from the fish, dried in the sun and then cut into petal shapes. It was tough work and hard to pierce holes for the needle to penetrate, but 70 years later, though the black velvet background was fraying, the rosettes of fish scales were as robust as when first sewn by their sister.

Shah, at the age of 82, created a new piece for *Stitch*. She was inspired by the peacock on a traditional *kantha* (quilt) from northern Bangladesh (pl.45). She created her own version of the pattern on the original textile and added an individual twist. 'I imagined it was a female peacock,' she said. 'So I gave her a necklace and a hat.'

Chhaya Biswas, who had done little embroidery since childhood, was captivated by a complex traditional English wallpaper design. For her, as with Fatema Khatoon Hossain and the dandelion, a common British flower was far more than a mere feature in the seasonal landscape (pl.46). She

had studied William Wordsworth's famous poem *Daffodils* at school as a young girl in Bangladesh. 'They told us that they [daffodils] were yellow and swayed in the breeze but I had never seen one. When I was 18, I came to this country… and saw my first daffodils on Wandsworth Common. They have been my favourite flower ever since.'

Both the *British Sari Story* and *Stitch* offered people the opportunity to make visual and personal connections between their everyday lives and their histories. Unexpected links were made – economical, political, cultural and social. The *British Sari Story* demonstrated that the sari is clearly far more than a piece of clothing and a fashion item. Creating new patterns for it and customizing it tapped into issues that were central to people's sense of identity. In *Stitch*, through the study of existent embroidered items – owned by the women themselves – and in the creation of new work, old interests and skills were revived and revisited, friendships forged and knowledge shared.

Artists and non-artists, skilled embroiderers and novices spoke out. The exploration of pattern, place and heritage through textiles, art and design proved to be a starting point for deep thought and debate. From this platform, both the work and its message reached a wide audience and built unexpected bridges between individuals and communities. Fabric, embroidery and stitch offered anyone with something to say, whatever his or her level of artistic skill or expertise, the chance to make a lasting mark.

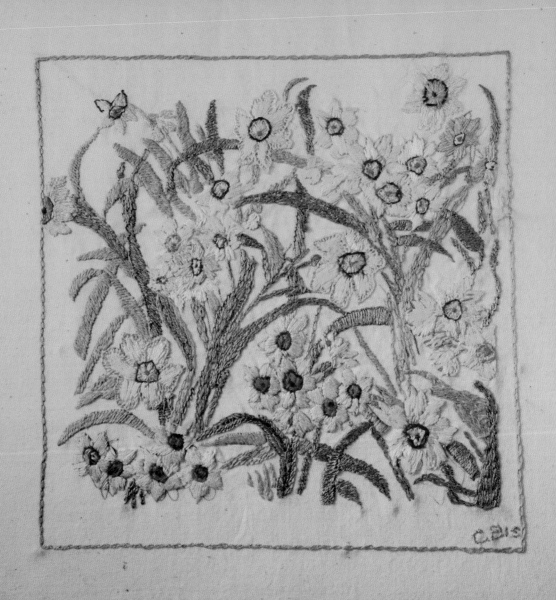

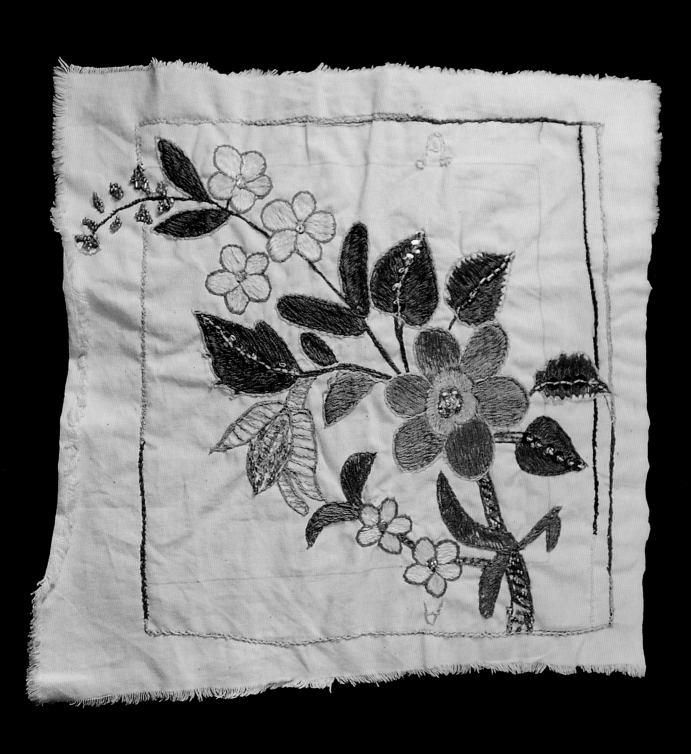

styles

the south asian twist in british muslim fashion
by emma tarlo

48
Friends in Whitechapel, London, 2009

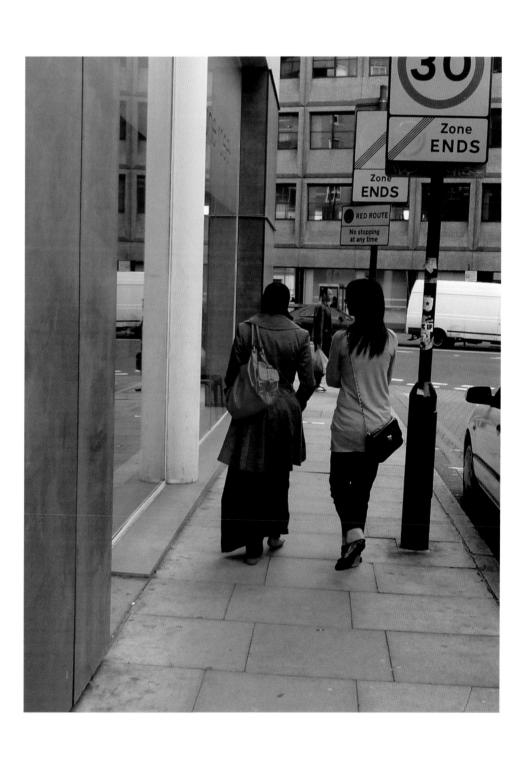

49
Pro-*hijab* demonstrators protesting outside
the French Embassy, London, 2004

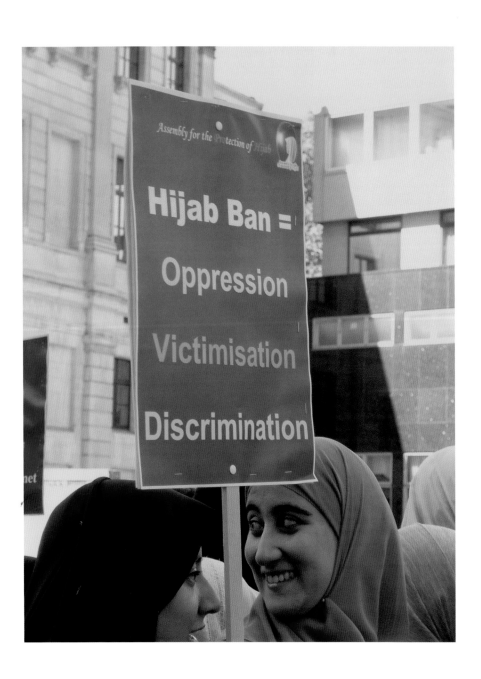

What do multicultural styles look like? How do they emerge in the complex fabric of contemporary British cities with populations drawn from all over the world? How do they simultaneously evoke and rework different cultural repertoires, drawing both on remembered pasts and projected futures? How does the right to look different translate into a multitude of different looks?

Walk down the high street of any major British city and you are likely to encounter a variety of appearances, many of them recognizably fashionable and stylish but in ways that diverge both from what is marketed in mainstream fashion magazines and stores and from what is sold in shops catering to particular ethnic tastes. One important feature of the cosmopolitan street fashion scene in Britain is that many young people, whatever their backgrounds, feel free to create outfits by combining items of dress with diverse cultural associations in unexpected ways. Just as a young white British woman is unlikely to feel restricted to wearing recognizably British clothes, so many young women of Indian, Pakistani and Bengali origin do not feel obliged to wear South Asian styles in the way their mothers or grandmothers often did, although they may still evoke South Asian associations perhaps in their choice of jewellery, particular colour preferences or their penchant for scarves. These preferences are often mixed and matched with clothes from a variety of sources, including high street fashion brands that are themselves eclectic in design. What results are stylish outfits that are less an expression of ethnic background than an expression of the diversity of British cities and the wide range of visual and material possibilities they offer through the influx and interaction of people and goods from around the world (pl.48).

Prominent amongst the new multicultural street fashions in Britain are new styles of Islamic fashion, which signal both a person's religious identity and faith and their stylistic flare and fashion competence. Here again, the relationship between ethnicity and fashion is complex as the British South Asian example demonstrates. Approximately half the British South Asian population is Muslim and well over two-thirds of all Muslims in Britain trace their roots to South Asia.

In view of this it is not surprising that British Muslims of South Asian origin are the most prominent actors in the Islamic fashion scene. What is striking is that the clothes they wear and the new Islamic fashions they design and market are multicultural in composition and inspiration, often drawing simultaneously from elements of South Asian, Middle Eastern, North African, Turkish and Western clothing traditions and trends. Here fashion is not seen as being opposed to religious identity or faith but as an important vehicle of it. A beach sarong, designed in England and made in China, may end up worn in London as a *hijab* (a Muslim headscarf)[1]; a sun dress designed to expose the arms and shoulders may end up worn as part of a layered ensemble that satisfies a young Muslim woman's interpretation of Islamic requirements of modesty. Such an outfit may look bold and stylish when worn over a polo neck sweater and jeans with carefully chosen shoes and eye-catching *hijab* tied in one of the latest styles picked up from a British, Turkish, Egyptian or Pakistani friend or by studying new layering techniques demonstrated in a *hijabi* fashion blog or on You Tube.

It is this combination of unpredictability, experimentation and cultural eclecticism that often makes Islamic fashions in Britain distinctive from those popularized elsewhere. Another distinctive element is the widespread presence of scarves and shawls with a strong South Asian resonance in terms of their colours, patterns and design features, many of which are imported from India and Pakistan. These are often incorporated into eye-catching *hijabs*, built high through twisting and layering techniques or decorated with elaborate *hijab* pins and brooches that add an unexpected element of sparkle. But it should also be recognized that the same scarves or shawls have also entered popular British

50
Opposite, above:
Zarina Saley at home in central London,
2009

51
Opposite, below:
Zarina Saley out shopping, London, 2009

Following pages, left:
52
Models wearing *jilbabs* from Imaan
Collections at IslamExpo fashion show,
Olympia, Earls Court, London, 2008

53
Grey woollen *jilbab* with red felt poppies
from Imaan Collections, 2008
Leicester-based designer Sophia
Kara wore the *jilbab* in recognition of
Remembrance Day, November 2008

54
Hijabs on display in the Arabiannites
boutique, Whitechapel, London, 2007

55
New range of coloured *jilbabs*,
Arabiannites boutique, Whitechapel,
London, 2007

fashions more generally – bearing testimony to long-term Anglo-Indian exchanges of cloth and tastes.

Multi-culturalisms old and new

If today Britain prides itself in the sartorial eclecticism of its multicultural population, this was not always the case. Many first generation South Asians who came to Britain in the 1950s and 60s found their clothes an object of derision, a target of racism and a barrier to social inclusion. As a result many chose to down play markers of ethnic affiliation. Sikh men, for example, often shaved their beards and removed their turbans in the interests of finding accommodation and getting jobs. Children born to South Asian parents often found themselves negotiating the conflicting demands and expectations of school and family. Some parents, anxious about the exposure of their daughters' legs, encouraged them to wear trousers under their skirts, a practice which marked them out as different from their peers, causing anxiety to some. Ironically today the wearing of trousers under skirts and dresses has entered mainstream fashion. Although not generally understood as being associated with South Asian dress practices, this trend could be interpreted as an example of the absorption and adaptation of elements of South Asian style.

Two factors which played an important role in paving the way for today's multicultural fashions were the efforts of South Asian women to retain their saris and *salwar kameezes* (trouser and tunic combination), despite unfavourable cultural and climactic conditions, and the struggle on the part of some Sikh men for the right to wear items of ethnic and religious significance in the workplace. An example is that of Mr Sagar in Manchester, who was refused the job of bus conductor in 1959 on the grounds that his turban did not conform to conditions of service. After garnering support from local dignitaries in Britain and India, and from important figures in the British army where Sikhs had been employed for generations, Mr Sagar finally won his case in 1967. By then too old for such employment, he did not

take up the work but his and other turban struggles paved the way for provisions made in the Race Relations Act of 1976. In many ways these campaigns of the 1960s and 70s can also be considered the precursors of more recent *hijab* campaigns, in which British Muslim women have united with European Muslims to protest against restrictions on the wearing of religious symbols in state schools in France and other European countries (pl.49).

The political shift towards supporting and fostering multiculturalism in 1990s Britain also played an important role in enabling different communities to take pride in particular regional clothing traditions. But whilst such policies were essential for supporting the right to difference, they also simultaneously played a subtle role in fixing cultural stereotypes, which some younger generation British Asians are now keen to resist.

Born and raised in Britain, many young British Muslims of South Asian origin are keen to find ways of dressing that express their religious identity and faith without necessarily signalling their ethnic origin. Not only do many find saris and *salwar kameezes* too body-hugging and bright to conform to their interpretations of Islamic criteria of modesty, but they also consider them 'too Asian' and associate them with the conservative values of their parents' generation. Viewed from this perspective, new Islamic fashions offer an exciting alternative. By simultaneously combining concerns with religion, fashion and cosmopolitanism, they challenge conventional understandings of 'Asian', 'Western' and 'Islamic' dress. This represents a shift in the understanding of multiculturalism from a set of distinct cultural traditions to be preserved to an understanding of how new multicultural forms come about through combining, adapting and reworking elements drawn from different cultural traditions. Here diversity may be expressed within a single outfit and may be interpreted more generally as a feature of British urban life rather than as an attribute of particular groups by dint of their different ethnic origins (pls 50, 51).

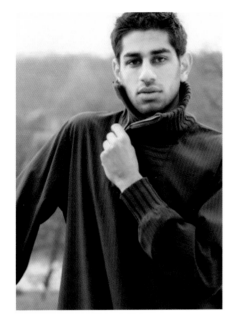
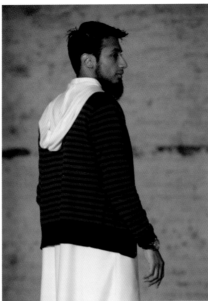
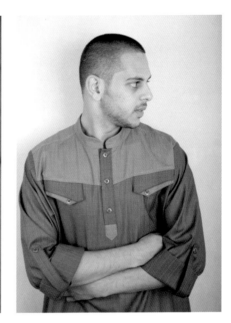

New Islamic fashion design in Britain

There is no formula to the styles being developed by British Islamic fashion designers of Asian origin in what has become known as 'the post 9/11 era'. Some take obvious inspiration from clothing traditions of the Arab world, while others are more overtly Western or South Asian in their associations. Many reference several cultural traditions at once. The clothes they design are marketed as 'Islamic', 'Islamically inspired' or 'modest' depending on the orientation of particular companies and the publics they seek to address. What they share is a desire to unite ideas of modesty with fashion and to counter negative stereotypes of Islam and Muslims by developing new modern and attractive forms of covered dress. The styles they develop and their modes of presentation are, however, varied.

In Whitechapel, east London, an area locally known as 'Little Bengal' for its large population of families of Bengali origin, is a boutique with the name Arabiannites (pls 54–5). It sells fashionable forms of dress for women who cover. These are based on elaborations and transformations of Egyptian *galabiyas*, Moroccan *kaftans* and Arabian *jilbabs* and *abayas* (all long-sleeved full-length garments), and are produced in India and Dubai using the tailoring and embroidering skills of Indian Muslim embroiderers. The designer and founder of the company is Yasmin Arif, a young woman of Gujarati origin, raised in east London but with a professional training from the Chelsea College of Art and the London College of Fashion. To the untrained eye the clothes she sells may simply look Middle Eastern, but on closer inspection they are quirky, playful and eclectic, incorporating embroidery in unexpected places, extended hoods, elaborate sleeves and interesting cuts. The boutique also sells an unusual range of scarves from India and Pakistan, to be worn round the neck or as *hijabs*, along with a wide range of luxury *hijab* pins. What emerges is a new multicultural exotic look, which cannot be pinned down to any particular regional tradition but which draws inspiration from different sources, including South Asia and the Gulf. Situated in the East End of London where many Bengali Muslims wear more conservative styles of dress, Arabiannites, with its sensuous and luxurious interpretation of covered dress, is quietly innovative and transgressive.

In stark contrast are the more explicitly urban street *jilbabs* developed by the company Silk Route. It was a desire to avoid the 'cultural baggage' associated with both Middle Eastern and South Asian dress that motivated the founders of this company to develop new styles of full-length covered dress for Muslims. 'We're British,' Junayd Miah, one of the founders, told me. 'We have a sense of fashion and style. It's important to us. We wanted to express our unique identity and we were well placed to do that. It was our search for a means of expression for people like us, and our sisters and cousins – a new generation who were turning to Islam.' To express this British Muslim identity, Miah and his partners turned not to South Asian lifestyle and fashion magazines but to British youth magazines for inspiration. They then employed fashion designers to develop Islamically appropriate versions of popular street styles. What has resulted are long-sleeved full-length *jilbabs* with tracksuit piping, pockets for mobile phones, combat features and hoods – a new modern look for Muslim youth. Though very much rooted in their experience as British Muslim Londoners from South Asian backgrounds, the five entrepreneurs behind the company (three men and two women) have global ambitions. The company recently shifted manufacturing from Bangladesh to Egypt and hopes to capture a global Islamic youth market.

A similar ambition is shared by the founder of Lawung, Faisel Ibn Dawood Acha, a young man of Gujarati origin, born and raised in Preston in the North of England. Lawung specializes in cutting-edge men's Islamic dress (pls 56–8), consisting of *thobes* (long-sleeved full-length robes) designed as modern versions of the garment worn by the Prophet Mohammed, whose example many Muslim men seek to follow. The use of fashionable materials and

56–58
Previous page:
Three *thobes* by Lawung, 2009
According to the Lawung website, these
thobes, designed as functional
daywear, were 'conceptualised by street
culture'. The 'white hoodie'
(centre) is modelled by Faisel Ibn Dawood
Acha, founder of the company

design features such as zippers, hoods, ribbed sleeves and combat pockets situate these clothes within contemporary fashion. Names such as Urban Streetz, Urban Navigator, Urban Military, Urban Executive and Urban Extreme further testify to the assertive modernist intentions behind these designs. Lawung *thobes* were initially distributed through Islamic shops in cities with a strong Asian Muslim presence in the North of England and the Midlands as well as at Islamic events up and down the country. At Islam Expo 2008 in Earls Court, London, they were displayed on futuristic mannequins and proved extremely popular amongst Muslim men of different ages and backgrounds. Today the company also markets its products online and has stockists in Abu Dhabi, Dubai, Al Ain, Riyadh and Bahrain. Whilst production was recently shifted to China, the label Lawung England identifies the *thobes* as a new exportable form of British Muslim men's fashion.

Arabiannites, with its explicitly Eastern inspiration, and Silk Route and Lawung, with their explicitly Western inspiration, represent two contrasting approaches to Islamic fashion, both of which have grown out of the British Asian Muslim experience. They reveal how British Asian Muslim designers may reference their cultural backgrounds in very different ways and how many do not feel obliged, or may actively choose to avoid, producing an overtly South Asian aesthetic. Identifying a demand for fashionable forms of covered dress, some designers also seek to reach beyond the Muslim market. For example, Sophia Kara, the British Gujarati designer and founder of the Leicester-based company Imaan, has recognized that her quirky interpretation of professional, modest, fashionable dress has both real and potential appeal to women from different communities (pls 59–60). In response to this she recently redesigned her website, removing slogans which identified her designs as Islamic and re-defining them as 'contemporary modest designer wear'. She takes pride in participating in an annual fashion show in Leicester, where her designs are appreciated by people from different backgrounds and faiths, including some British Asian Hindus. Similarly her shop attracts a range of British women keen to find fashionable styles of dress that are not too revealing of body shape. Though many of her clothes are made in India, Pakistan and Syria, they often incorporate materials more associated with Western fashions such as wool, linen, leather and suede. She also likes to incorporate feathers and buttons reminiscent of 1920s British fashions and to suggest unexpected combinations such as hats and bulky costume jewellery worn with *hijabs* and *jilbabs*. Like other Islamic fashion designers she sees her clothes as breaking through and breaking down cultural barriers. As British designers and entrepreneurs, they feel at liberty to experiment with style and to draw on different fashion regimes and cultural traditions for aesthetic inspiration, design ideas and materials. Their customers, some of whom are themselves from British Asian Muslim backgrounds, are often attracted to such fashions partly because they offer new multicultural alternatives to the types of dress worn by their parents.

A brief look at the world of new multicultural, visibly Muslim, Islamic fashions developing in Britain suggests that stylish young British Muslims, many of whom are of Asian origin, are not so much abandoning South Asian dress as redefining its place in their wardrobe. Brought up in Britain, attuned to the latest mainstream and street fashions as well as to developments in Islamic fashion elsewhere around the world, they embrace an innovative multicultural approach to fashion in which South Asian elements are often referenced in subtle ways. Such fashions co-exist with more overtly Asian styles and fabrics, which may be favoured for festivals and special events and which are purchased by British Asians from different regional and religious backgrounds. It is this combination of cosmopolitan eclecticism, cultural elaboration and innovation that gives British street fashions their distinctive multicultural edge in the complex world of global fashion.[2]

59
Linen blended 'Kimono wrap' *jilbab*
as advertised on the website for Imaan
Collections, Leicester

60
Website advertisement for Imaan
Collections, Winter 2009

61
Jilbabs from Silk Route
As advertised on www.hijabshop.com

62
Sports *jilbabs* from Silk Route
As advertised on www.hijabshop.com

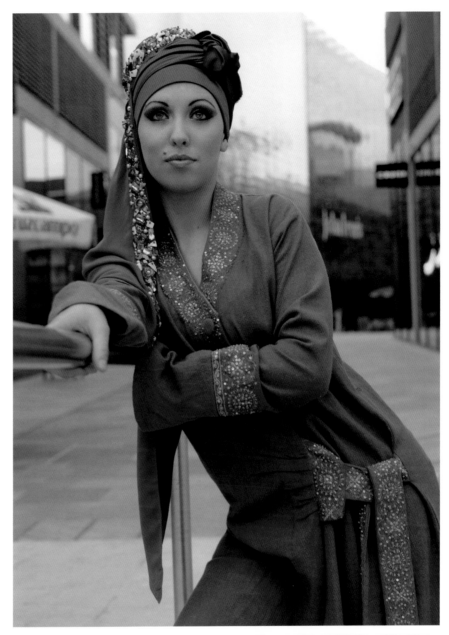

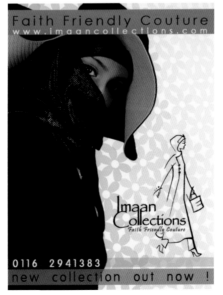

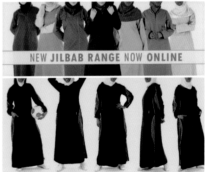

wardrobe stories
by shivani derrington

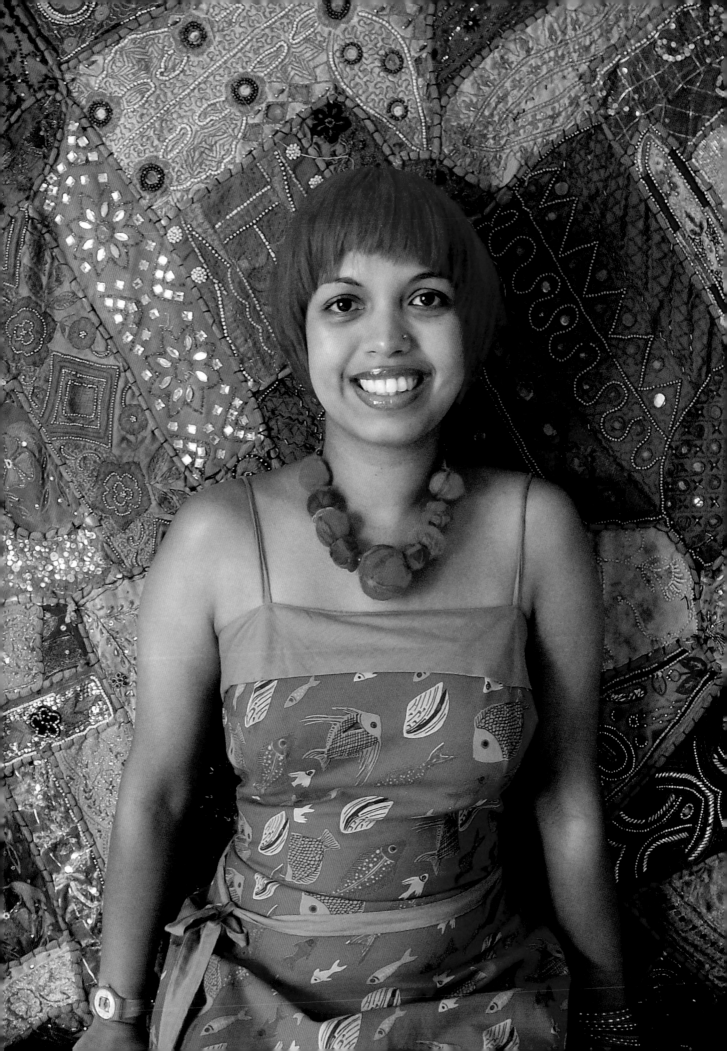

63
Previous page:
Momtaz's wardrobe, London, 2008
The wardrobe presents an everyday
dilemma for British Asian women that
touches on issues of identity, race and
social space

64
Opposite:
'This is me', Momtaz, London, 2008
Momtaz's style mixes South Asian and
British fashion

'Clothes are … about how you feel when you put them on'
Sandeep Rai, 2008

Our sensory fascination with clothes lies in our tactile
experience of them. Clothes sit on the body and stand
between our private and public worlds. We look around; we
see what is in fashion and what is out of fashion. We choose or
discard items depending on how they look and feel, and what
they say about us. In the act of dressing we create and present
our own personal style. Here, in front of the mirror, in what
Sophie Woodward has called the 'wardrobe moment', British
Asians have their daily wrangle with style. Our clothes are
linked to tradition as well as providing a method of creating
individual style. Within her wardrobe a woman develops
her own aesthetic look, which mediates her relationship to
the social space. For British Asian women this relationship
is refracted by histories of migration and cross-cultural
influences: British, Asian and, of course, 'British Asian'. Out of
the pleasures and pains of our clothing choices an individual
look emerges from the memory of our experiences, which
speaks out and says, for better or worse, 'This is me'.

In the summer of 2008 I conducted interviews with a number
of British Asian women living and working in London, and a
selection of edited excerpts from these interviews follows. We
talked about their clothes, how they dressed and what decisions
went into the creation of their own personal style. The
aim of these discussions was not to be an all-encompassing
investigation of the issues British Asians face when finding a
look that works for them in the British social space: gender,
race, religion and politics are implicitly rather than explicitly
explored here while some areas of British Asian dress, such
as veiling, are not included. Instead a narrative has emerged,
drawn from personal experience, in which a group of women
reveal the influences that they feel have been significant in
the creation of their wardrobes. It embraces the pleasure of
shopping for weddings, the negotiations made when entering
public spaces and how we learn traditions of dress. At the
outset I want to express my thanks to all those who talked to

me, let me invade their homes and wardrobes, and so kindly
agreed to be represented here.

The private and public worlds of dress

Dress can be thought about as a personal, bodily experience
as well as the way we present ourselves in public. Our clothes
may even act as facades, which we stand behind when we
leave our homes and enter the wider world. In the words of
Jo Entwistle, the dress we step out in becomes 'the meeting
place of the private and public'. One of the questions I asked
in these interviews was 'How is this presentation of self in a
public space viewed by British Asians?' Here are the thoughts
of some of the women involved in this research.

For Nidhi, sari-wearing is a practice she enjoys in many areas
of her life:

'I have always worn one, since I got married, for a special
occasion. Whether it was Asian and religious or Western with
English friends who were getting married or anything, I would
always go in a sari. I would invariably be the only person in a
sari, but I knew it would be appreciated and I felt adequately
dressed as well, adequately attired. I think I have more formal
Asian than Western clothes, so it's an easy choice.'

Other women described the decision as to whether or not
to wear Asian clothing as a negotiation between wanting to
express themselves and wanting to dress appropriately, wanting
to assert their links with South Asia but also to follow what they
consider to be normative dress codes in mainstream British
culture. As Samia articulates, dressing in South Asian clothing
is often a dialogue between standing out and fitting in:

'I wouldn't say I'm the sort of person who needs to fit in but
at the same time I don't necessarily want to stand out either.
If I'm going to a very Asian event, then I'll wear something
appropriate. If I've got a South Asian dress that I'm going to
wear to a non-Asian event, then I'll just tone it down slightly, so
I don't stand out.' Clothes choices to Samia are informed by a

variety of influences, which speak to our various concepts of identity and self:

'I don't think that wearing South Asian clothes means you have a more secure identity. It might just mean that you get your fashion inspiration elsewhere. Maybe you're following a different trend because you live here [in the UK] but we have cultural influences outside of our homes.'

For Kiran, this development of a personal look is not just about traditions or cultural norms; it is about the creation of new and innovative ways of dress that speak to the British and Asian sides of her:

'[Dressing in South Asian clothes] is not a sort of hankering for what's back there. It's saying, well there's a rich tradition there, which you can change; it can morph with you.'

Equally, Sohini expresses her individuality in Asian dress by creating her own style:

'The very fact that I choose to wear a sari of a certain colour maybe, or a certain quality, means that I'm conforming to … what people expect me to wear and do. The way that I [express] my individuality would probably be in the design of it maybe, or the shade of it, and … what I choose to use for my accessories.'

In addition to thinking about British Asian audiences when dressing in Asian clothes, Sohini feels she elicits appreciation from non-British Asian audiences. Sometimes standing out and fitting in collide and garments bring to mind the memories of these encounters:

'I think they [non-British Asians] just appreciate it. Hopefully they'll feel I look pretty in this sari and that it suits me, and they'll think, "Oh, she looks nice" and "Oh, she's carrying on [British Asian] traditions in our culture, which is really important," rather than my turning up in some Western

clothes or something. Once I was going to a friend's registry office wedding. I wore a salwar kameez – it was summer time – and it was a really lovely pale lilac colour with silver embroidery on it. As I got onto the train this old woman got up, she was this English lady, and she said, "My, don't you look pretty," and I said, "Oh, thank you". And it was my outfit. Actually a few times when I've been in the street, you know, walking from one event to another or something, people have commented, "Oh, that's really pretty," or "You look lovely". And, you know, English people, like young girls, really like it. They appreciate it. You live in this country but you're still carrying on a tradition.'

Ruchi also perceives the gaze of others when dressing and feels it is clothes that provide the initial identifications for others to see you by:

'When someone looks at you they automatically think something – just from the way you are dressed. They won't think about your personality, or the way you are, unless you start talking to them and have a conversation. That first impression is always made from the way you dress.'

The gaze of others influenced these various dress practices, learned practices that are thought about in terms of the geography of daily life. People, of course, dress differently for different occasions from the everyday to the celebratory. Different aspects of self are revealed through our clothes at different times. For many of the women I interviewed the specific public spaces they dressed for were crucial to their presentation of self. Different environments are thought of as being either appropriate or inappropriate for Asian clothes, as Ruchi explains:

'[Our dress choices are informed by] the environment we have been brought up in. I would not go to Tesco in my Punjabi suit, or sari or anything, if you know what I mean. I don't have anything against it – it just wouldn't feel right. I always think of [dressing in Asian clothing] as something to be proud of –

65–66
Following pages:
Five wardrobes in close-up, London, 2008
Silk, cotton, wool, dyed, spangled,
embroidered: eclectic fabrics from
within the wardrobes of Nidhi, Kiran, Samia,
Ann and Chandan

I am not embarrassed by it. So I am always surprised when I do wear it [how] many people ask me about it, people from other cultures who don't know so much about it.'

Sandeep also pursues this idea. She feels that she wears South Asian clothes as a way of projecting a confidence about her identity:

'Anything [South Asian] that I wear, I wear with pride and as long as I'm not going to an interview or to work … If I was just walking down the road or, you know, getting on the tube and going through somewhere where nobody else would be wearing Indian, I'd be fine. Because at the end of the day it's my right to express my own identity and to do that through my clothing, so in that sense I wouldn't feel – I don't ever feel – uncomfortable.'

To gain admittance to certain areas of life these women also expressed how they changed their dress practices. As mentioned by Sandeep, the workspace does not always seem the place for Asian clothing, as Ansuya also discusses:

'I didn't want to stand out if I wore my sari. I wanted to be part of everything, you know. And I think that's stuck with me, even now. I mean there are people who wear their own [Asian] clothes, but I've never felt right wearing saris to work.'

Listening to these narratives we might ask who owns and has access to British social space? Where and how are we allowed in? To some, Asian clothes do not lend themselves to a professional identity. To others, Asian clothes allow access, to perhaps familial or religious spaces. Dress here is partly political, shaped by and intervening in matters of race and identity. But it is also deeply personal. In our everyday navigations of our wardrobes we both confront wider political landscapes and, at the same time, domesticate that wider world of style and fashion, reworking it into something personal and our own.

Wedding memories

A moment that cropped up again and again in our discussions was that of the wedding, both their own and those of others. The women I spoke to felt that this was an occasion on which they wore the most specially selected garments, for which they thought carefully about what did and did not express them sartorially. Indeed much time and attention, it would seem, is spent thinking about wedding clothes, shopping for them and, of course, wearing them.

As Nina mentioned:

'When the right occasion comes along everyone gets excited, everyone is looking at what they are going to wear … it's a big thing for everybody.'

For Sandeep wedding clothing plays a central role in her sense of her own look:

'A garment reminds you of the time [you last wore it]. Like my orange lengha [a garment consisting of a skirt, top and stole, popular at weddings]. Every time you put something [like that] on, it makes you feel good, it changes your whole perception of whatever you're doing, doesn't it?'

For Momtaz, a sari would be the only garment appropriate to wear at her own wedding:

'The sari to me just speaks of weddings. I think that the only time I would consider wearing a sari would be if I were getting married. It seems the right kind of style to wear. I mean I would not consider Western-style wedding clothes and even a salwar kameez, to me, does not feel quite right as I might wear one anyway in my daily life. The wedding is special, a one-off event. For this kind of occasion I would go for a goldy-red one, really glamorous, with nice embroidery. A wedding is the one time you get to dress up like that. Everyone you know will be there. A sari would just feel right.'

67
Material memories, London, 2008
Clothes represent more than fashion,
symbolising special occasions, such as
weddings, and other key events

Framing clothes in relation to the past rather than a
projected future, Nidhi's special saris are a repository for
both memories of the occasions on which they were worn
and the history behind them:

'I was given [a sari] on my wedding day – the sari that I
changed into before I went to my in-laws' house. It was not
one I was going to wear, but one I had draped around me. It
was my mother-in-law's – there is also jewellery to go with it
– and it was her mother-in-law's before that, sort of a family
heirloom. And not so long ago my maternal aunt passed
away and [left us] her saris; we took one each. That is very
special. I actually wore it for a religious ceremony. That was
nice; it kind of felt like she was there with me.'

For Sohini, her wedding outfits evoke wonderful memories
of shopping with friends for her big day:

'[The] registry isn't a great big affair with 300 people.
It's a small intimate affair and I felt that [a cream *lengha*]
was far more appropriate. It is a bit plainer, with some
embroidery around the front but not too much. You know,
really nice. That outfit is quite special because my friends
picked it out for me. I took a couple of friends shopping.
I'm terrible at shopping. I get fed up really easily whereas
one of my friends is just shop till you drop! So they were
great. It was one of the last outfits I tried on, and I was
like, "Yeah, okay, what do you think?" and they went,
"That's the one," and I said, "Are you sure?," and they
went, "Yeah, that is definitely the one". And so that was
my registry office outfit. I have actually worn it a few
times since, and I love it to bits.'

Clothes designed to be worn for special occasions are therefore
viewed as something more than just pieces of fabric. Such
clothes are able to become mementos of an event, devices to
make us feel good and heirlooms to be passed down to future
generations and worn again. Symbolic of their former uses
and owners, they are material memories.

British Asian style

These are some of the stories women had to share about
their clothing choices. What is it about these stories that
speak to an idea of a British Asian style? Here are some of
the comments they made.

For Kiran, Indian clothes are an integral part of the
landscape of British fashion:

'It's not cutting edge any more because it's moved into [the
mainstream]. You've got shops like Monsoon that provide
you with garments that are made out in India, and you
know they change them to [suit the] fashion.'

For Chandan, British Asian style is in part about accessing
fashion from a wide range of sources. The crossover
between high street and Asian clothing styles is also
something Chandan has seen develop:

'If you go into my local shopping area, there are loads of
different Asians from different backgrounds. A lot of the
younger ones are wearing [Punjabi] suits and they're much
more fashionable, so there is a kind of different atmosphere
compared to where I was brought up, an area in Nottingham
where everyone wore English clothes and you wouldn't have
gone out in Asian clothes that much. Or you might just try it.
Now you can wear tops with jeans or Indian shoes with jeans,
so you don't think about it as much. I think there's much more
of a casual approach. I feel that I can wear some of my Asian
clothes with other clothes as it will look quite nice … so in that
sense it feels much more natural as well.'

For Momtaz, her own style is a mixture of South Asian and
British fashion influences:

'I tend to make sure I've got something South Asian on me,
like an accessory, but I tend not to wear an entire outfit. I often
wear … some bangles or earrings, or a swatch or something
like a trim because I like to have [that] look in my outfit. I've

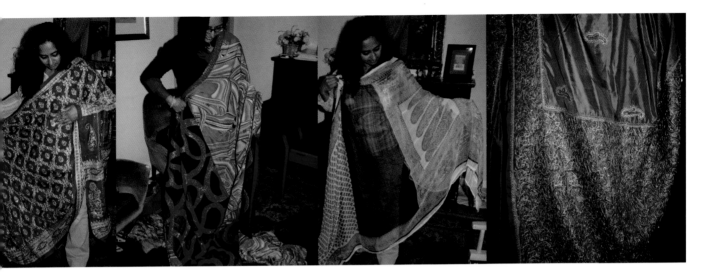

only got one fully Asian outfit and that's for occasions. I don't usually wear typically Western clothes, or typically Asian clothes. I just like to create my own look really, which will have a bit of both in, pretty much.'

Rohema and Nasima also find that they create their own British Asian style through the use of elements from British and Asian fashions. They discuss whether there is a conceptually distinct British Asian style to be seen on the streets of London today:

R: 'There is in some sense because it's how we wear … clothes. We might not wear [on an everyday basis] the actual stuff [for example, saris, *salwar kameezes* and *lenghas*] that we wear to … special occasions but we do wear Easternized, I mean Westernized clothing … Which is kind of like Eastern clothing but Westernized. So I guess you could say that's kind of British Asian fashion in some sense. Always mixed.'

N: 'I don't think it's even a fashion. It's just a state of mind, isn't it?'

R: 'Yeah.'

N: 'It's the way that an Asian person incorporates "Asian-ness" into their dress. It's not even only about the Asian. "British Asian" is pretty indigenized into British [culture]. It could be the other way round. It could be about putting a bit of Britishness into something quite South Asian.'

At one level, then, British Asian style evokes fashion that is neither exclusively South Asian nor exclusively British, but that exhibits and uses references from both areas. In part this reflects how British South Asians have worked with and challenged British sartorial ideas through the development of individual styles and relationships with transnational landscapes of fashion. It relates also to the wider influence of British Asian dress and South Asian styles, such that British fashion itself has been changed. British Asian style is not just

a form of 'minority' culture; but it is also a transformation of what British dress is. The diasporic aesthetics created in Britain today are a distinctive expression of contemporary British ideas of self and social identity.

Reflections

These conversations open up the idea that public and private worlds are mediated through clothes. In front of the mirror, as we create our own personal style, we ask ourselves which dress practices are appropriate and can best help us mediate our relationship with the outside world. How we choose to inhabit the world is indeed enacted through the clothes that enfold our bodies. They become the public expression of our inner thoughts on the self. Of course, how we enact this dialogue between self and other, private and public, differs from person to person. The preferences and styles discussed here are both personal and specific. By presenting these wardrobe stories as a narrative British South Asian fashions can be seen to reflect a diversity of experience as varied as those who comprise this group. And there are still wider insights to be gained from these specific testimonies.

Through our wardrobes we develop a set of styles of dress that express our selves to the world. The dress choices discussed not only construct in Britain a cosmopolitan dress style that is worldly wise, but also draw the world close in, making it personal. These wardrobe stories are simultaneously global and geo-political, subjective and emotional. Moreover, the accounts developed in these interviews point to the limits of framing clothes, and diasporic culture more generally, around oppositions between tradition and modernity. Clothes are seen to signify memories, pull in families and link us to social networks. They are also a site of innovation and improvisation. It is evident from this narrative that ideological differences between 'traditional Asian' and 'modern Western' clothes transcend the more literal forms, tangible in front of the wardrobe.

Today British Asian style is fashioned in part by style-makers who work across national borders, who physically and imaginatively travel between South Asia and Europe. Further examples are found elsewhere in the pages of this book, for example in considerations of British Asian fashion shops and British Islamic fashion, but here we showcase four such cases. These illustrate something of the variety of stylistic travels possible in terms of biography and cultural identity, the styles being fashioned, and audiences and markets. At the same time they also suggest how, within this variety, common issues return: the importance of material form; the negotiation of heritage and creativity; and the making of styles that are truly distinctive rather than merely representative of a presumed cultural difference.

contemporary british asian fashion designers
by philip crang

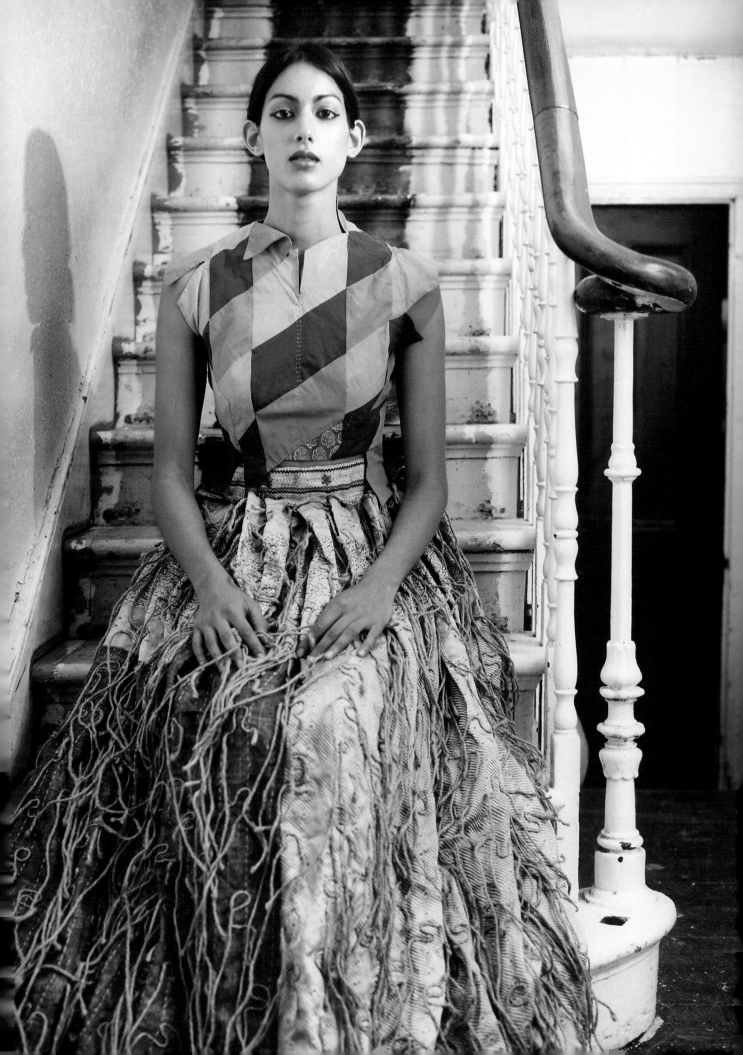

68
Liaqat Rasul founded the Ghulam
Sakina fashion label in 1999 following
his graduation from the University
of Derby. As part of his course,
Rasul chose to spend time studying
at the National Institute of Fashion
Technology (NIFT) in New Delhi.
There he gained a work placement
with Ritu Kumar, who inspired him
to engage with the textile traditions
of South Asia in his own work. She
sponsored his degree show, which in
turn led to his first Ghulam Sakina
collection, Multicultural Mind
Mayhem, commissioned by the
London retailer Liberty.

Named after Rasul's parents (Ghulam
means servant, Sakina beauty),
the label was to make a distinctive
intervention in British Asian fashion
culture over the following decade.
Emphasis was placed on Indian
craft skills and practices, including
embroidery and sewing, block-
printing, dyeing and quilting, within a
commitment to pieces that combined
fashion and longevity. Hand-finishing
of garments was a signature feature.

Ghulam Sakina had to navigate the
wider currents of a fashion for Indian
aesthetics in Britain, but was never
reducible to them. The label may have
been launched on the wave of so-called
'Asian Kool', a pre-millennial return
to fashion for things South Asian,
but its style was not defined by that
trend. Rasul's own biography made
the label much more than an ethnic
archaeology. Born in Wrexham, Wales,
to British parents of Pakistani origin,
he encountered India not as homeland
but as a place that fostered creativity of
mind and matter.

Made in Delhi and London, Liaqat
Rasul's women's wear emerged from
travels between Britain and South Asia.
Its combinations of colour, texture,
pattern and detailing speak to traditions
and translations of Indian craft in the
making of a contemporary style.

liaqat rasul

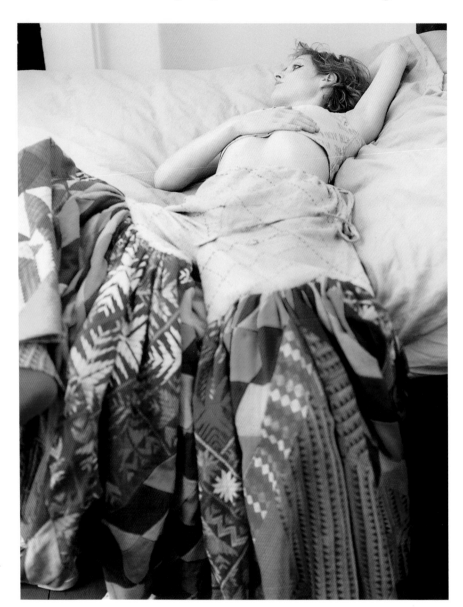

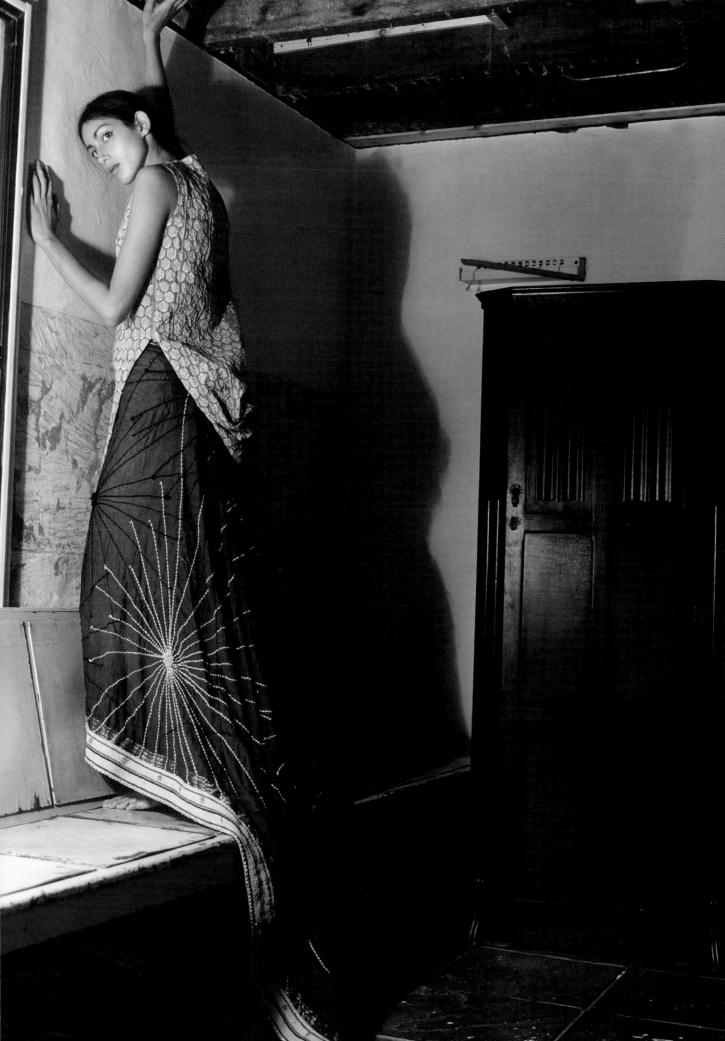

69

Little Shilpa is both nickname and brand of Mumbai- and London-based milliner, accessory designer and stylist Shilpa Chavan. Inspired by Philip Treacy's work and known for her fantastical headpieces, she was one of five 'new wave London milliners' selected by curator Stephen Jones for Headonism, an event at London Fashion Week, 2009.

British culture has long understood India as a place of craft and creativity. Chavan displaces such associations away from the rural, the communal and the workshop, and looks to the street. Her Mumbadevi installation (V&A, 2007), for instance, fashioned headwear from plastic toys, rubber sandals and *rangoli* pattern stickers. Contesting a linear sense of time and divided senses of place, her designs for Headonism 2010 unite the manmade with the natural, Perspex with feathers. Colour features as both lived tradition and a source of energy and modernity. Tribalism becomes urban.

Chavan was trained in Mumbai, with diplomas from the SNDT Women's University, and in London, at the London College of Fashion and Central Saint Martins Summer Schools. In 2005 she undertook an apprenticeship with Philip Treacy. As well as producing her own collections, Chavan accessorizes for designers such as Manish Arora in India and Boudicca in London. Films, galleries and installations are as important an exhibition space as the catwalk and celebrity adoptions, by American pop star Lady Gaga for instance, engage other audiences.

Chavan's work has been publicized as 'a madcap mix of East, West and everything in-between'. But apparent, too, is a sense of the originality of this 'maverick milliner from Mumbai', which exceeds easy concepts of an East-West fusion, even as it fashions a noticeably British Asian style.

little shilpa

70

Sarah Mahaffy opened Maharani, her shop in Fulham, London, in September 2006. Here she provides a showcase for the wide variety of contemporary and antique textiles that can be found in the Indian subcontinent. Having travelled fairly widely in India, she has become fascinated by the extraordinary craftsmanship that still survives there, and by the work that is being done to keep that craftsmanship alive.

In a small space she sells designer clothing from Gujarat, traditional embroidered silk jackets from Rajasthan, shawls of all types including the finest from Kashmir, and throws and hangings from Bengal, the Punjab, Hyderabad, and the Thar Desert. Textiles are a passion for Mahaffy. She has learned about Indian textiles through travel and through reading, but most importantly through friends in India, who have taken her to such out of the way places as Bhuj in Gujarat and Sri Kalahasti in Andhra Pradesh.

All her products are personally sourced. Three of her favourite places are Maheshwar in Madhya Pradesh, a town of 700 silk weavers on the banks of the Narmada river; the workshop of Suraiya Hasan, in Golconda outside Hyderabad; and Ahmedabad in Gujarat. Ahmedabad's fortunes were founded on cotton, and it is home to a number of cutting-edge designers working in textiles, of whom Archana Shah is one. Through her work with local artisans, she has fostered a major revival in the production and embroidery of textiles. Designing under the Bandhej label, Shah has an eye for both the past and the present, and her collection includes traditional and designer saris as well as 'Western' clothes with an Indian spin.

Mahaffy feels the Bandhej label suits Maharani's customers, who are not so much into fashion as into original, elegant clothing in which they can feel distinctive.

sarah mahaffy

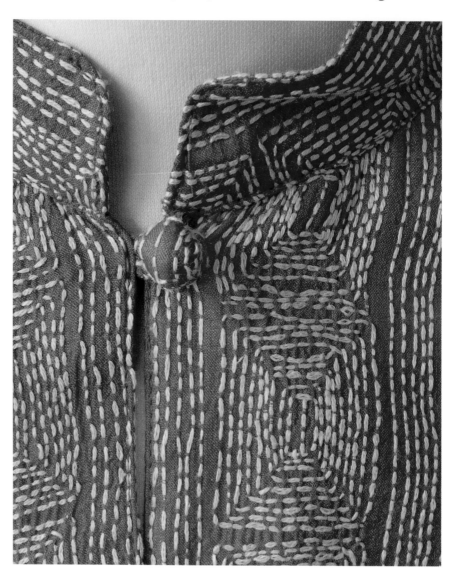

71

Gaurav Gupta launched his eponymous label at India Fashion Week, 2006. An alumnus of the National Institute of Fashion Technology (NIFT) in New Delhi and Central Saint Martins, London, he had previously gained experience with Hussein Chalayan, Stella McCartney and Rafael Lopez, among others.

Gupta has designed women's wear in both South Asian and Western forms, including saris and *lenghas* as well as dresses. Perhaps reflecting this dual expertise, his clothes are renowned for the way they work with the lines and motion of fabric. His early Western-styled pieces featured draping, flowing transparent jackets and deconstructed dresses. His saris became known for their chic evening dress qualities, as well as for specific features such as the use of metallic brooches and buckles. His couture bridal collections were read as having a punk attitude, combining the regal with rock and roll. Recurrent devices are three-dimensional embroideries and volume play.

Gupta's Spring/Summer 2010 women's collection took the theme of flight. Here drapery and structure met in creative opposition, in trapezium shapes, wing-like sleeves and anti-fit volume. A neon colour palette, combined with accompanying neckpieces and accessories of Swarovski crystal shapes, added a touch of 'bling', whilst still resisting over-ornamentation. The accompanying menswear collection featured draped trousers in both more exaggerated and simpler forms. The 'quirky formal' ethos of the label was apparent.

Gupta's work retails in India and globally. He describes his work as hard to place, as reminiscent of something 'future primitive'. Certainly his work points to the ongoing role of Indian dress forms in the future of couture.

gaurav gupta

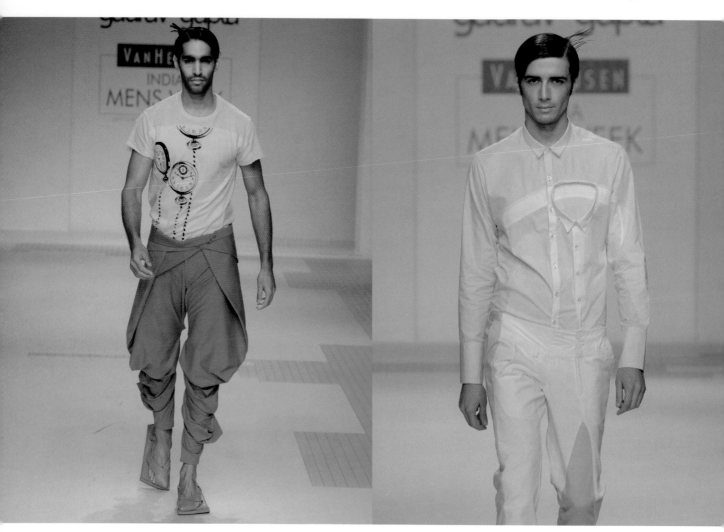

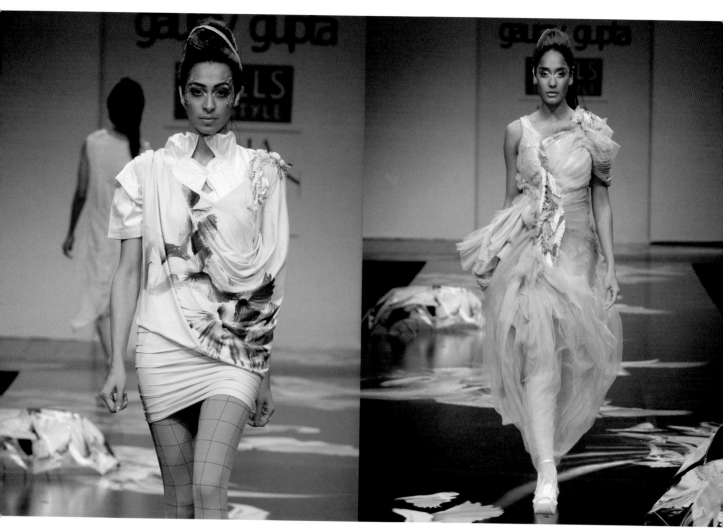

Photographer and fashion stylist Gavin Fernandes originates from India (Goa), was born in Africa (Kenya) and emigrated to the United Kingdom as a child in 1968, part of the East African-Asian diaspora. The themes of cultural identity, religion, feminine empowerment and gender encourage socio-political debate, both complex and provocative, in his work. These different aspects are united in his exploration of cultural integration, seen from an immigrant's viewpoint, inspired by autobiographical elements and combined with an analysis of the broader culture that exists within metropolitan life.

portfolio
by gavin fernandes

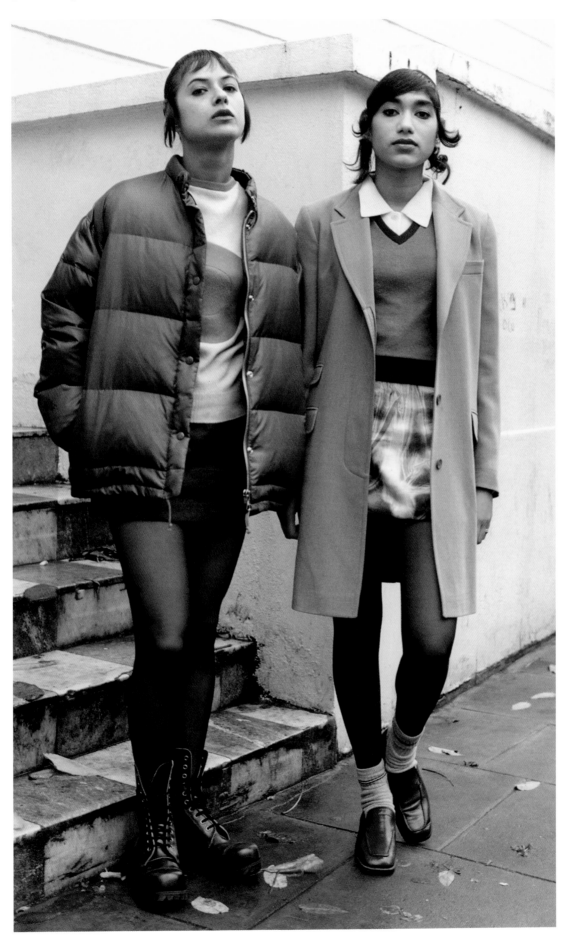

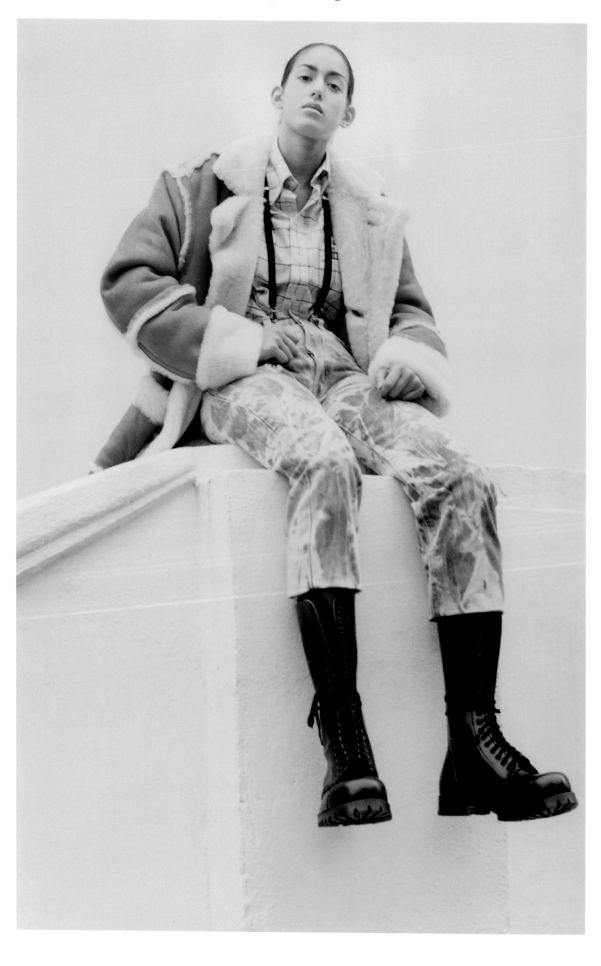

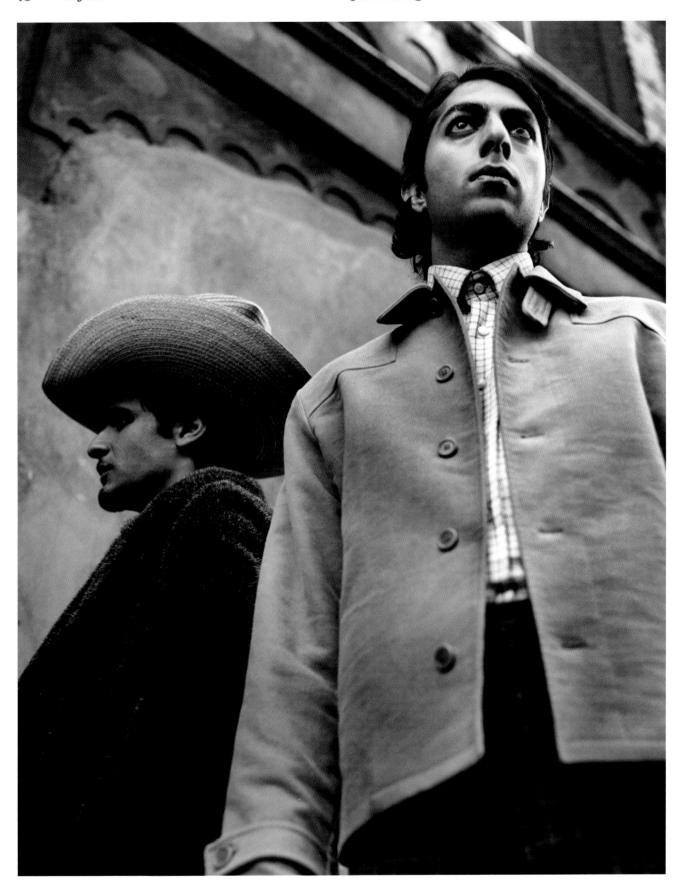

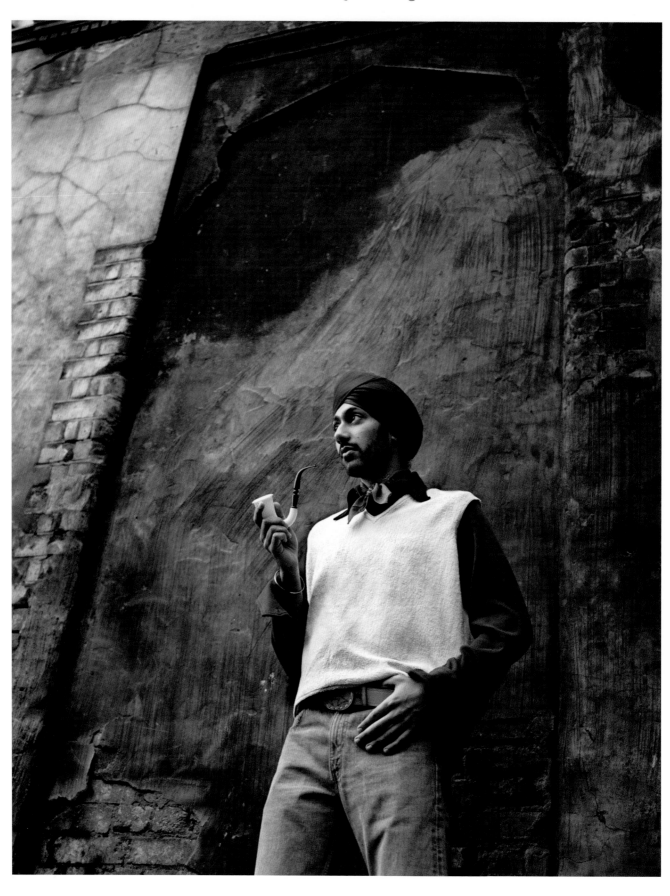

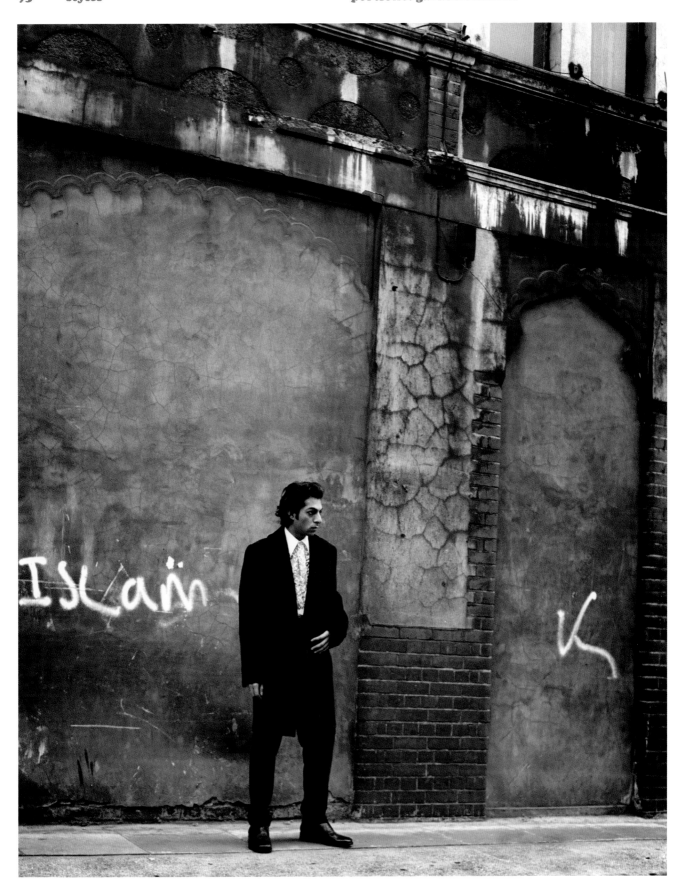

72

Page 89:

The Stealth Corporation

One of six C-type prints, London, 2001. Styling by Gavin Fernandes Photographed two months prior to the events of 9/11, this fictitious portrayal of the anti-Taliban feminist group RAWA (Revolutionary Association of the Women of Afghanistan) is a critique of feminine empowerment. The veil is redefined as a form of protection; the prohibited attributes of lipstick and jewellery become symbols of resistance.

73

Pages 90–92:

Skin Too

Three of eight C-type prints, London, 1996. Styling by Sarah Gilfillan and Gavin Fernandes
Skin Too is inspired by early memories of when Fernandes' family lived in Upton Park, east London, newly arrived as immigrants in 1969: the teenage longing of his older sisters for Ben Sherman shirts and tonic jackets, and listening to C-60 cassette tapes of Jamaican Ska music. By creating an uncompromising image of Asian skinhead girls, the work confronts notions of South Asian female passivity and subjugates racial victimization.

74

Pages 93–95:

Indians and Cowboys

Three of eight black and white bromide prints, London, 1997. Styling by Sarah Gilfillan
Indians and Cowboys is a response to stereotyping in child's play. Constructed as an analogy of the historical rivalry between Islamic, Hindu and Sikh faiths, the work was photographed near Brick Lane, east London, in a parody of a 'Curry Western'.

75

Pages 97–101:

Wrapstar

Four of eight C-type prints, London, 1998. Styling by Sarah Gilfillan Inspired by male British Sikh youth of the 1990s, some of whom adhered to the American culture of Rap and Hip-Hop in both music and style, *Wrapstar* questions contemporary Punjabi identity, which is here represented by a female role model, styled in urban fashion supplemented by the rudiments of Sikh culture.

76

Pages 102–105:

Empire Line

Four of twelve silver gelatin prints, London, 2005. Styling by Victoria Cumming and Gavin Fernandes
By subverting representations of British 'memsahibs' and their indigenous Indian servants, and through the interaction of period British costume and native Indian dress, *Empire Line* explores the politics of clothing and its relationship with class and caste in 19th-century colonial India.

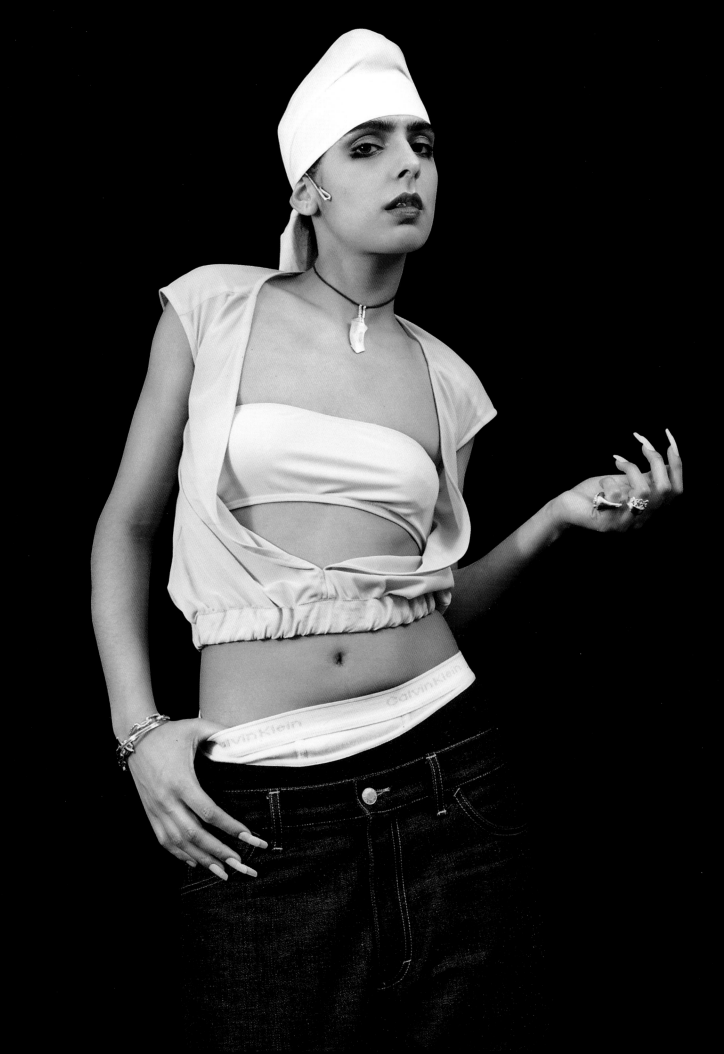

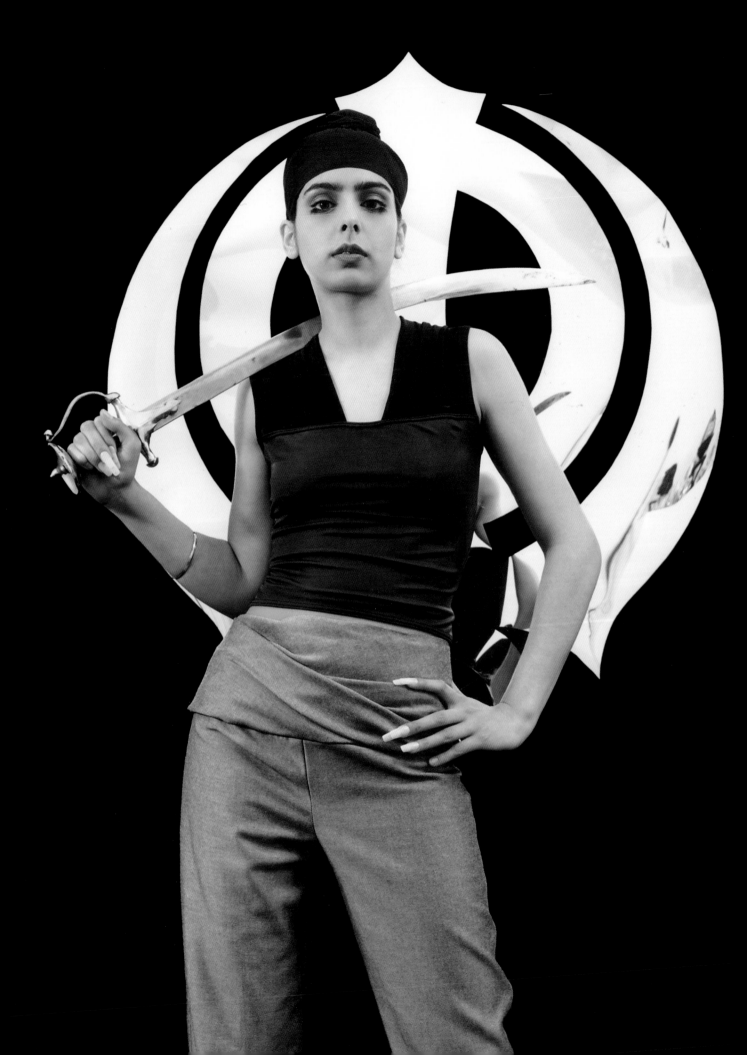

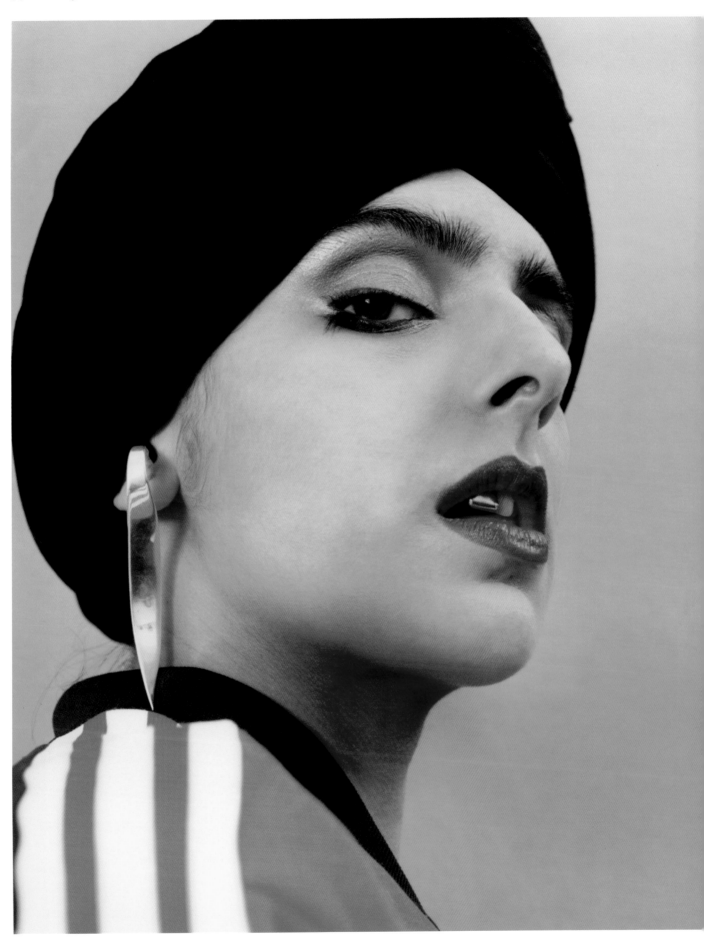

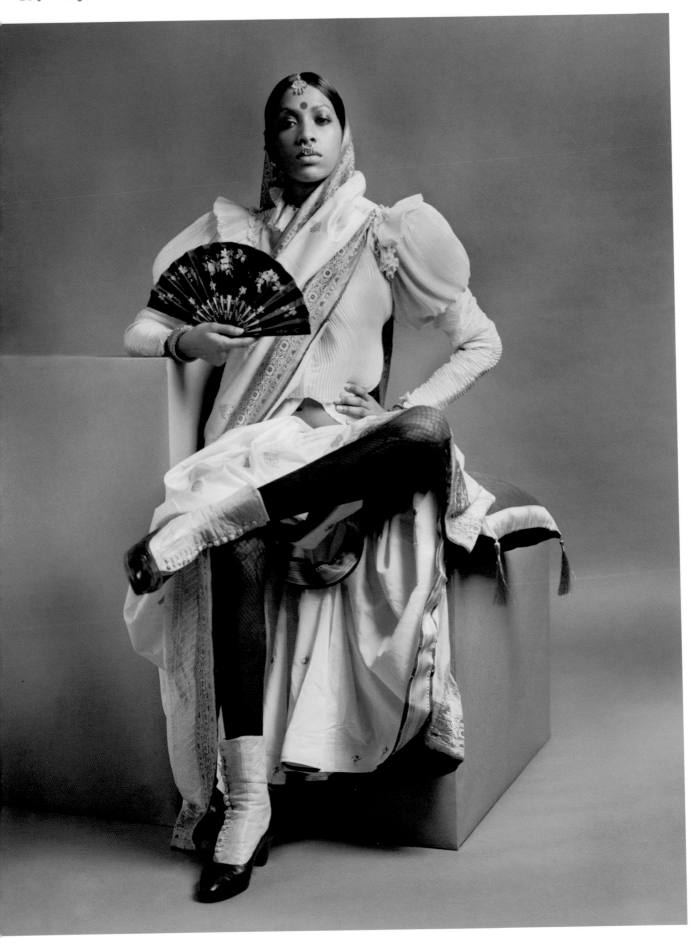

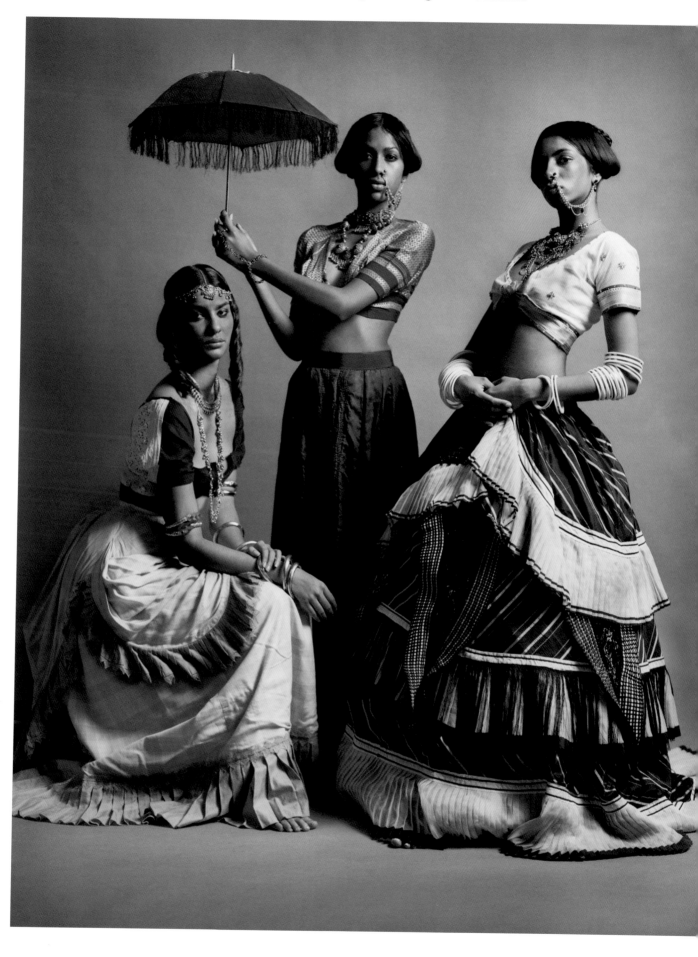

hippies, bohemians & chintz
by sonia ashmore

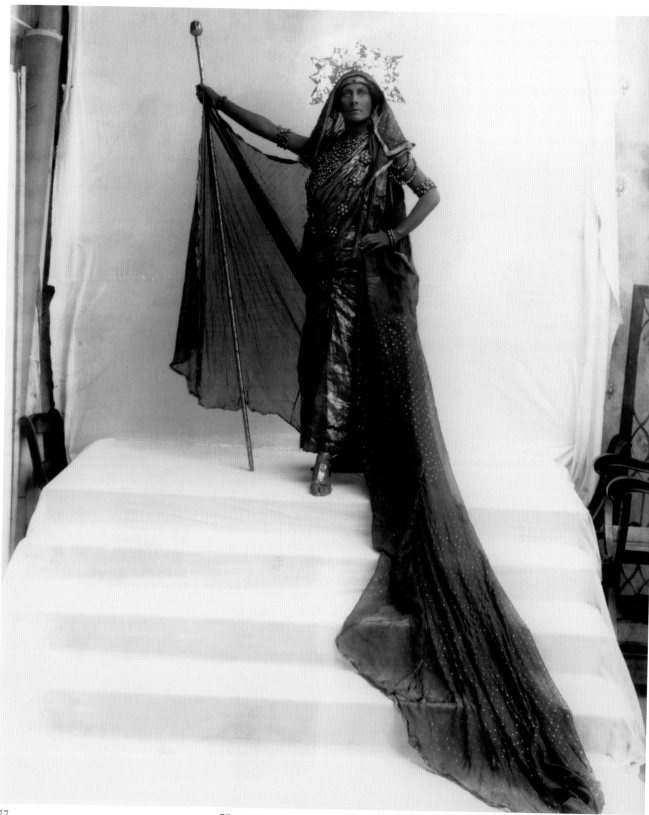

77
Above: Nancy Price as 'India' in the masque
Crown of India
Bassano (1829–1913)
Whole-plate glass negative, 1912
National Portrait Gallery, London

78
Following pages, left: Evening ensemble
Silk georgette with metallic thread
embroidery from Nabob, London, 1927–8
V&A: T.144–1967

79
Following pages, right: Jacket (and detail)
belonging to Lady Ottoline Morrell
Possibly made from an Indian sari, with
metal thread and black brush braid trim,
early 20th century
Fashion Museum, Bath & North East
Somerset Council

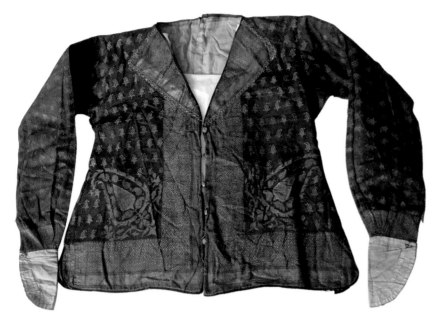

Fashionable men and women in Britain have been 'going Asian' since at least the eighteenth century, by wearing textiles and dress from India and using Indian fabrics in the decoration of their homes. Our fondness for chintz, Paisley – a pattern derived from the Indian *boteh* motif[1] – and *pashminas* has persisted for nearly 400 years. Today elite designers and high street retailers continue to turn to the subcontinent for inspiration, fabrics, craft skills such as block-printing and embroidery and, it must be said, cheap labour. Decades after India's political independence trade links and cultural resonances remain, stimulated today by British Asian designers, entrepreneurs and consumers.

European fashionable dress has long been influenced by a South Asian trade in cotton, silks, dyestuffs and finished textile goods. The British East India Company controlled an ancient, global Indian textile trade in unequal partnership with Britain; Gandhi's spinning wheel eventually became a symbol of Indian resistance to both imperial rule and Britain's vision of India as a vast market for its factory-made textiles. The way in which we have used and worn South Asian textiles has inevitably reflected changing relationships between Britain and the subcontinent. During the British Raj[2] dressing in Indian style was generally discouraged as the first sign of 'going native'. Verity Wilson, reflecting on 'borrowing other people's dress', suggests that dress codes maintained social and racial hierarchies and resolved 'real anxieties to do with the loss of identity in a foreign land', and emphasized that one had *not* 'gone native'.[3] Consequently exotic dress worn in Britain was more often Middle Eastern than Indian; Japan and China also had their fashionable moments.

Public performance

During the period of British rule in India textiles from the subcontinent were used in both formal and domestic contexts by the British royal family. For Edward VII's coronation as King Emperor in 1902 Queen Alexandra wore a gown made in Paris from fabric embroidered in India under the supervision of Lady Mary Curzon (1870–1906), wife of the Viceroy, who adopted the same diplomatic dress strategy in her own viceregal wardrobe.[4] The royal family also engaged in the popular Victorian and Edwardian practice of fancy dress; Indian fabrics were used in 'historical' costumes and for informal theatrical tableaux. This kind of exotic dressing up, which evoked rather than accurately reproduced 'oriental' dress, is epitomized in the image of Nancy Price in her costume as 'India' in the *Crown of India*, a masque with music by Edward Elgar staged to celebrate the 1911 Delhi Coronation Durbar (pl.77). The cloth of gold (or silver), wrapped sari-like beneath her diaphanous train and gold-trimmed veil, possibly a genuine sari, recalls the gold under-dress of Queen Alexandra's Coronation robe. Price's authoritative pose suggests a contemporary Britannia; Britain and Empire combined in one image. Today public figures continue the practice of cultural cross-dressing in a sometimes uneasy attempt to convey empathy rather than colonial authority. Cherie Booth wore an outfit by British Asian designer Babi Mahil to celebrate the fiftieth anniversary of Indian independence in 1997; pop singer Gerri Halliwell dressed in turquoise sari and matching *bindi* in her role as United Nations 'ambassador' in Nepal in September 2009.

From Bohemia to couture

Exoticism as part of the style of non-conformist dress remained a recurring theme in Britain; non-Western garments have consistently been appropriated and reworked to suit Western tastes. According to Tony Glenville and Amy de la Haye, this was at first an expression of dissent: an 'idiosyncratic, Bohemian approach to dressing up … has become assimilated within the British fashion psyche'.[5] Before the Second World War upper-class bohemians like Lady Ottoline Morrell (1873–1938) signalled their worldliness, romantic individualism and 'liberated' modernity with an eclectic mixture of exotic garments bought on their travels.[6] A jacket from her

wardrobe, now in the Fashion Museum, Bath (pl.79), is crudely made from a gold Varanasi brocade sari, likely to have been bought by her in India, and probably run up by her maid.[7] The result is a garment far removed from the unstitched, wrapped cloth that is the Indian sari.

As twentieth-century European fashion designers developed their signature styles or brands, many looked regularly to the subcontinent for inspiration and materials and borrowed from indigenous dress, but with a cavalier attitude to authenticity. The sari in particular was 'cannibalized' by influential twentieth-century designers such as Elsa Schiaparelli and Alix Grès, who were looking for fluid, unstructured shapes.[8] An evening ensemble of the late 1920s by a British company evocatively named Nabob, the term for a wealthy returnee from India, makes a low key reference to India in its restrained use of Indian metallic thread embroidery (*zari*) on a contemporary silk georgette jacket, reflecting the 1920s fashion for combining heavy beading with delicate fabrics (pl.78). Indian turbans did not escape attention: worn by men as informal indoor wear in the eighteenth century and widely fashionable by 1800, they were revived in the early twentieth century by the French designer Paul Poiret, who was inspired by seeing Indian turbans in the Victoria and Albert Museum, and have been popularized at intervals since (pl.83).[9]

During and after the Second World War, Indian textiles provided a luxurious alternative to rationed fabrics, for those who could get hold of them. In 1948 the important Indian Art Exhibition at the Royal Academy in the wake of Indian independence inspired *Vogue* to feature socialites in evening dresses made from Indian saris.[10] In the 1950s a reaction to the years of austerity generally focused attention on Western fashions such as the New Look, but international designers including Dior, Mainbocher, and subsequently Saint Laurent and Versace turned regularly to South Asia for both ideas and materials.[11]

The hippy trail at home

In the 1960s and early 1970s, a different kind of interest in 'ethnic' dress emerged as a part of a counter-cultural reaction to conventions of all kinds. 'Hippy' dress was eclectic, resisting the tailored, seasonal correctness of prevailing fashions and embracing the sensual aspects of fabrics: silk, velvet, embroidery, pattern and colour. While hippy clothes often referred unconsciously to a historic British relationship with India in their adoption of vernacular costumes and decorative Indian fabrics, exoticism was often undifferentiated. North African, Native American, South American, 'peasant' and 'gypsy' styles were also casually borrowed, as if different cultural identities could be tried on like clothes. Again, social celebrities of the day had the confidence to lead the style. Jane Ormsby Gore was a debutante in 1960 and describes the contrast that these colourful garments provided to prevailing dress codes.[12] 'I "came out" and went to all those parties. People were very conventionally dressed. The kind of dress I had to wear was of white tulle, fluffy and puffy.' This did not last; Ormsby Gore became part of the bohemian Chelsea scene where her husband Michael Rainey opened a boutique for men called Hung on You; later they sold textiles from South Asia and boots made of oriental rugs from a shop on the King's Road. She recalls:

'All those wonderful embroidered Indian and Palestinian dresses. I started wearing them when I was pregnant ... Ethnic clothes translated well for wearing in the "gypsy" caravans ... that was very hippy, the change from the slick look to the hippy look with long dresses. As far as I was concerned I liked them because they were embroidered and then it turned into the serious hippy shakes ... We were walking round the streets in our embroidered boots and long dresses and stuff.'[13]

The post-war period had brought new financial and social independence to a broader spectrum of young people, enabling them to shop in the new boutiques, buy clothes

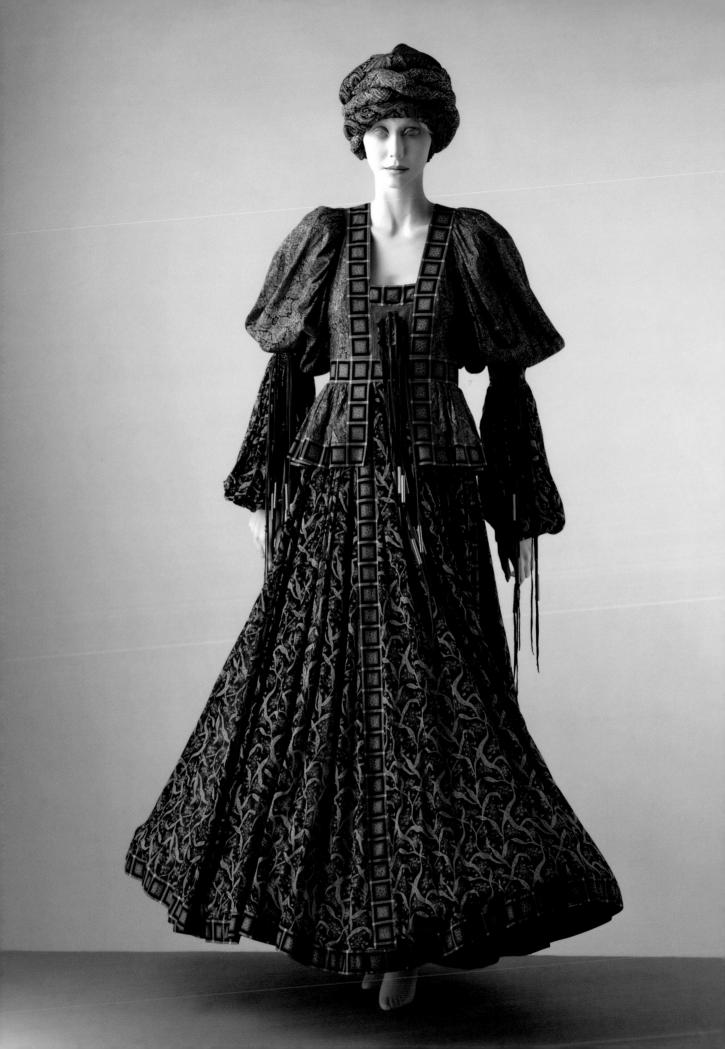

80
Previous pages, left: The Beatles and their
wives and girlfriends with the Maharishi
Mahesh Yogi, at Rishikesh, India, 1968

81
Previous pages, right: 'Indian' jacket worn by
young man at a hippy rally in Raphael's
Park, Romford, Essex, 1967

82
Opposite: Dress and turban
Cotton trimmed with leather, designed by
Bill Gibb (1943–1988), London, 1972
V&A: T.94–1981

83
Right: Model with turban
John French (1907–1966), London, 1960s
V&A: JF5600

that did not reflect their parents' taste, and travel. Many
went overland to India, Nepal and Afghanistan; some
brought back jewellery, fabrics and clothes. People began
to import and sell both indigenous and Westernized Indian
garments and textiles, in upmarket boutiques like Savita,
Malabar and Bodima in London's Knightsbridge and
from market stalls. By the late 1960s shops and interiors,
from society drawing rooms to student bedrooms, were
transformed with the aid of Indian textiles into exotic tents,
where one lounged in co-ordinating garments.

A new generation of pop musicians also made exotic clothes
fashionable. In 1968, at the height of their celebrity, the
Beatles went to India in pursuit of spiritual enlightenment
(pl.80). They and their retinue wore *kurta* (knee-length
shirt), saris, kaftans (more north African than Indian) and
marigold garlands; George Harrison had a gold brocade
'Indian' suit. The style was soon imitated with both men and
women wearing loose garments and floral patterns (pl.81).
Robert Orbach, a director of the clothes shops I Was Lord
Kitchener's Valet and Kleptomania, both of which did well
out of the fashion for 'Indian' beads and bells, recounted
how the new, do-it-yourself side of the London rag trade
capitalized on the widely publicized pilgrimage.

'Kaftans started off … when the Beatles had been to India.
I used to go to Derry and Toms department store [on
Kensington High Street] to buy Indian bedspreads, and
had an old Jewish tailor make them all up … it was the first
time we got into manufacturing.'[14]

Other entrepreneurs in both Britain and Asia were quick
to exploit the mood. Small businesses in the East End
of London imported the ubiquitous and smelly 'Afghan'
coats and embroidered *kurta*; vividly coloured Kuchi
dresses from the borders of Afghanistan and Pakistan
with their random profusion of brightly coloured velvet,
floral prints, embroidery, appliquéd beads and coins,
were popular. By the mid-1970s cutting-edge Carnaby

Street had become more like a bazaar of cheap Indian
garments than the haunt of East End dandies. The general
fashion for exoticism was captured in a 1969 *Vogue* feature
photographed by David Bailey in Kashmir.[15] It showed
flowing garments sourced in London from the Indian
boutique Savita, a Susan Small outfit in *boteh-motif* Liberty
silk and Belinda Bellville's 'harem' outfit with floaty trousers
in Paisley chiffon. Other garments evoking this 'oriental'
mood were by Gina Fratini, Jean Muir and Syrian-born
Thea Porter, known for her luxurious kaftans in a then-
daring mixture of oriental fabrics, including pieces of
Indian silk saris.[16]

Reworking Indian style

Indian textiles and clothing styles have consistently had
a deeper influence on designers looking beyond current
fashions, absorbing and reworking ideas of cut, pattern and
colour in their own idiom. Bill Gibb frequently played with
a variety of 'ethnic' themes in his own romantic manner;
his 1972 dress and turban (pl.82) use Liberty printed
cottons in the revival designs developed by Bernard Nevill,
which often referred back to Liberty's nineteenth-century
Asian sources. Once again the Paisley or *boteh* motif and
Indian shawls were reconfigured.

Wendy Dagworthy, a designer who started her fashion label
in 1972, has explained how she responded eclectically to
non-European sources, producing layered, nomadic-looking
clothes using a mixture of fabrics and textures:

'[My] clothes were a fusion of lots of different inspirations.
They were never tight, always loose, comfortable. I travelled
to India and fell in love with the colours. I amalgamated
that with, say, priest clothing, or Nehru or Caribbean batiks.
I mixed patterns. A stripe mixed with a flower. Things like
that just weren't being done then.'[17]

Her 1987 collection was directly inspired by a visit to
India: dresses over trousers, bangles and anklets, the use

of white Nehru jackets and contrasting patterns casually juxtaposed (pl.84).

The rediscovery of India in the mid-twentieth century also coincided with a renewed interest in craft. Knitwear designer Sarah Burnett, who makes complex handknits in naturally dyed yarns, has also been profoundly influenced by many visits to India since making the overland trip in 1971. Burnett wanted 'to create something vibrant for a cold climate that gave some kind of feeling of the textiles and clothes I first saw in Bhuj [Gujarat]'; this inspired her Abstract jacket (pl.85).

'The design of this jacket comes from a backlog of images from the last twenty years or so. I wanted to get the effect of techniques like block-printing and tie-dye, and of a mix of fabrics such as *mashru*.[18] The bobbles and circles are improvised and reflect the idea of the mirror work used in Bhuj and Rajasthan. Even the poorest women there wore incredible clothes, using many different techniques: printing, mirror work, embroidery, double *ikat* weaving … all put together in a sort of gypsy way. The colours had a big impact on me (see pl.86).'[19]

The memory of visiting Rajasthan as a child has been a key motivation for designer Gracie Burnett. She has since worked in India, developing a personal style that interprets South Asian clothing forms with a modern sensitivity to ethical sourcing in India of handmade fabrics and natural dyes. 'The vibrancy in colour and ever-present use of natural dyes were like the North Star for me,' she says. 'The Indian indigo tradition … has shaped most of my designs.'[20] Her silk jacket (pl.88) utilizes a running stitch technique used in the traditional *kantha* quilting of Bengal and Bangladesh (pl.87).

India on the high street
Besides influencing individual designers, India has also had a lasting impact on the British high street. Some retailers

originally built their business on imports from India during the early 1970s. Monsoon, founded by Peter Simon in 1973 after what he has described as 'a period of selling shaggy woollen coats on the Portobello Road and hand-block printed clothes from Rajasthan', is now firmly positioned in the high street, selling clothes with an Indian feel in terms of light cottons and silks, embroidery, mirror work and sparkle (pl.89).[21] Another mass-market brand, EAST, was associated with Monsoon and then with the Jaipur-based block-printing company Anokhi. EAST continues to use Anokhi's natural fabrics and handmade features to position itself as both 'Indian' and 'individual', although not limiting itself to Indian sources.[22] Newer forms of cross-cultural or 'fusion' design have recently come from British-Asian designers like Liaqat Rasul, designing for his label Ghulam Sakina (pp.80–81).

The persistently broad, mass-market appeal of Indian pattern appears in the use of the perennially popular *boteh* or Paisley motif, which first entered the European imagination through imported Kashmir shawls. A Biba dress of 1971 (pl.92) and Kate Moss's 2009 Tattoo Maxi Dress for TopShop (pl.90) both recall an imaginative photograph by John French in which he created a tattoo effect by superimposing a boteh pattern on his model (pl.91). Another Kate Moss/TopShop design (pl.93) references both the youthful, almost child-like styles of the 1960s and early 1970s and Indian printed textiles. The fabric is printed with a design similar to the Indian diaper or trellis patterns admired by nineteenth-century designers like William Morris, while the border pattern resembles a traditional block-printed textile from Lahore (pl.94).

While fashion today is increasingly borderless, produced for global brands in world markets, designers at all levels of the clothing industry still look to India for materials, ideas and manufacture. Within this historically-rooted network of trade and consumption, exploitative labour practices have been an issue both with mass production and luxury trades,

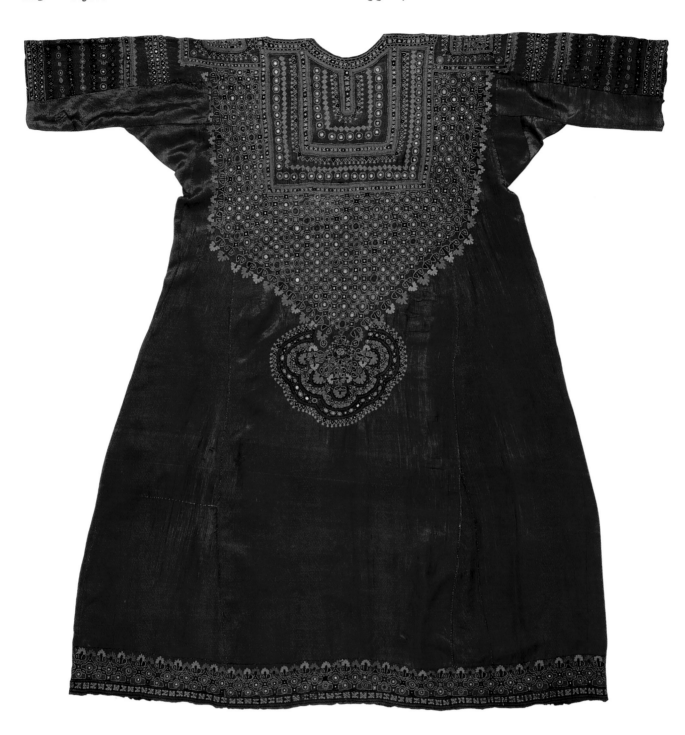

Opposite page:
84
Indian-inspired collection, designed by
Wendy Dagworthy, Spring/Summer 1987

85
Abstract hand-knit jacket
Silk, wool and cashmere, designed by
Sarah Burnett, 2007

86
Above: Woman's garment
Silk-satin, embroidered with silk thread
and mirrors, Gujarat, early 20th century
V&A: IM.232–1920

87
Opposite, above: Bedcover
Cotton, *kantha*-stitched and embroidered
with cotton thread
Bangladesh, late 19th/early 20th century
V&A: IS.62–1981

88
Opposite, below left:
Songline jacket (detail)
kantha-stitched silk, indigo-dyed, hand-
painted collar, designed by Gracie Burnett,
2008–09

89
Opposite, below right:
Monsoon shop window, Kensington High
Street, London, 2009
The mirror work skirt is based on those
worn in Saurashta, Gujarat

with production often located in the developing world,
and particularly with regard to the hand-embellishment
characteristic of Indian garments.[23] This is partly driven
by the economics of mass-market fashion. Looking more
broadly at the global process of fashion production, Michiel
Scheffer has noted that 'The speeding up of fashion cycles
leads to a focus on techniques of differentiation at the end
of the production cycle', such as embroidery. These are
'highly labor intensive … affordable only by tapping into
low-cost production in developing countries'.[24]

A century after Mary Curzon's experiments, jet travel
and electronic communication have made the design
and manufacture of garments in multiple global
locations commonplace.[25] In design terms, disentangling
appropriation from inspiration is difficult, but, while there
are profound cultural and political issues embedded in
the Anglo-Indian objects described in this chapter, they
have also stimulated passion, creativity and visual pleasure.
And the British fondness for floral chintz, with its origins
in India and design motifs borrowed from Europe, has
persisted in one form or another for more than 300 years,
despite the efforts in 1996 of the Swedish retailer IKEA to
persuade consumers to 'chuck out your chintz' in favour of
contemporary design.

90
Tattoo Maxi Dress
Silk, Kate Moss for TopShop, Summer
2009

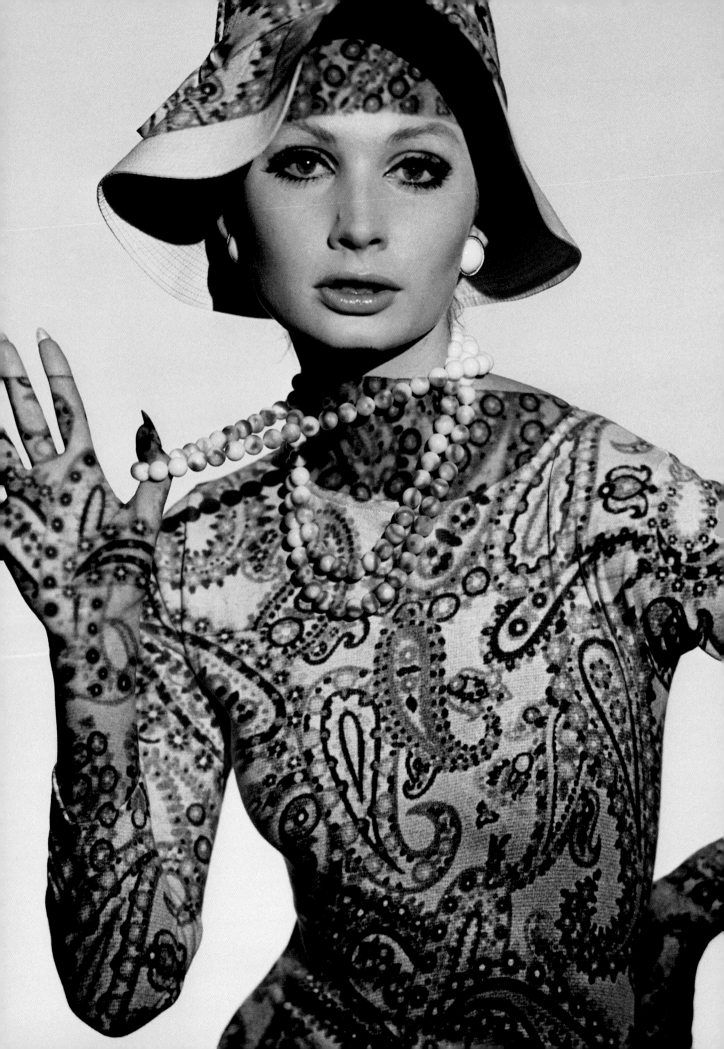

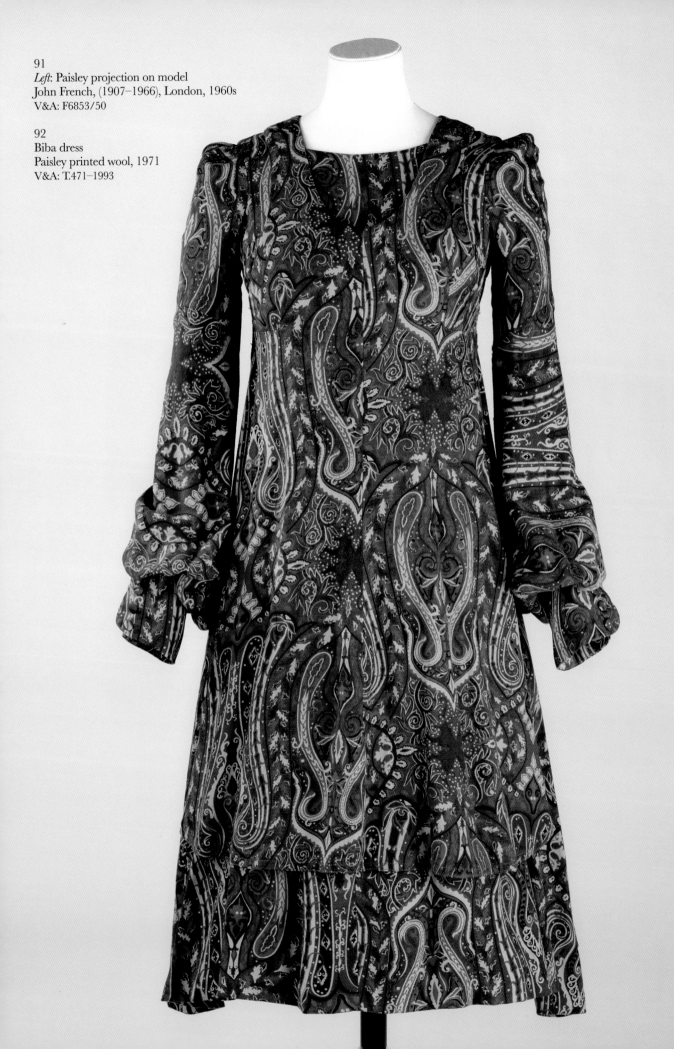

91
Left: Paisley projection on model
John French, (1907–1966), London, 1960s
V&A: F6853/50

92
Biba dress
Paisley printed wool, 1971
V&A: T.471–1993

93
Hippy Dress
Kate Moss for TopShop, Summer 2009

94
Opposite: Wall hanging
Block-printed cotton, Lahore, Pakistan,
*c.*1930
V&A: IS.129–1986

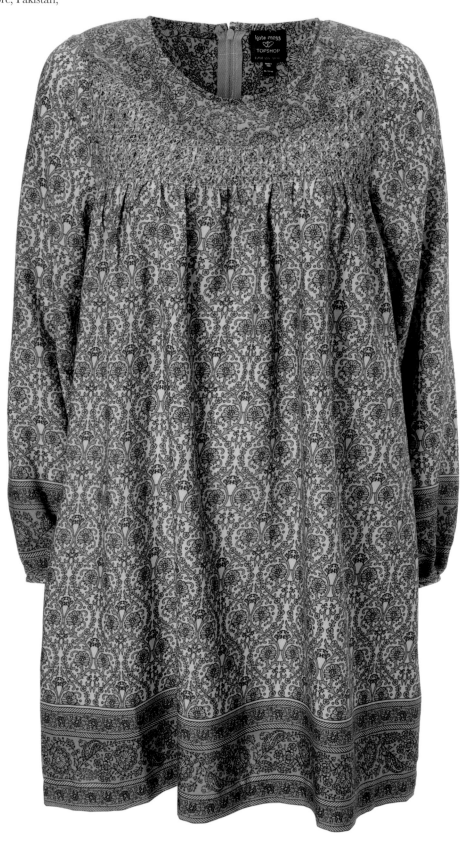

banyans, smoking jackets & suit linings
by christopher breward

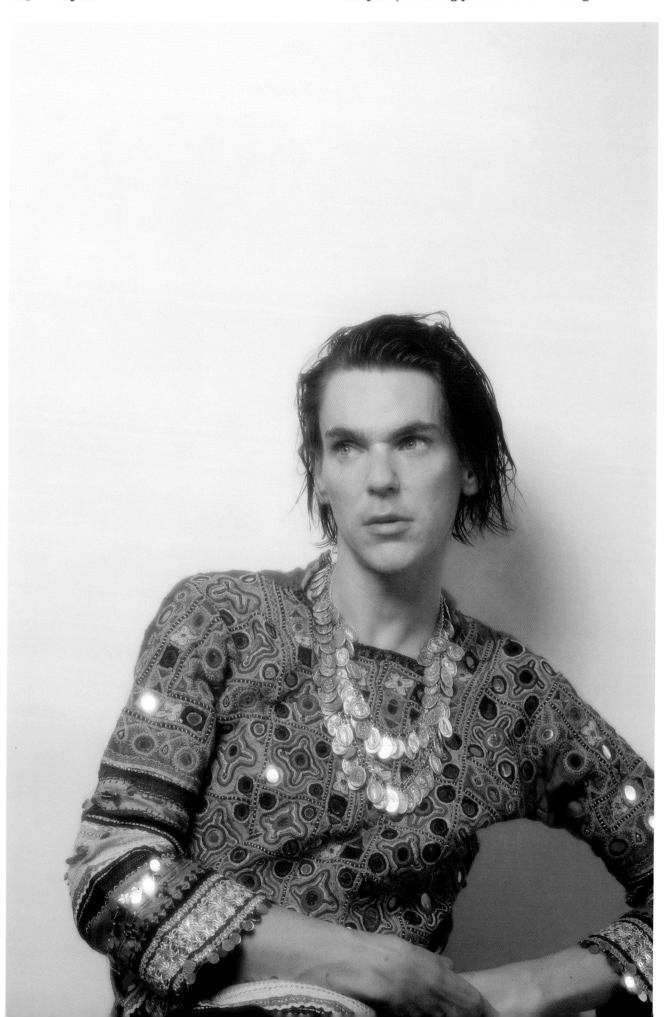

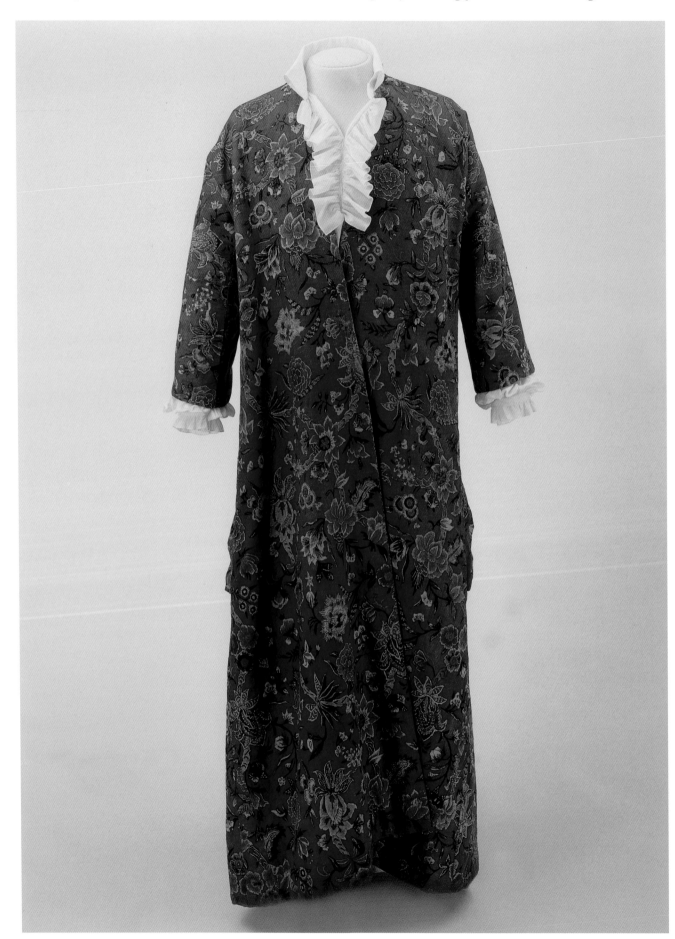

95
Previous page:
James Jeanette Main, stylist, wearing a
Sindh bride's embroidered bodice
From *Bon* magazine, Autumn/Winter
2009–10

96
Opposite:
Banyan
Painted and dyed cotton chintz with
printed cotton lining
Coromandel Coast, India, *c.*1740–60
V&A: T.215–1992

'This morning I went up and down into the city to buy several things, as I have lately done for my house. Among other things a fair chest of drawers for my own chamber, and an Indian gown for myself. The first cost me 33s; the other 34s. Home and dined there, and Theodore Goodgroome, my singing master with me, and then to our singing. And after that to the office and then home.'[1]

At the beginning of July in 1661, Samuel Pepys, enjoying all the optimism of a London summer that had recently seen the restoration of King Charles II to the throne, indulged in one of his frequent shopping sprees. A rising young man of substance, with a good job as an officer of the Naval Board, his choices are an eloquent reminder of the pretensions of Englishmen's consuming habits, which echo through the centuries: the elegant furniture for the study, the polite and convivial singing lessons, and – combining the elements of quality, usefulness, novelty, luxury, and not a little-theatricality – the 'Indian gown'. Pepys was a worldly and sophisticated man, and in the purchase of an Indian gown he put his character on show (at least to his intimates, for the wearing of such gowns was generally restricted to the home or bathhouse). Five years later he hired another, perhaps more sumptuous or more fittingly patrician (at this time of Chinese silk), 'to be drawn in' for his portrait by the painter John Hayls.[2] Pepys was clearly well aware of the cachet that rare and glamorous fashions might bestow and his auspicious acquisitions set the tone for three centuries of dressing up (pl.96).

Historians of male dress have generally looked to the late seventeenth century for evidence of the emergence of the prototypical Englishman's suit: woollen, plain, dark, symbolizing a new patrician sobriety in politics, philosophy, art and sartorial matters, and associated with the distinctive landscape and attitudes of the young British nation.[3] But Pepys's Indian gown provides a counter story in which the dominant narratives of English, and later British taste, are shot through with references and reminders of a wider,

more colourful and deeply complex world beyond the boundaries of Albion. Accounts of English clothing have generally emphasized its conservatism, its opposition to ostentatious 'cosmopolitan' or 'urban' registers of style: they have confined themselves to the language of the suit. In 1948 the great English fashion journalist Alison Settle suggested that 'it is probably the un-self-consciousness of English fashion which is its most enduring characteristic'. She believed that this was derived from the stability of traditional English lifestyles, a world 'largely of men's activities, of sport, the love of animals, of the open air, and always of the home and its comforts'.[4] This is a nostalgic interpretation, which has endured remarkably well. In 1996 the style commentator Peter York repeated the mantra in *Country Life*, the bible of the British landowning classes. 'Tradition,' he stated, 'is what we're best at, and the dominance of tradition … is more marked now than at any time since the Second World War. Just see how those mainstream classics power on!'[5] His 'classics' included Jermyn Street shirts, the uniforms of guardsmen and cricket players, the Clarks desert boot and the Land Rover: all masculine icons which are seen to embody an easily identifiable English 'feel' (and yet which also carry with them histories of colonial and global connection).

The English suit

Naturally the danger of traditionalist definitions of national styles lies in their tendency to fix concepts of identity. The lived experience of race and nationhood as expressed through clothing and fashion is a far more contingent and layered affair than the rather constraining idea of the persistence of the English 'classic' might infer. As Stuart Hall, one of the most influential contemporary writers on the challenges thrown up by conflicting definitions of culture, community and nation in Britain, stated at the end of the twentieth century: 'It should not be necessary to look, walk, feel, think, speak exactly like a paid-up member of the buttoned up, stiff-upper-lipped, fully corseted and free-born Englishman, culturally to

97
William Fielding, 1st Earl of Denbigh
Anthony Van Dyck (1599–1641)
Oil on canvas, *c*.1633–4
National Gallery, London

98
Following pages, left:
Maharaja Duleep Singh
Franz Xavier Winterhalter (1838–1898),
Lithograph, 1854
Private Collection

99
Following pages, right:
Waistcoat (detail), made from an Indian
shawl, *c*.1790
V&A: T.440–1966

be accorded either the informal courtesy and respect of civil social intercourse or the rights of entitlement and citizenship … Since cultural diversity is increasingly the fact of the modern world, and ethnic absolutism a regressive feature of late modernity, the greatest danger now arises from forms of national identity which adopt closed versions of culture or community and refuse to engage with the difficult problems that arise from trying to live with difference.'[6] Whilst one might debate with Hall on the historical development and literal existence of the mythical 'free-born Englishman' conjured up by his prose, his setting up of this narrow stereotype and embracing of a more open concept of diversity is apposite for the themes of this essay. For in celebrating the overlooked engagement with South Asian textile patterns, forms and styles long enjoyed by many types of British men, we are at least liberated from the Anglocentric tendencies of certain forms of fashion history.

Pepys was not the first Englishman to engage with ideas of India through his choice of dress. Thirty years previously, at a time when the craze for imported Indian textiles was generally confined to domestic rather than corporeal decoration, William Fielding, 1st Earl of Denbigh, had himself painted by Van Dyck in a glorious rose-pink silk, shot through with gold-thread stripes and cut in the fashion of the Indian *paijama* (pl.97). Fielding had toured India and Persia between 1631 and 1633 and the portrait commemorated his achievement as the first English nobleman to have completed such an extensive trip. As a former Master of the Great Wardrobe and Gentleman of the Bedchamber in the Courts of King James 1 and King Charles 1, he was no fashion ingénue, but the portrait's inventive fusion of Eastern and Western motifs demonstrates a distinctive approach to self-fashioning that was in some ways much ahead of its time.[7] The traditional Indian trousers, tapered to the ankle and tied with a cord at the waist, would not become a staple of the Englishman's wardrobe (for day and night

wear) until the middle of the nineteenth century; and yet Fielding's pairing of them with a coat, modelled on the English doublet of the period but retaining a South Asian looseness, is the strongest possible premonition of the inevitable rise of the Englishman's suit: here emerging from the Mughal Court, rather than Whitehall.

Exotic choices

By the beginning of the eighteenth century the English taste for Indian textiles had expanded across classes and was especially marked in women's clothing. As Daniel Defoe remarked in 1708: 'Chints and painted calicoes, which before were only made use of for carpets, quilts etc., and to clothe children of ordinary people, become now the dress of our ladies, and such is the power of a mode, we saw our persons of quality dress'd in Indian carpets, which a few years before their chamber-maids would have thought too ordinary for them; the chints were advanced from lying on their floors to their backs, from the foot-cloth to the petticoat.'[8] It was perhaps the liminal quality of these imported items, falling between furnishing and dress, the everyday and the exotic, which marked them out as noteworthy. And while they continued to find their most obvious use in the clothing of women, a more idiosyncratic and subtle adoption of the fashion, as pioneered by men like Fielding and Pepys, persisted in the elite masculine wardrobe. A man's square-cut waistcoat of the 1790s (pl.99) is one of several in the Victoria and Albert Museum's collections that show an ingenious incorporation of Indian textiles and embroidery. Here a cashmere shawl of the type that was rapidly gaining favour amongst fashionable British women has been re-styled to form the basis of a double-breasted vest, the fringed edge of the shawl forming the border of the lapels, which would have lain over the coat lapels in a highly romantic manner.[9]

It was the romanticism of Indian dress, as opposed to its novelty and modishness, which sustained its appeal to many early and mid-nineteenth-century Britons. David

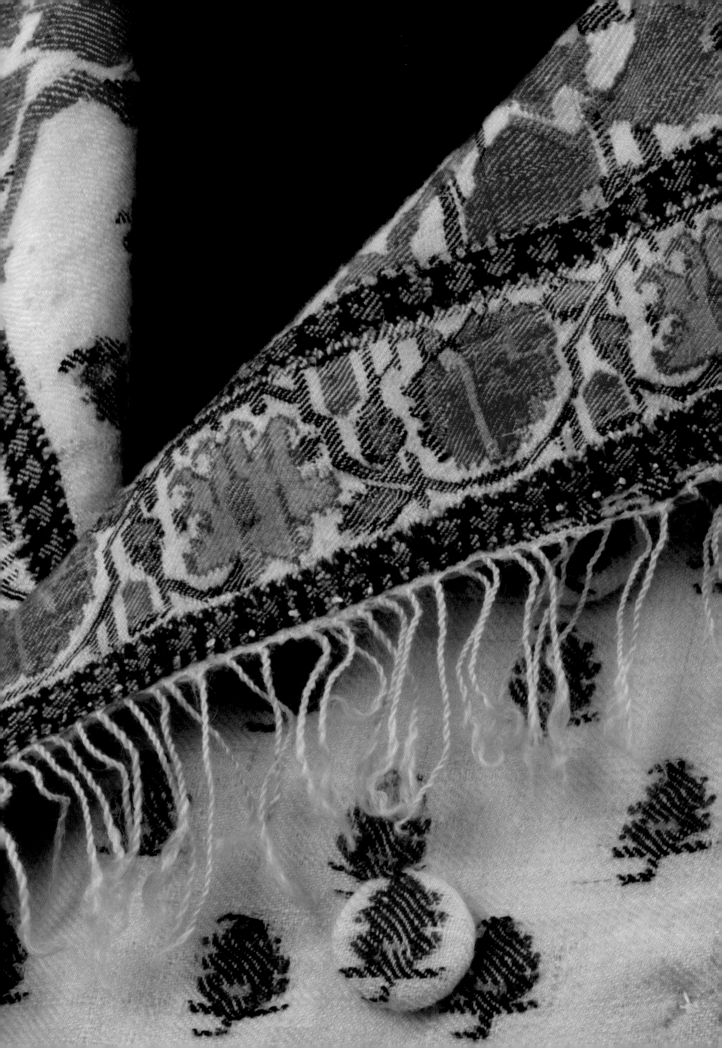

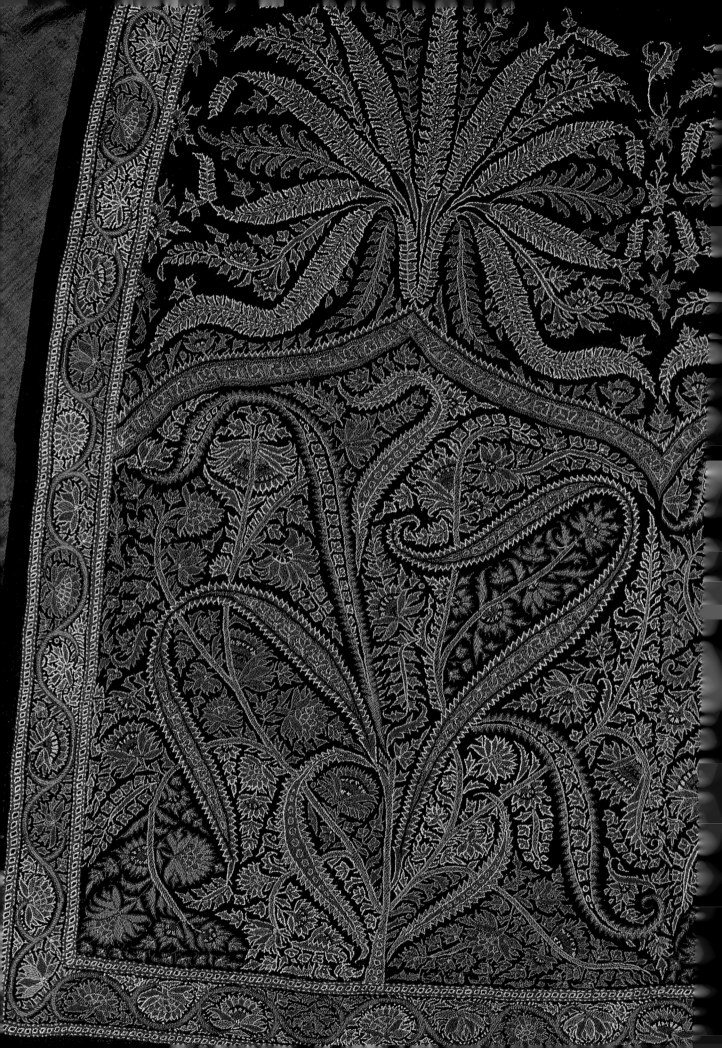

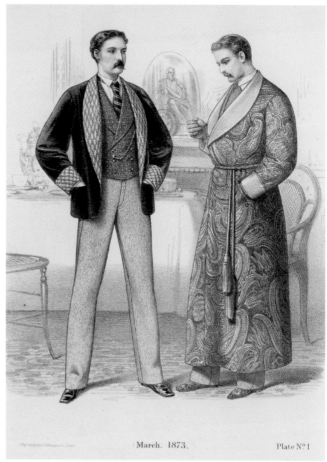

March. 1873. Plate Nº 1

Indian ✢ Pyjamas. ❧

Libertys' soft Indian Silks are specially adapted for Pyjamas, being exquisitely soft, very light, durable, and of excellent washing qualities.

✢ Plain, White, Cream or Art Colours. ✢

PATTERNS AND INSTRUCTIONS FOR MEASUREMENT POST FREE.

Octavius Hill and Robert Adamson's calotype of a
'Mr Lane in Indian Dress' of the mid-1840s (pl.102) is
an exuberant projection of orientalist fantasies that may
record the Arabic scholar and traveller Edward William
Lane (1801–1876); equally it could portray an Edinburgh
actor of the same name (the former was coincidentally
sculpted by his brother Richard James Lane in Egyptian
dress in 1829).[10] Both professions were certainly concerned
with the fantastical and escapist representation of
Empire at this time and dressing up in exotic fancy dress
was a popular diversion for private leisure and public
performance.[11] In painting as well as photography the
Eastern-costumed portrait was a familiar genre and Mr
Lane's turban, jewellery, slippers, ceremonial weaponry
and heavily embroidered sash and robe are broadly
suggestive of near contemporaneous images of Indian
royalty, such as Franz Xavier Winterhalter's burnished
portrayal of the young Maharaja Duleep Singh of 1854
(pl.98); even if the total effect is closer to masquerade than
authentic reproduction.

A sense of opulent escapism also pervaded elements
of the everyday masculine wardrobe throughout the
1840s and 50s in Britain. Silk waistcoats were often
embellished with oriental motifs, from the ubiquitous
boteh to swirling peacock feathers (pl.101), but one of the
most striking adaptations of Indian patterns can be seen
in the application of Kashmiri silk embroidery over a
conventional black superfine (wool) cloak, following the
forms usually used for export shawls. Here twisting fronds
and stylized carnations in vivid pinks, purples, greens,
whites, blues and yellows explode across the garment in an
extravagant display that rather undermines assumptions
about the sober restrictions of sartorial taste for men in
mid-nineteenth-century Europe (pl.100). However, it is
notable that by the 1880s such extravagance was more
often confined to garments designed for private spaces.
Smoking caps and jackets, dressing gowns and pyjamas
offered surfaces for expressive Indian designs that sat

well amongst the colonial clutter of gentlemen's studies
and dressing rooms, but seemed inappropriate beyond
the comfort of home.[12] When the fabric of Empire
migrated to public dress codes its expressive forms were
usually restricted to the mere hint of a waistcoat border,
emerging beneath the grey serge of a morning suit. The
tighter control over men's dress exerted through stricter
sartorial and social rules throughout the second half of
the nineteenth century might offer one explanation for
the relegation of Indian motifs to the edges of the British
gentleman's wardrobe; but it is also tempting to wonder
how far a shift in the public understanding of Britain's
relationship with its colonies, which followed the Indian
Rebellion of 1857 and the naming of Queen Victoria as
Empress of India in 1876, contributed to a more overt
distinction between Eastern and Western fashion codes.

The romance of the Raj
In late Victorian and Edwardian London the contrasts
between the dress of white professionals and visiting Indian
dignitaries and students, or the South Asian inhabitants of
the docks, were certainly sharply observed and underwritten
by imperialist rhetoric.[13] Thomas Burke's evocative *Nights
in Town: A London Autobiography* of 1915 is typical in its
characterization of Asian dress as glamorous and dangerous,
the 'other' to the suburban English clerk's safe conformity:

'These London docks are like no other docks in the world.
About their gates you find the scum of the world's worst
countries; all the people of the delirious Pacific of whom
you have read and dreamed – Arab, Hindoo, Malay … a
mere catalogue of the names is a romance. Here are pace
and high adventure; the tang of the east; fusion of blood
and race and creed. A degenerate chaos it is, but do you
know, I cannot say I don't prefer it to the well spun gold
that is flung from the Empire on boat-race nights. Place
these fellows against our blunt backgrounds, under the
awful mystery of the city's night, and they present the
finest spectacle that London affords.'[14]

105
Left:
Advertisement for printed materials, from
Britain: Leader of Men's Style, The National
Trade Press Ltd, 1937

106
Right:
Man's single-breasted suit
Cream linen, from Blades of 8 Burlington
Gardens, Savile Row, London, 1972
V&A: T.353–1980

In a similar but opposing vein, when Anglo-Indian clothing was described and imagined in Britain in the years around and following the First World War, during the era of the Raj, it was not the skill and opulence of indigenous crafts that were celebrated and co-opted, but rather the 'dashing' uniforms of colonial adventurers and administrators: a dream of pith helmets, puttees and crisp linen suits that dominated the advertising of Empire-manufactured goods and populated stage and screen melodramas from the 1920s to the 50s – even continuing to inspire British audiences through the David Lean and Merchant Ivory film fantasies of the 1980s.[15] The *boteh*, which had once decorated banyans and waistcoats so extravagantly, survived only through its muted and miniaturized reproduction on the Paisley ties, handkerchiefs and scarves of the Scottish and English menswear trades (pl.105): a staple of twentieth-century provincial British good taste, complementing the tweeds and corduroys of the middle-aged dandy.

Beyond the hippy trail

Yet, while Indian textile forms in one sense seemed as redundant a facet of British sartorialism as Empire Day, in the post-colonial context of post-war Britain they also found vibrant instances of revivalism and reification. During the late 1960s the combined effects of the hippy counter-culture, with its discovery of Eastern mysticism, and what was termed the 'peacock revolution' in British menswear design provoked a flamboyant return to South Asia as a source of inspiration. The leaders of London's fashionable 'Swinging' scene from Christopher Gibbs, through Michael Rainey, David Mlinaric and Rupert Lycett Green embraced the paraphernalia of India in the styling of their homes and shops and in the incorporation of motifs into their merchandising.[16] The shimmering pale sheen, 'Nehru' collar and luxurious silk patterning of a suit produced by Lycett Green for his men's boutique Blades in 1968, now in the V&A's collection (pl.106), is a direct descendant of Pepys's Indian gown, purchased four centuries earlier in the same district of London.

This homage by British men to the traditional textiles of India has persisted alongside other memories and continuities of colonial relationships that can be traced in food, architecture or music, for example. But in textiles the threads seem particularly long and resilient. In the twenty-first century a generation of British Asian men and women, born and raised in Britain following the migration of their parents in the 1960s and 70s, have generated a whole new language of 'Asian Kool' in which the connections and disconnections of the diasporic experience produce fresh and vibrant interpretations of style. And still the older traditions of buying-in to the glamour of the East persist. As I write, late in 2009, I am inspired by a fashion magazine portrait of the London fashion stylist and East End club character James Main wearing a Sindh bride's embroidered bodice (pl.95). I email him for more information and he replies, 'I love Indian dress … the top was a gift from a friend of mine, the designer Louise Grey. She gave it to me one very late night back at her studio after a party we had both been at. It was hanging on her wall as an inspiration piece, as she uses a lot of colour in her designs. I tried it on and she loved it on me, so I got it! It's very my style … I love the shape, the colour and of course the mirrors! It's great in the sunlight and also at the disco … you become a human mirror ball!' Long may the tradition continue.

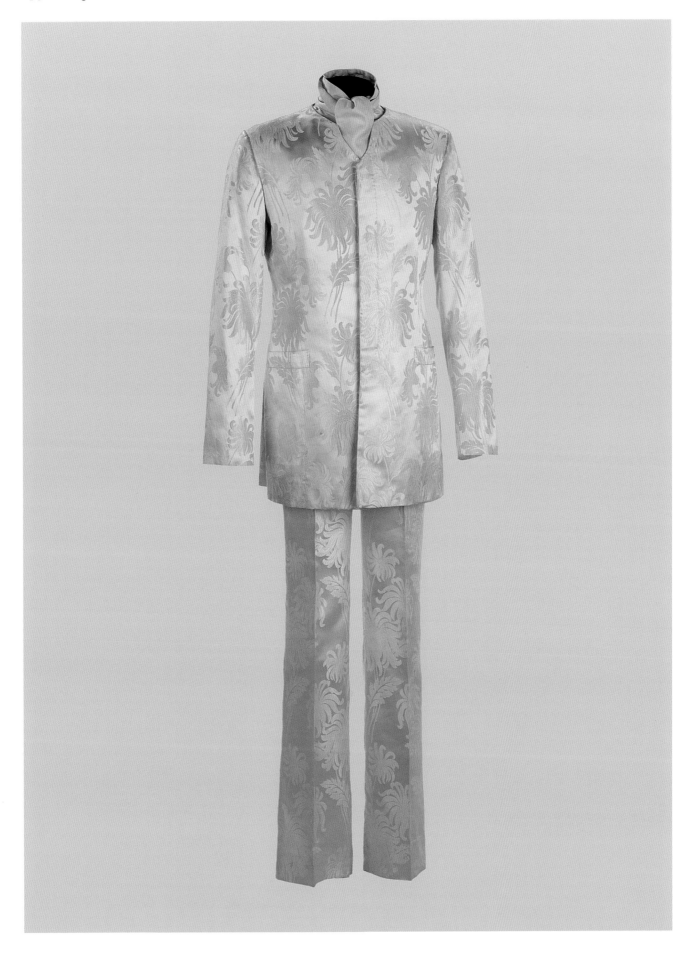

the media & british asian fashion by rajinder dudrah

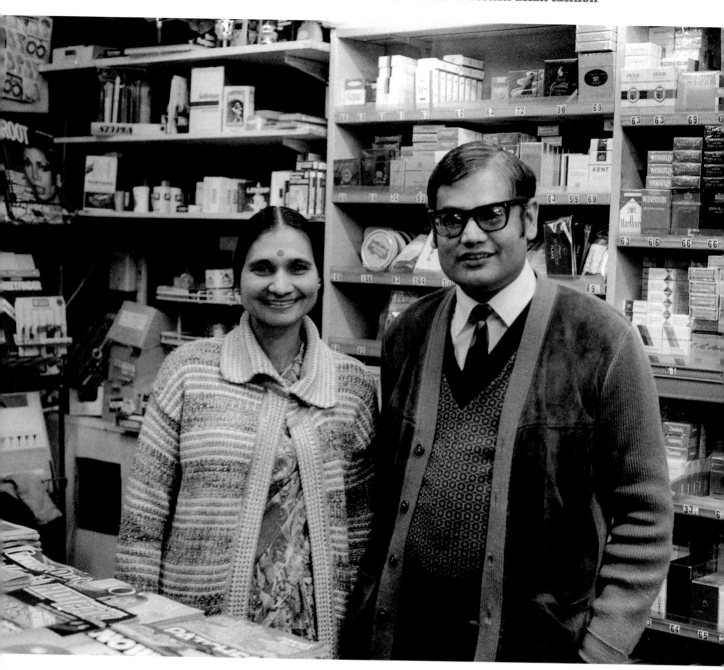

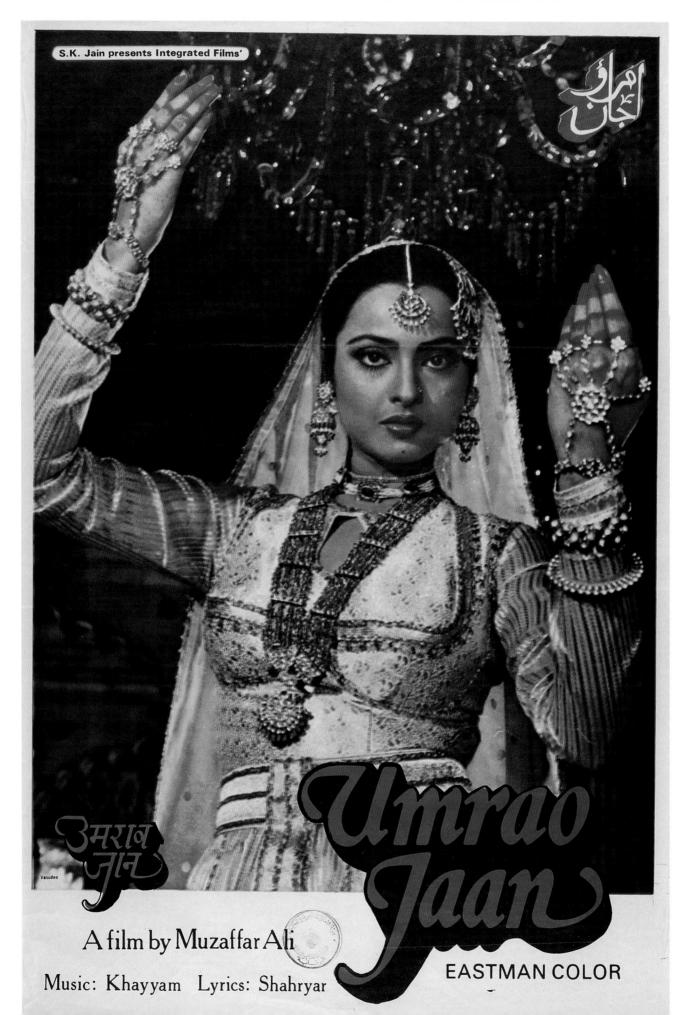

S.K. Jain presents Integrated Films'

Umrao Jaan

A film by Muzaffar Ali

Music: Khayyam Lyrics: Shahryar

EASTMAN COLOR

107
Previous pages and pages 56–7:
South Asian couple working in a
newsagent's shop, London, 1979–80

108
Opposite:
Hindi film poster of *Umrao Jaan*, 1970s
V&A: IS.112–1986

109
Right:
Bhangra dance scene
Empire Ballroom, Leicester Square,
London, 1986

The media and British Asian fashion can be considered as two parallel tracks running alongside each other, taking us through a recent period of post-war British history during which Asians exchanged their early immigrant status for citizenship. In the course of this journey two predominant types of representation emerged: one forged in the mainstream white media and the other by British Asians themselves (pls 107, 108). These in turn influenced and then began to transform the relationship of one to the other.

Track 1: Media itineraries in transit
British Asians arrived en masse in post-war Britain with a sense of fashion and attendant style histories from the subcontinent. These included an array of regional folk and urban South Asian dress styles that were mixed and matched in the new settlements across Britain. Saris, *salwar kameez, sherwanis* (traditional Indian/Pakistani dress, usually worn by men as wedding attire and comprising a long coat, buttoned up in front), petticoats, shawls, head wear, jewellery, fashion accessories, and urban cosmopolitan suits and dresses found interesting accompaniment in the new diasporic environment.

Alongside other black Britons, South Asians in the latter half of the 1940s and 50s were given a conservative welcome mixed with suspicion and intrigue. To some they posed a threat, bringing racial change to the social fabric of British culture and society. The experiences of this first wave of post-war black British migrants have been well documented by others (e.g. Fryer 1984; Gilroy 1987). By the 1960s and 70s limited visibility was accorded to British Asian fashion in the mainstream media. Televised reportage of Asian life was based generally upon documentary-style footage; programmes were aimed at making the white British aware of the new brown arrivals and helping Asians to adjust to, and integrate into, a supposedly conservative British way of life (see Ross 1996; Malik 2002). British Asian fashion, as seen through the mainstream lens, at best was curiously observed or remarked upon; orientalist in tone,

attention was paid to the loud, lurid and 'very different' cultural aspects of Asians as 'immigrant others'. British Asian fashion at this juncture did not exist as 'fashion'; rather it was considered and depicted as something strange and culturally exotic.

Yet amidst a struggle for settlement and civic rights in a new land, and access to means of representation (which continued well into the 1980s and early 90s), British Asian fashion was flourishing unbeknown to – or rather neglected by – mainstream eyes and ears. For instance, small shops were being opened in growing black and South Asian residencies, particularly in the inner cities. These stocked imported materials from overseas, not least the Indian subcontinent and Asia, and tailoring accessories that allowed skilled, predominantly post-war South Asian women to make personalized garments for themselves and for others. From the late 1960s and throughout the 70s weekend screenings of the latest Hindi films provided the opportunity for communities to get together, usually after a week of manual labour. Men, women and young families dressed in their best to socialize, to catch up with one another and to be entertained by the big screen. Popular Hindi cinema of this period provided inspiration for British Asians who borrowed from their favourite film styles to create their own sense of fashion – a homage that continues today.

Track 2: Arriving at destinations
Newspapers and magazines, TV shows, the international fashion scene, diasporic film and media, as well as music videos and the new music genres that started to take off from the mid-1990s provided a variety of platforms for British Asian style. The following three examples can help us to survey, in part, the rise of British Asian fashion, particularly in terms of its presence in the media.

While white post-war British broadcasting was documentary in format and news-led to inform the wider populace about the newly arrived non-white immigrants to Britain, Asian

110
Cover and contents page of *Asiana*
magazine
Winter 2009 edition

productions working from within mainstream sectors, such as the BBC, began to offer a media sphere for South Asians adjusting to their new places of settlement. Programmes such as *Apna Hi Ghar Samajhiye* (Make Yourself At Home, BBC TV), *Nai Zindagi Naya Jeevan* (New Way, New Life, BBC TV) and *Asian Magazine* (BBC TV) offered settlement advice and summaries of weekly news and current affairs pertaining to the subcontinent in an early TV magazine format, which was aimed at late 1960s and 70s British Asians. Fashion and style were covered sparingly in such programmes and then focused almost exclusively on women. Tips on clothes, make-up, hair and jewellery were almost always illustrated by women presenters for female audiences and were contained within the realm of domesticity – i.e. they were communicating to 1970s South Asian women primarily as home-based housewives and mothers during daytime TV.

In the 1980s programmes with black British media personnel at their creative helms started to take shape, aimed at and for non-white Britons. These came after intense periods of social unrest and struggles for access to the means of producing representational programming, and helped to pave the way for the development of multicultural arts and media units. Amongst some of the pioneering work of this period were *Here and Now* (Central TV, 1979 onwards), *Eastern Eye* (Channel 4, 1982) and *Network East* (BBC 2, 1984). Such programmes inserted into the terrestrial media landscape a notion of the Asian as British and here to stay, helping to shape ideas of Britain as multicultural and dynamic in cultural and racial terms. An intermittent component of these eclectic shows was the attention paid to everyday British Asian lives, health and style. Fashion was often interspersed with other aspects of British Asian popular culture so as to provide a wider means of representation of and for South Asians that was not readily available in the mainstream, predominantly white, media (pl.109). Aimed at an emergent first generation, British-born Asian audience, live British bhangra music

would be broadcast alongside reviews of the latest Hindi film releases; hip hop and South Asian-infused dance competitions would follow recipes for quick British Asian cuisines; British Asian fiction, poetry and art would be recited and illustrated by writers and artists alike; and examples of what was hot or not on the British Asian fashion scene, through studio catwalks and interviews with designers and stylists, was a common feature.

The mid-to-late 1990s witnessed the advent and growth of British Asian fashion magazines. Their forerunners had existed in the 1970s and 80s in the British Asian print media and newspapers in particular. Here, supplement features, or at the very least a page or two, were devoted to matters of style and fashion. Unlike their predecessors, however, the magazines of the 1990s, although also largely aimed at women, were additionally targeting the British Asian male with regard to issues of fashion. By the 1990s, with the cost of colour production now more affordable than in previous decades due to accessible computer software and print technology, British Asian magazines were glossy and produced in full colour. They took design and layout cues from older and existing publications in the Western mainstream (e.g. *Marie Claire*, *Vanity Fair* and *Vogue*) and developed these further with both British and Asian sensibilities, stories, chic photography, popular culture and plenty of individual style and fashion. These magazines were brown, loud and proud in slick magazine technicolour.

FOR THE ASIAN WOMAN WHO WANTS MORE

ASIANA

WINTER 2009
£4.50

2010 A NEW DECADENCE

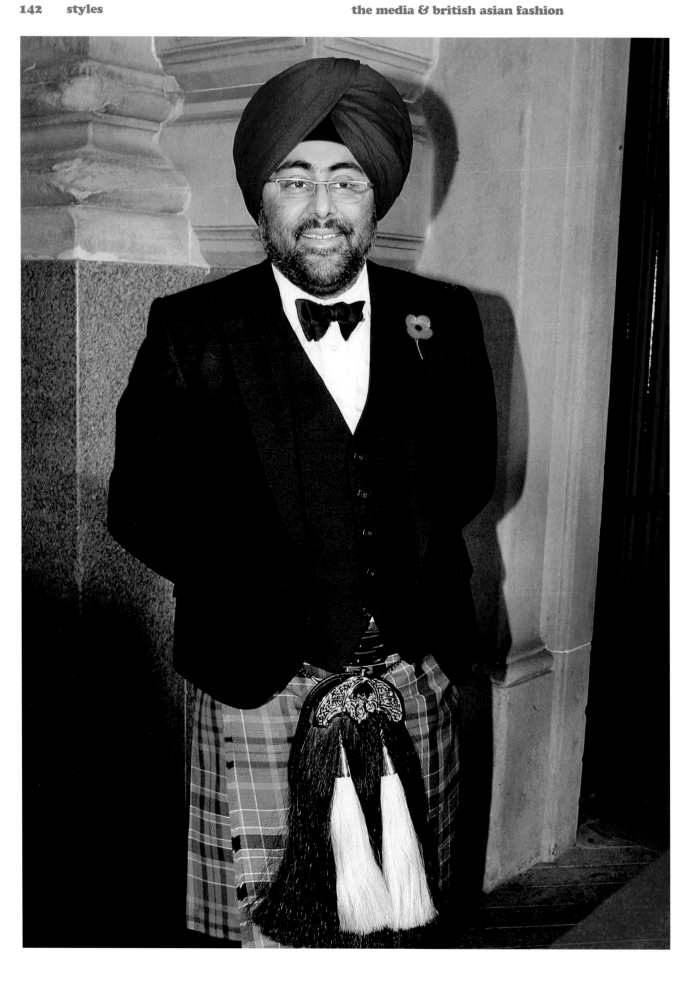

111
Opposite:
Hardeep Singh Kohli, comedian and
presenter, at an award ceremony in
Glasgow, 2008

Left to right:
112
Cherie Blair dressed in a sari, with then
Prime Minister Tony Blair arrive for a
gathering of British Asian millionaires,
London, 1998

113
Meera Syal, comedienne and actress,
attends the Pride of Britain Awards at
Grosvenor House, London, 2009

114
Aishwarya Rai, Bollywood actress, 2007

A look at one such publication from this genre, *Asiana* (pl.110), shows the way in which this niche publishing sector is vying for British Asian fashion audiences as readers, whilst also plugging them into a lucrative multi-million pound industry (see also its accompanying website: www.asianamag.com). *Asiana* is published monthly with the addition of a specialist magazine, *Asiana Wedding*, in July-August, summer months that are considered the peak season for British Asian weddings, due to holidays and the anticipated good weather. Produced by a professional team of editors and writers (from Editor-in-Chief to Art Director, Designer, Features Writer, Beauty Editor, Fashion Stylist and individual Contributors), the first twenty to thirty pages are packed with full- or double-page advertisements selling the latest fashion and jewellery designs, largely aimed at women, while a smaller number of pages consist of formal South Asian men's wear.

Feature articles are varied. In *Asiana Wedding*, as one might expect, contributions range from tips on how to plan one's dream wedding to whether or not to share stories about an ex with one's partner, or live with in-laws. In the general magazine they vary widely from whether mixed race relationships can work or not, to being a modern woman balancing professional and domestic commitments, to what was in at the last British Asian fashion show, to everyday beauty, hair and make-up tips. There is also a section for men. Advertising fills several pages and promotes not only wedding caterers, exclusive car hire, DJs and live bands, venue hire, beauticians and stylists but also the next South Asian *mela*, a careers fair in central London and diasporic South Asian broadcasting channels, both radio and satellite. In this way, such periodicals are more than simply high-end catalogues for expensive British Asian styles and haute couture labels, or an endorsement for aspirational living. These publications also offer their readers, largely though not exclusively women, a one-stop light read which, through columns that comment and give advice on health and fitness, celebrity, relationships, legal issues, holidays, and

financial tips and planning, place fashion alongside notions of a changing British Asian sense of self.

By the mid-to-late 1990s and the onset of the new millennium, brown – in the form of British Asian style – appeared to be all the rage. If one cast an eye over the whole media spectrum from the printed page to television to film, music videos and the internet, the adage 'brown is the new black' would not have been amiss. Interestingly, in earlier decades brown was the difficult and un-absorbable signifier in mainstream British culture and society. By the beginning of the twenty-first century, however, an assertive confidence was being displayed by many third- and fourth-generation British Asians in all walks of life, and the earlier strides made towards cultural and racial understanding and harmony in Britain by whites and non-whites had paved the way for such developments. Some of these emerging representations were welcomed more than others, or at least received mixed responses. One such instance included pop star Madonna who, from about 1998 onwards, was seen to wear *bindis*, painted parts of her body with henna (*mehndi*) (pl.117) and chanted in Sanskrit – on music videos and in performance – on tracks from her 1998 album *Ray of Light* and on her 2001 Drowned World Tour. Madonna is known to construct or re-invent herself according to her changing global tour brand, with a massive publicity machine to support her. In the past she has created controversy amongst the Christian community; this time she stirred critical and angry reactions from some Hindus and cultural commentators who questioned the sincerity of her use of such South Asian symbols, which they perceived as fashion embodying cultural values and ways of life. Was Madonna simply increasing her international popularity and music sales by flaunting her new-found difference, which thus amounted to nothing more than exotica? Or was she genuinely playing with notions of identity and expressing universal human emotions, this time through her deployment of South Asian fashion references. In another instance, barrister Cherie Blair (wife of then Labour Prime

Minister Tony Blair) stepped out for official British/Indian social events in London adorned in dazzling high-end saris (pl.112). Whether or not she was able to carry off wearing this garment with some elegance and panache is one issue. Another that seemed to permeate current public opinion was whether this was a positive sign of the times, with establishment figures embracing modern, multicultural Britain by explicitly donning such attire, or whether it was more of a diplomatic ploy, a political act by the ruling white elite that often goes down well when entertaining, or wanting to make friends in the Indian subcontinent.

During this time British Asian music was also being mixed and spliced with the best of its contemporary counterparts – hip hop, R&B, bhangra, Bollywood and pop – creating international sounds with accompanying music videos that featured a mixture of black and Asian fashion repertoires to match. Music and fashion danced side by side, with *desi* chic bopping alongside urban street wear. To name just a few examples, Bally Sagoo's *Bollywood Flashback* album (1994) with the track 'Chura Liya' (You have Stolen my Heart), Missy Elliott's single 'Get Ur Freak On' (2001), Truth Hurts' single 'Addictive' featuring Rakim (2002) and Panjabi MC's single 'Mundian to Bach Ke' (Beware of the Boys, 2003) all reached global popularity and are worthy of lasting and critical comment (pl.116).

Prominent British Asian actors, musicians, celebrities and presenters are often seen and heard advocating the latest eye-catching contemporary British Asian fashions in the media, both mainstream and South Asian. Apache Indian, Meera Syal (pl.113), Talvin Singh (pl.115), Gurinder Chadha, Sanjeev Bhaskar, Nina Wadia, Hardeep Kohli, Preeya Kalidas, Bobby Friction, Nihal, Hard Kaur and Jay Sean, amongst others, regularly strut their respective professional stuff whilst decked out in cosmopolitan British Asian attire, making their own style statements through their idiosyncratic swagger and sense of fashion. Hardeep Kohli, for instance, proudly wears his colourful stand-out turbans

with equally colourful designer ties, shirts and suits, creating the impression of a late modern British / Scottish / Punjabi dandy figure (pl.111). Add to this list South Asian icons from the Indian subcontinent, not least Bollywood film stars like Aishwarya Rai and Shahrukh Khan (pls 114, 118) who regularly visit Britain, and the possibilities for constructed grace and flair are multiplied manifold. The presence of such celebrities, in both audio and visual terms, is not only made available through the terrestrial, mainstream media but also through the proliferation of non-terrestrial media outputs, especially since the mid-1990s, by means of which they are disseminated around the world.

The image of the British Asian as immigrant in the immediate post-war period has come some way over the past decades during which a sense of British Asian style has slowly registered, particularly in the mainstream media. British Asian fashion now circulates globally and in turn is infused and reinvigorated with style statements from elsewhere. Indeed, in the contemporary moment global media cannot afford to ignore the presence and contribution of British Asian fashion and style makers.

Opposite, left to right:
115
Talvin Singh, London, 1996

116
Panjabi MC at The Dome
Olymphiahalle, Germany, 2009

117
Madonna wearing henna on stage at the
San Remo Pop Festival, Italy, 1998

118
Below:
Shahrukh Khan and Rani Mukherjee in
the film *Paheli*, 2005

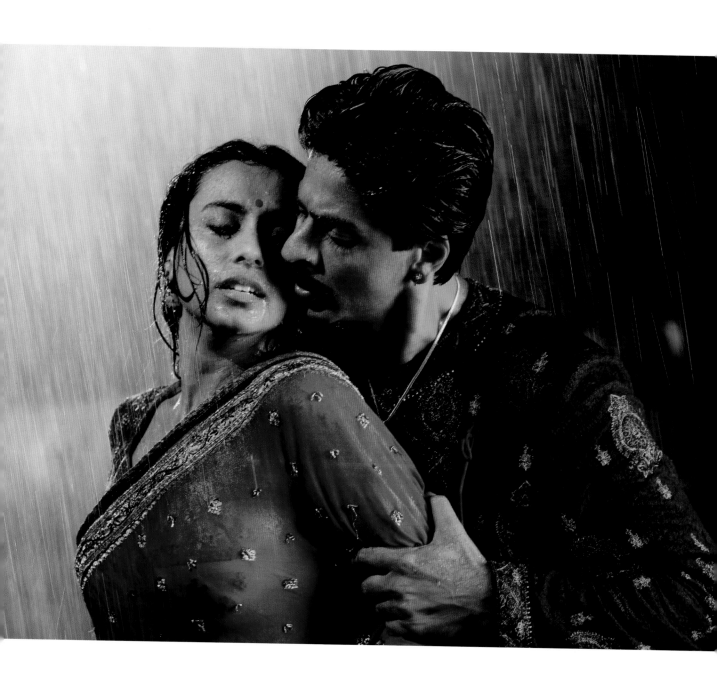

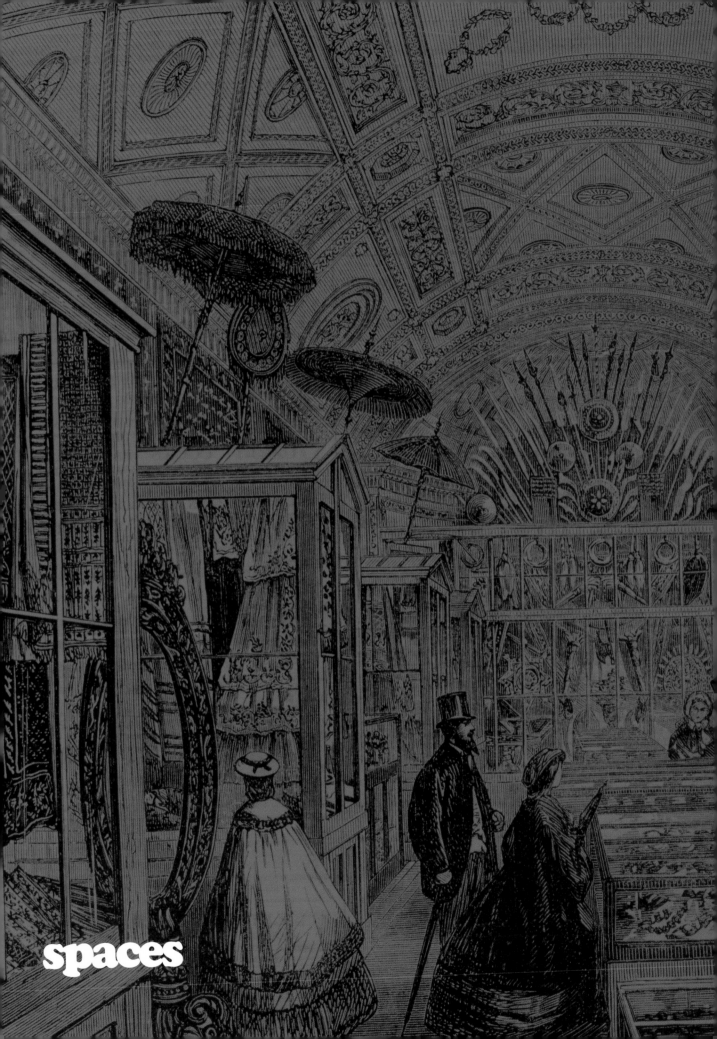

spaces

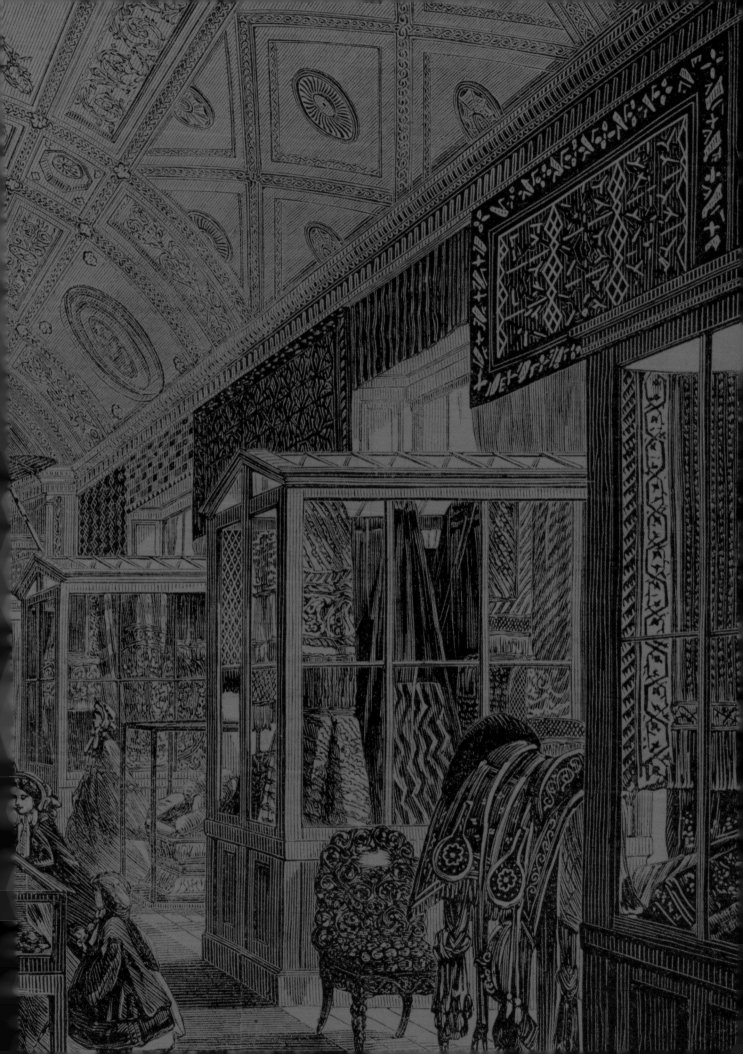

from suitcase to showroom
british asian retail spaces
by claire dwyer

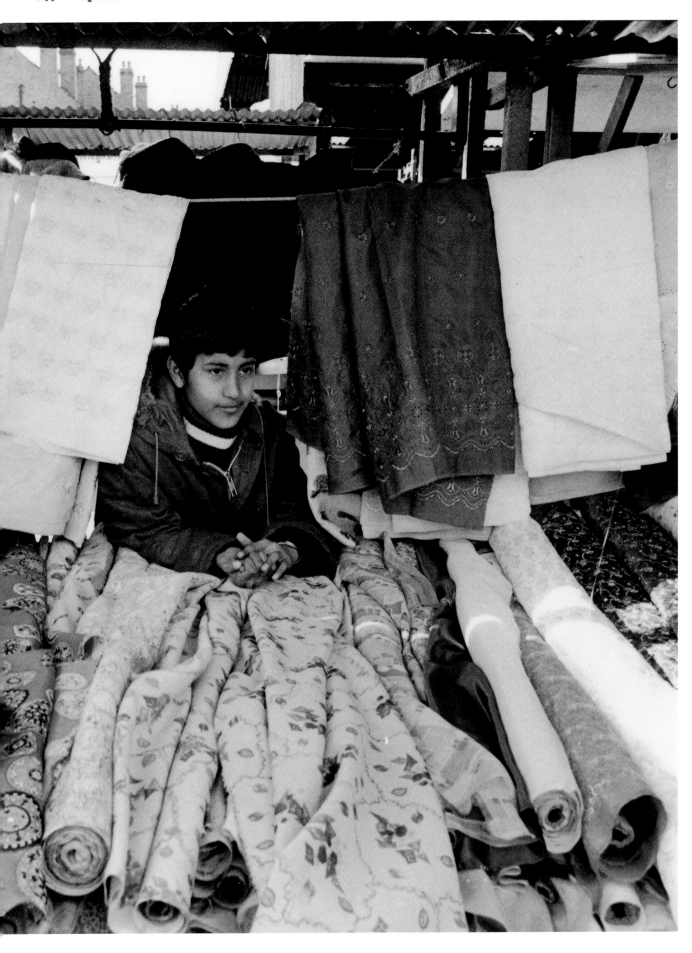

The history of British Asian post-war settlement in Britain could be told through an account of the changing fortunes of the British Asian fashion retailing sector. This is a story not only of ethnic enterprise and entrepreneurship but also of the changing roles of British Asian women, as feminine identities have been negotiated through British Asian style. It begins with the first entrepreneurs of the post-war migrant generation, selling rolls of fabric door-to-door or via market stalls, followed by pioneering women selling 'suitcase collections' of ready-made suits imported from India out of garages or back bedrooms, and continues with the contemporary emergence of a new class of British Asian fashion designer, producing 'fusion' or 'East-West' designs. The story of British Asian fashion retailing emphasizes the significance of textile and sewing traditions to British Asian cultures[1] and illustrates how fashion cultures are integral to processes of migration, transnationalism and settlement.[2] This history is illustrated by three case studies, drawn from an in-depth research project on British Asian fashion and chosen to document the dynamics of, and changes within British Asian retailing.[3]

The development of British Asian fashion mirrors the migration histories of the post-war generation from the Indian subcontinent. The earliest settlers were adaptive in their dress, women workers often choosing to retain saris or *salwar kameez* for the home and dressing in what were often described as 'English' clothes for work. Yet this adaptation, often a strategy to avoid racism, should not be interpreted as a rejection of Asian style. Instead a ready market was available to traders who sold loose fabric, often imported from India, either door-to-door or from market stalls (pl.119), which would be made up into suits at home or by local seamstresses or tailors. By the mid-1960s and later, boosted by the arrival of Asian refugees from Uganda and Kenya, fashion retailers were becoming established in emergent Asian neighbourhoods. One example is Variety Silk House in the Ealing Road, Wembley, one of the premier Asian shopping districts

in London. An early specialist retailer of saris and loose fabrics, Variety Silk House was opened in the late 1960s by Mayur Shah, a Gujarati who had come from Kenya where he already owned a textile business. The shop catered for a local, mainly Gujarati migrant clientele and developed a retailing style familiar from the subcontinent, with many staff at separate counters and an attentive and formal approach. Other shopping districts emerged in Southall in west London, Soho Road in Birmingham and Belgrave Road in Leicester.

Parminder Bhachu describes the importance of a home-making textile culture for British Asian women. Yet by the late 1970s British Asian retailers faced an uncertain future and many, as Mr Shah of Variety Silk House recalls,[4] predicted decline as the second generation of British Asian young women rejected British Asian style. Instead the last 30 years have seen a resurgence of enthusiasm for Asian fashion, which has sustained a proliferation of new retail outlets and the emergence of new young British Asian fashion designers. The explanation for this process lies partly in India. In the early 1980s considerable investment in the Indian fashion industry, including the founding of the Delhi-based National Institute of Fashion Technology (NIFT), was orientated towards expanding the Indian export market, particularly through ready-made clothing. This built on a long tradition of state-sponsored support for textile manufacture, initiated by the nationalist revivalist arts and crafts movement.[5] Enthusiasm for Indian clothing was promoted by elite fashion designers such as Ritu Kumar[6] and showcased by successive Indian beauty queens as well as the burgeoning Bollywood film industry. As Miller and Banerjee[7] illustrate, the flourishing Indian fashion industry also saw the revival or re-working of subcontinental styles, with the *salwar kameez* becoming widely adopted. For members of the British Asian diaspora the subcontinent became a site of fashion inspiration and a new retail culture of 'suitcase collections'[8] began. Entrepreneurial women would buy collections of ready-

Following pages:

120
Left above: Proprietors Mr Singh Banwait
Snr and his son Raj in their shop Banwait
Brothers, Southall, London, 2009

121
Left below: Choosing fabrics at Banwait
Brothers, 2009

122
Right above: Men's wedding attire, Daminis,
Green Street, Newham, London, 2009

123
Right below: Wedding saris, Sequinze,
Southall, London, 2009

made suits – both the *salwar kameez* (trousers and tunic) and the *lengha* (long skirt and tunic) – from India to sell back home in Britain, often opening up informal retail spaces in garages or back bedrooms. The revival of the subcontinental fashion industry was also paralleled by a new creative energy within British Asian style, which Khan[9] and Bhachu[10] place within the context of the anti-racist politics of the 1980s, as confident young British Asian women used clothing to fabricate new hybrid identities.[11]

By the early 1990s the British Asian retail sector was expanding rapidly and through a range of different outlets. Alongside the established wholesalers of loose fabrics or suits for home-stitching were many new shops selling only 'ready-made' clothes, directly imported from India. A new generation of young British Asian fashion designers, often trained in fashion in Britain and interested in designing clothes that might be described as 'East/West' fusion, was also emerging. These young designers understood how young British Asian women wore British Asian style, often adapting and combining looks, and interchanging 'Western' and 'Asian' clothing styles. As Bhachu[12] suggests, these designers operated within a dynamic transnational space, faxing individual designs to the subcontinent for rapid manufacture and detailed hand-embroidery. The expansion of the retail sector was paralleled by a proliferation of new consumer spaces, including fashion magazines, wedding fairs and fashion shows, and also new media spaces, which were provided by websites and dedicated Asian media channels. While new designers capitalized on renewed enthusiasm for British Asian style amongst a British Asian population, which was becoming more affluent and more self-confident in displaying and consuming British Asian fashion, there was also a growing interest in selling beyond this 'ethnic niche' market.

In the late 1990s media commentators celebrated the rise of the so-called 'Asian Kool' in music and fashion as high profile figures (including the late Diana, Princess of Wales and Cherie Blair) were photographed wearing *salwar kameez* and a range of festivals celebrated British Asian culture and style (for example, Selfridges' Indian Summer in 2002 and the Mayor of London's Festival of India in 2007). An enthusiasm for Indian music and film was consolidated in the hit musical *Bombay Dreams*. Of course, many were critical of 'multicultural capitalism'[13] through which 'the exotic' was commodified. It is also true that the media hype may not have sustained the 'crossover' markets hoped for by many British Asian retailers and designers. Nonetheless contemporary British Asian style is now well established, evident in a wide range of retail spaces from market stalls, which continue to sell cheap loose fabrics for home-stitching, to the proliferation of small shops selling ready-made suits in many different ethnic shopping districts throughout Britain, to a few more established retailers, who offer modern showrooms and designer fashion. Three analyses of these successful British Asian retailers follow, in which I trace how each defines and retails British Asian style.

From wholesale to ready-made: Banwait Brothers

Located in the bustling ethnic shopping district of Southall, Banwait Brothers provides a good example of a business that encompasses the changes in Asian fashion retailing. Bainwait Brothers was established as a fabric wholesale business in 1958 when Sardara Singh Banwait, a migrant from India, began selling door-to-door. He was joined by his brother and the two eventually established a shop in Southall, alongside a network of suppliers to smaller Asian shops across Britain. The business is now run by Mr Singh Banwait Snr, his two sons Raj and Jags, and their partners (pls 120, 121).

The company imports not only a very wide range of fabrics from India, which remains important for particular kinds of textiles including specially commissioned hand-embroidered organza, but also increasingly chiffons and

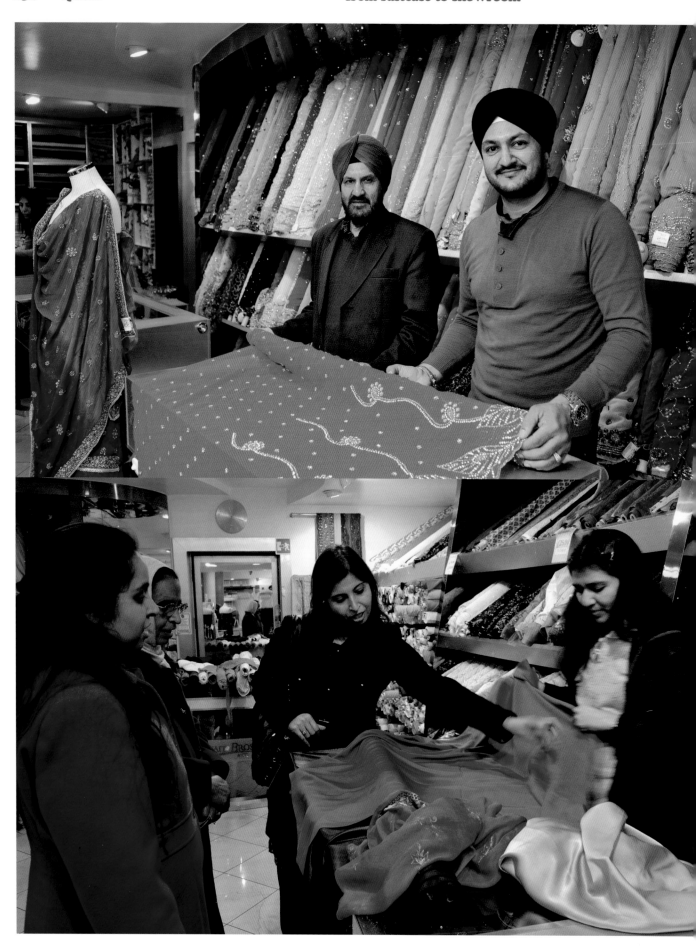

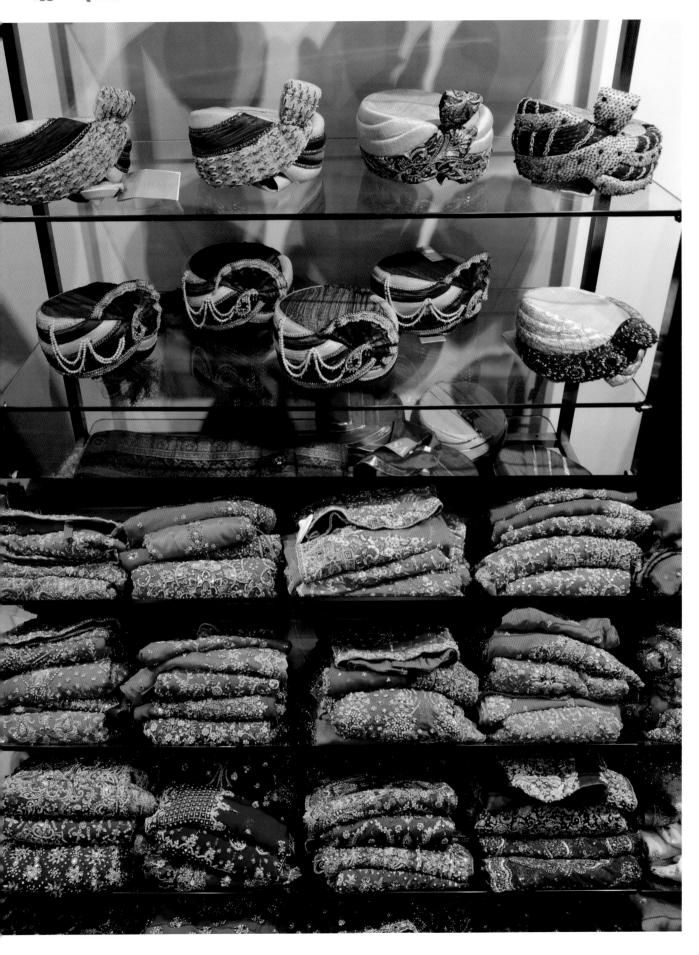

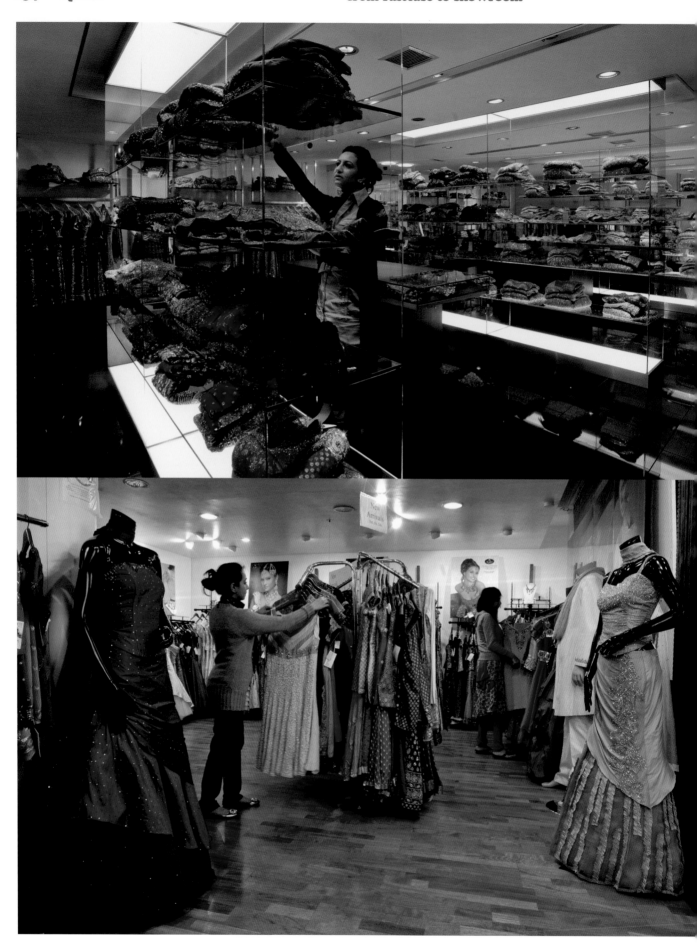

124
Opposite, above:
Bridal sari display, Daminis, Green Street,
Newham, London, 2009

125
Opposite, below:
Upper Bridal Gallery, Sequinze, Southall,
London, 2009

silks from China, Korea and Japan. Raj and his father make frequent trips to India and China to choose and order fabrics. This is a long established company, which is well known in Southall, and has built up firm relationships with customers. It is a shop that caters for a wide variety of British Asian consumers, extending beyond the local predominantly Punjabi-Sikh clientele and crossing the age spectrum from those older buyers seeking fabric to make their own clothes to those who want more fashionable ready-made clothes for bridal wear. It is also a popular destination for costume designers working in the film industry, seeking unusual fabrics.

The shop was refurbished in 1999 and is organized as two very distinct retailing spaces. The ground floor is dedicated to loose fabrics and suit lengths, and the floor space is organized both to display this range of fabrics and, via a range of counters with staff, to serve customers. Previously the shop has also set up tables outside to sell loose fabrics – a common practice in Southall to entice customers who would not enter a more formal shop, believing the prices to be cheaper outside.

Although they had sold ready-made clothes from the mid-1980s, it was not until 1993, with the arrival from India of Jasleen, Raj's wife, who spearheaded the expansion, that this section of the business grew into a separate label and retail space called Sequinze. The name 'Sequinze' was chosen very deliberately to sound modern and 'not too Asian'. The ready-made designer clothes collection is sold within a separate upstairs gallery, which is styled with references to Indian heritage including carved wooden chests and brass vases. Sequinze is designed to attract a particular kind of customer – younger British Asian women seeking bridal or party wear. So alongside the designer clothes, the upper floor is dedicated to wedding saris, which are displayed next to large mirrors and stylized posters (pls 123, 125). Here a designer service is offered whereby customers can choose a suit and have it

made in India to their specifications. In order to promote their designer fashion collection, which at times has also included Jasleen's own designs, the company regularly works with the leading Asian fashion magazines including *Asiana* and *Asian Woman* providing clothes for fashion shoots and participating in wedding fairs and fashion shows.

Retailing entrepreneurs: Daminis
Daminis was first established in Romford Road in east London in 1969 by Mrs Mohindra. Mrs Mohindra, who originates from India, had arrived in London in the early 1960s with her husband, a businessman from Baghdad. Shortly after they set up the first shop, however, he died, and Mrs Mohindra continued to run a thriving business alone, retailing fabrics imported from India and establishing a loyal client base. Parminder Bhachu[14] celebrates Damini as a 'commercial matriarch' in her history of Asian fashion entrepreneurs. In the early 1980s Mrs Mohindra's son Deepak joined the business and was the impetus for expansion, which eventually included both a newly designed shop in Green Street in east London and three further shops in Southall, the Edgware Road in the 'West End' and Belgrave Road in Leicester (although by 2009 business was consolidated in Green Street) (pls 122, 124, 126, 127).

Daminis' retail identity was built both on an early commitment to ready-made clothes, *salwar kameez* and *lenghas*, and the adoption of new forms of retailing practices, which were uncommon in the more traditional British Asian retail shops. In the mid-1980s Daminis was one of the first retail pioneers to concentrate on ready-made clothes, which is the sole focus of the shop with the exception of bridal saris. In 1995 a new flagship store was opened on the site of a former petrol station in Green Street. The shop was purpose-built and its design inspired by established retail showrooms in India, such as Sheetal in Mumbai. Deepak also wanted the shopping experience in Daminis to parallel that of mainstream

126
Opposite, above:
Choosing a bridal sari, Daminis, Green
Street, Newham, London, 2009

127
Opposite, below:
Children's wear, Daminis, Green Street,
Newham, London, 2009

high street stores such as Next or Oasis, places his young British Asian customers would also frequent, in contrast to 'traditional' Asian retailers, which were defined as 'dark, cluttered and over crowded'. The shop on Green Street is brightly lit, accessorized with subtle touches like vases and flowers, intended to welcome both a young British Asian clientele and non-Asian consumers. Within the shop clothes are arranged over three floors including menswear and children's clothes as well as an extensive bridal floor with sofas, mirrors and fitting rooms. Daminis has also adopted retailing practices consistent with other high street stores but which, until they were pioneered here, were uncommon in most British Asian retailers. Clothes are co-ordinated by colour and arranged thematically with one design being offered in several sizes.

Deepak describes Daminis' clothes as 'East/West fusion', arguing that the suit designs are mainly driven by trends in the Western fashion market. Clothes are ordered on regular buying trips to established partners in Delhi and Mumbai. A range of ready-made suits in different sizes will be ordered and while the shop does not offer a made-to-measure service, small adjustments can be made by a local London seamstress.

Daminis has thus been at the forefront of change in British Asian retailing, not only in the prioritizing of ready-made clothes over loose fabrics but also in the stylization of retail spaces and the adoption of standardized retail practices. Recognizing a broader enthusiasm for 'Asian' fashion, Deepak has sought to extend Daminis' non-Asian customer base through a catalogue marketed through the celebrity glossy *OK!* Magazine and by opening their first 'West End' store (on Edgware Road) in 2001, although this store did not manage to attract enough customers to be sustainable. His entrepreneurial efforts have included participation in both Asian and non-Asian bridal fairs, a fashion show at the Victoria and Albert Museum, and endorsements from celebrity customers as well as the

seeking of new markets in North America and through the expansion of e-commerce.

Bespoke British Asian fashion design: Raishma

Raishma Islam is a British fashion graduate, of Pakistani heritage, who has worked as a fashion designer for about ten years. On graduation she worked with established bridal designers, including Elizabeth Emmanuel, before deciding to set up on her own. Raishma produces designer bridal wear for both Asian and non-Asian customers. With Asian bridal wear, however, while she works with a traditional colour palette of reds and golds, her designs include more contemporary boned bodices and fitted skirts. All designs are made-to-measure, first toiled in cotton before being completed in high quality silks and chiffons. Raishma's clothes are designed in consultation with clients at her bridal studio in Green Street, east London, before being sent to be hand-embroidered in workshops in Pakistan (pls 128, 129, 130).

Raishma's clientele is both contemporary British Asian women seeking more individual and less traditional bridal wear as well as non-Asian women. Her small studio, a converted terraced house, has been cleverly designed to incorporate two different bridal suites. The first includes dresses and suits in traditional reds and golds for her Asian clients, while the second holds white and cream dresses for her non-Asian clients. Raishma also maintains two separate web sites, one orientated towards Asian clients while the other, Raishma Couture, is orientated towards the mainstream bridal market. Raishma thus consciously positions herself within two different retail markets and her clothes are featured in the mainstream bridal press.

When she was starting up Raishma worked closely with some of the pioneers of the new Asian fashion press, developing fashion features aimed at young British Asian women. Developing a style that she described as 'East/West', emphasizing 'Western fashion' in the styles and

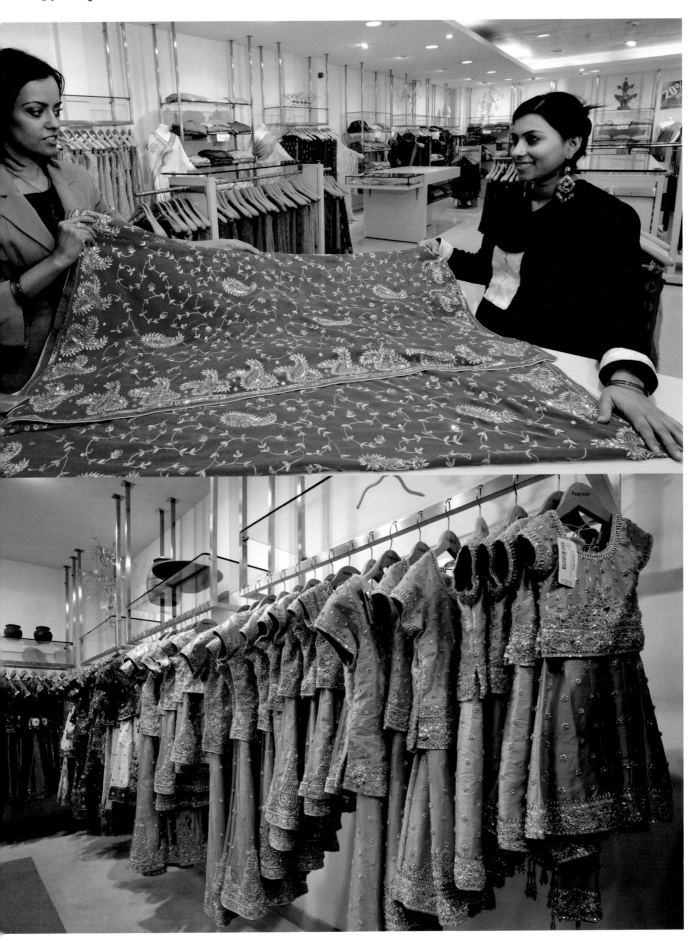

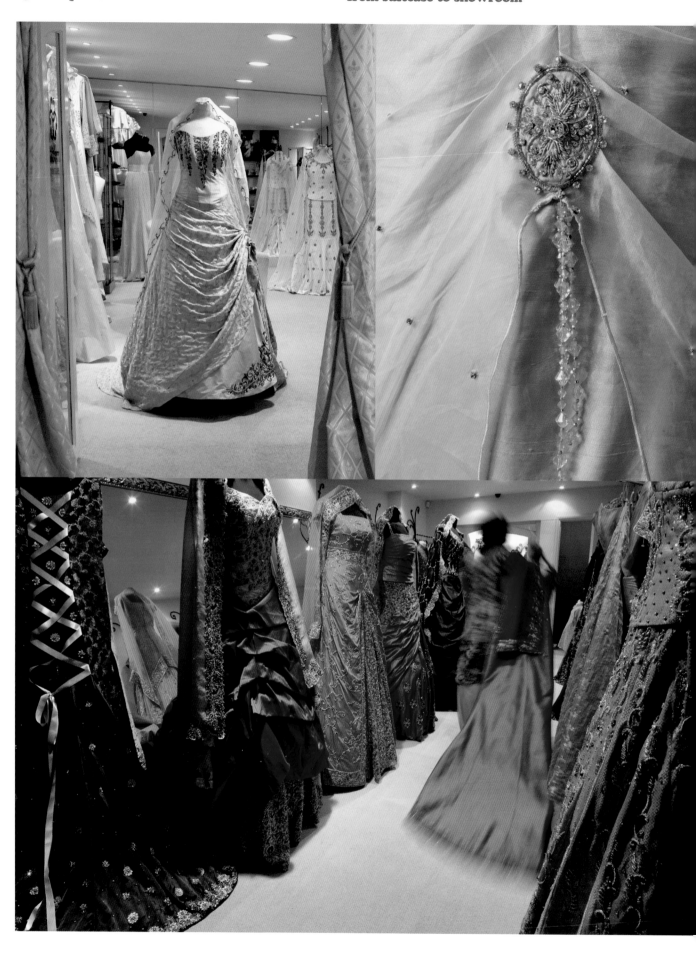

128
Above left: White Bridal Studio, Raishma,
Green Street, Newham, London, 2009

129
Above right: Embroidered bridal gown
(detail), Raishma, Green Street, Newham,
London, 2009

130
Below: Bridal Studio, Raishma, Green
Street, Newham, London, 2009

silhouettes used and 'Eastern traditions' in the fabrics and
hand-beaded embroidery, Raishma placed Asian models
in pastoral English settings. She also gained publicity
when she designed a backless 'sari dress' worn by Ffion
Hague, wife of Conservative leader William Hague, at a
political dinner in 1999, which showcased contemporary
British Asian style. More recently she has designed dresses
for Princesses Beatrice and Eugenie.

These three case studies offer an insight into the changing
dynamics of British Asian retailing in contemporary
Britain. They illustrate how pioneering entrepreneurs
such as Damini Mohindra and Sardara Singh Banwait
established a vibrant retail culture in textiles for the post-
war migrant generation, sustained by strong transnational
links to the Indian subcontinent. Successive generations
have transformed British Asian style through engagement
with the fashion industries of the subcontinent and
through fusion with more mainstream British fashion.
The result is testament to the creativity and confidence
of young British Asian women, who have continued to
embrace British Asian style as a marker of identity within
a multicultural society.

exhibiting south asian textiles
by felix driver

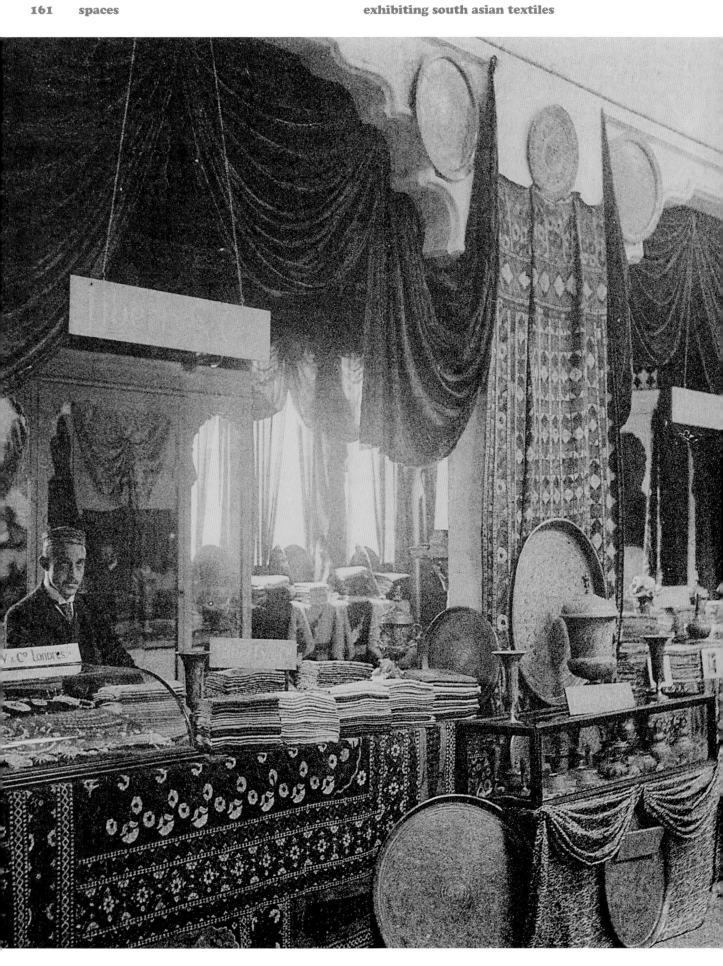

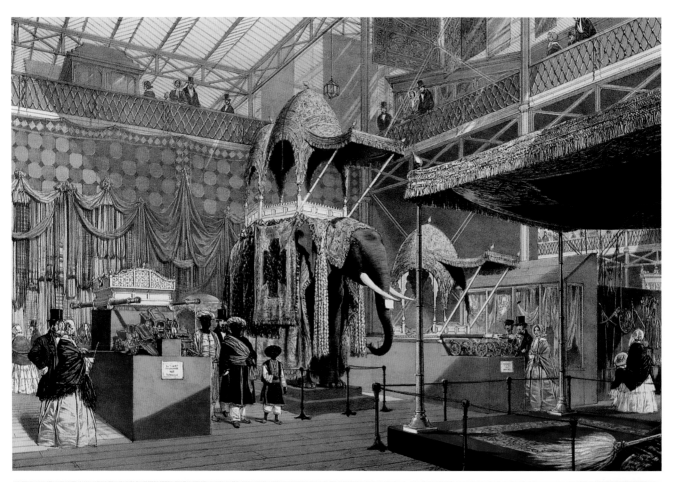

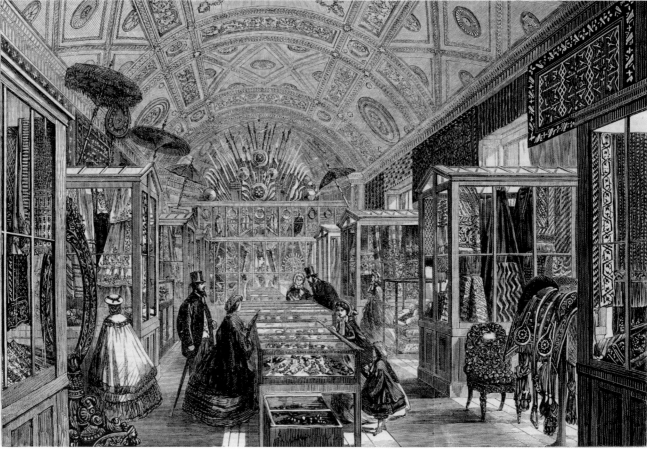

131
Previous page:
Liberty's bazaar, Paris Universal
Exposition, 1889
From *Journal of Indian Art and Industry*, 1890
National Art Library

132
Opposite, above:
The Indian Court at the Great Exhibition,
1851
Colour lithograph on paper
From *Dickinson's Comprehensive Pictures of the
Great Exhibition of 1851*
Dickinson Brothers, London, 1854
V&A: 19536:11

133
Opposite, below and pages 146–7:
'India Museum at Fife House, Whitehall'
Illustrated London News, 3 August 1861
National Art Library

At many of the great exhibitions held in Britain during the age of empire, India had pride of place. In the spectacular glass and iron Crystal Palace built for the 1851 Great Exhibition, the Indian court occupied a privileged position at the intersection of the great nave and transept (pl.132). At the Colonial and Indian Exhibition in South Kensington in 1886, displays from the subcontinent occupied over 100,000 square feet, more than three times the space given to them in 1851. At the 1924 British Empire Exhibition held in Wembley, the space occupied by the Indian pavilion had doubled in size again, its vast extent matched by the exorbitant rhetoric of empire. In the words of the official guidebook, 'To understand the resources and variety of India as set out in the Pavilion, and to grasp the part Great Britain has played in developing the one and unifying the other, is to understand why the title of King Emperor is the first of all titles throughout the world'.[1]

So the dream world of 'India' was conjured up through the display of both luxury items and everyday objects: sumptuous jewels, crowns, palanquins, thrones and other regal finery, alongside printed fabrics, working tools, metalwork and pottery. In the process South Asia was reduced to a world made up of princely courts and village communities, the former represented as the oriental counterparts of British royalty and the latter imagined increasingly as the antithesis of modern industrial society. In the choreography of display, textiles had several distinct roles: as inert materials ready for appropriation, as intrinsic parts of the fabric of daily life and labour, as material evidence of 'native ingenuity' and as a highly colourful backdrop to the pageant of empire. Raw materials such as cotton and jute were thus shown to highlight the rich potential of natural resources in the subcontinent. Manufacturing processes like weaving, spinning and embroidery were evoked through the display of tools, clay models and dioramas, and sometimes through the enactment of craft techniques by selected 'representative' artisans. Meanwhile, fine carpets, shawls, lustrous silks and printed cottons were hung on walls and

draped on balconies in order to enhance the impression of spectacular luxury and power.

The India Museum

The great exhibitions and world fairs were nothing if not attention-seeking: their purpose was to celebrate the progress of trade and empire, and thereby to promote the interests of their commercial and government sponsors. However, in describing the role of such exhibitions in relation to South Asian textiles, it is necessary to take a broader view. The idea of exhibiting textiles in order to encourage trade, educate taste and celebrate empire extended well beyond the great exhibitions. This much is clear from the history of textile collections now held within the Victoria and Albert Museum. The V&A's South Asian collection, for example, has its origins in the India Museum, founded by the East India Company in 1801 at its headquarters in Leadenhall Street, London. A wide variety of textiles – including shawls, silks, cottons, garments and carpets – were acquired by the museum, which continued to extend its collections after the establishment of the India Office in 1858, requiring the opening of new premises in Whitehall (pl.133). These collections provided materials for many of the international exhibitions of the period: they were also augmented by materials from these same exhibitions. The close association of the India Museum with exhibitions was one of the reasons for its move from Whitehall to South Kensington in 1875, while still under the authority of the India Office. In 1879, after much administrative wrangling, its collections were finally divided up between the South Kensington Museum, the British Museum and Kew Gardens, its textile collection forming a major part of the new India gallery that was opened at the South Kensington Museum in 1880.

To modern eyes, the collections of the India Museum appear remarkably eclectic, including as they do botanical, geological and zoological specimens, archaeological remains, manufactured products (notably textiles), works

134
Left: Bundles of off-cuts from samples for
John Forbes Watson's textile albums, mid-
19th century
Now in the V&A textile collection
V&A: 4738(IS)

135
Opposite: 'Stand, with frames, for the
exhibition of raw products'
From John Forbes Watson, *The Imperial
Museum for India and the Colonies*, W.H. Allen,
1876
National Art Library

136
Following pages, left: Kincob, Benares (Varanasi)
No. 407, second series, with smaller sample
'for examination of texture'
From John Forbes Watson, *The Collections of
the Textile Manufactures of India*, 1873–7
National Art Library

of art, sculptures, ethnological casts and photographs,
prints, drawings, coins and curiosities (including Tipu
Sultan's mechanical tiger, still on display at the V&A).
There was nonetheless a consistent emphasis on applied
natural history (and more specifically economic botany)
in the writings of successive curators, reflecting similar
impulses at work in better-known institutions such as Kew
Gardens and, later, the Imperial Institute. Increasingly
the India Museum was represented as an aid to imperial
commerce. In an official document in 1869, for example,
it was described as 'not a mere museum of curiosity, nor
even primarily a museum intended for the advancement
of science, but the reservoir, so to speak, that supplies
the power to a machinery created for the purpose of
developing the resources of India, and promoting trade
between the Eastern and Western empires of Her Majesty,
to the great advantage of both'.[2]

John Forbes Watson, appointed by the India Office to the
newly-established post of 'Reporter on the Products of
India' in 1858, argued that the museum's Indian collections
– notably the textiles themselves, but also raw materials and
dyes – could serve a useful purpose if organized as a 'trade
museum'. Forbes Watson's emphasis on the circulation
and diffusion of collections led him to promote new
techniques of display and reproduction. Ideally, he argued,
miniature mobile collections should be created, consisting
of several thousand specimens, which could be displayed
in a single room. A key part of this plan were ingenious
devices designed to maximize the efficient use of space: a
collection of glazed wooden frames attached to a portable
stand capable of displaying 1,000 specimens of 'Indian raw
produce' (pl.135). Similar stands, capable of displaying large
numbers of drawings, prints or fabrics, were introduced by
Henry Cole at the South Kensington Museum.

This idea of the 'portable museum' took a number of
forms, some of them capable of further multiplication.
Forbes Watson himself compiled a series of albums of

sample textiles (many of which had been exhibited at
international exhibitions), under the title of *The Collections
of the Textile Manufactures of India* from 1866 onwards
(pl.134). Twenty sets of the first series (containing a total of
700 samples) were produced for distribution to chambers
of commerce and art schools in Britain and India. A
second series appeared from 1873, with smaller and more
elegantly mounted samples, each with an additional small
piece 'for examination of texture'. Each textile sample
was accompanied by details of the length, width, weight
and cost of the fabrics and their place of manufacture
or purchase. In order to help British manufacturers
understand how the garment would be worn, many labels
included a phrase such as 'opposite end usually next to
body', or 'principal end to show' (pl.136). While such
projects reflected the conventions of manufacturers' pattern
books, they also remained faithful to the applied natural
history ethos of the India Museum.[3]

India Museum staff intended these textile volumes to be
mobile exhibits for the instruction for manufacturers and
designers in the heartlands of the British textile industry.
There they would function as instruments of commercial
intelligence: as Forbes Watson put it, 'These "local
Museums" will show what the people of India affect and
deem suitable in the way of textile fabrics, and if the supply
of them is to come from Britain, they must be imitated
there'.[4] He was especially concerned to ensure that the
necessary information was provided to facilitate copying,
so that British manufacturers could adapt their goods to
a potentially lucrative market in India at a time when the
Lancashire cotton industry was in serious trouble.

If seen in narrowly institutional terms, the eventual closure
of the India Museum in 1879 may perhaps be seen as a
sign of failure. However, while the map of institutional
ownership changed, the ethos of the museum and a
substantial part of the collections remained, and indeed
became a vital resource for the network of Victorian

FIG. 1.—STAND, WITH FRAMES, FOR THE EXHIBITION OF RAW PRODUCTS (GRAINS, DYES, &c.)

96244

KINCOB.

Length, 5 Yds. 3 Ins.; Width, 30 Ins.; Weight, 3 lb. 8 oz. 14 dr. Price per Yard £4 10 s.

BENARES.

NO. 407, SECOND SERIES.

" 4058 "

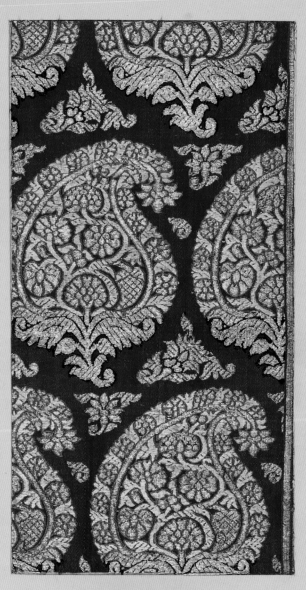

FOR EXAMINATION OF TEXTURE.

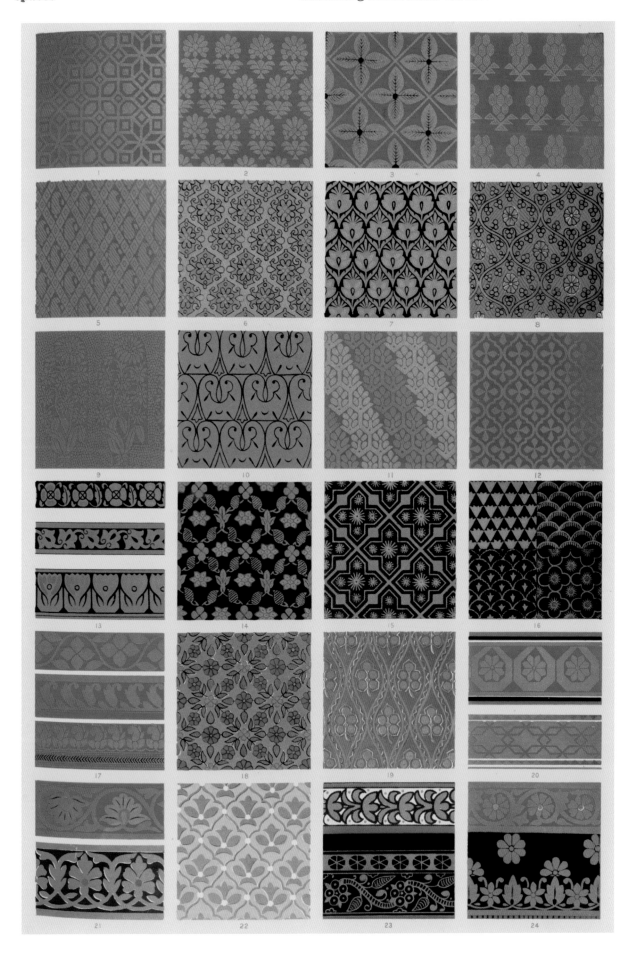

authorities and experts who came to define 'India'
for a wider British public. In its cramped Whitehall
accommodation the museum simply could not deliver what
was becoming an increasingly ambitious agenda. Far from
signalling the end of its mission, however, the relocation
of its textile collections to South Kensington marked the
acceleration of efforts to make knowledge of the arts and
manufactures of India more visible.

Design reform and the pedagogy of display
The zeal of administrators such as Forbes Watson in
promoting imperial trade was matched by that of the
proselytizers for design reform, for whom exhibitions were
a key pedagogic instrument. These critics used the 1851
Great Exhibition to draw attention to deficiencies in British
industrial design, highlighting the superiority of the best
work produced in the 'Orient', including India, China and
the Islamic world. Dubbed the 'Grand Polychromatist-
plenipotentiary' by one contemporary, the architect Owen
Jones played a decisive role in the popularization and
diffusion of 'Indian' and other non-European designs
in the nineteenth century.[5] His was a noted voice at the
Museum of Ornamental Manufactures at Marlborough
House, Pall Mall, founded in 1852. This new museum
sought to represent the best and worst in design traditions
and its collections included works purchased from the
1851 Great Exhibition (selected by Jones as well as Henry
Cole, Richard Redgrave and A. W. Pugin): a substantial
proportion of these were from South Asia, about half
of them textiles. In addition to displays at Marlborough
House itself, the museum organized circulating exhibitions
destined for provincial schools of art and design.

This use of South Asian textiles as exemplars of good
design found expression not only in museums but also in
the pages of design manuals, most notably Jones' celebrated
treatise *The Grammar of Ornament*, published in 1856 (pl.137).
A lavishly printed album of motifs supposed to exemplify
historic and world cultures, *The Grammar of Ornament* itself

became another form of circulating exhibition, and like the
South Kensington Museum was conceived of essentially
as an instrument of reform. The 'Indian' and 'Hindoo'
designs in *The Grammar* were taken from a variety of sources,
including textiles in the South Kensington collections as
well as architectural drawings, metalware and lacquerwork.
The drawings from textiles often took the form of details of
repeating border patterns or embroidery motifs. Particularly
admired by Jones were the kincobs of Benares (Varanasi),
rich silk fabrics with patterns woven in gold and silver-
wrapped thread. Other textiles selected as paradigms of
good design included a sumptuous sari originally purchased
from the 1851 Great Exhibition for £22. As Sonia Ashmore
has noted, the patterned loose end (*pallau*) of the sari
incorporates flower motifs, a floral meander and chevron
(*khajuri*), all of which were illustrated in *The Grammar* (pl.138).[6]

The reproduction of textile designs was enabled partly
by new forms of expertise in centres such as South
Kensington and partly by innovations in the technologies of
photography and print. These two mid-nineteenth century
developments came together in the career of William
Griggs, a photolithographer first employed, at the age of
18, in the Indian Court of the 1851 Great Exhibition. In
later years Griggs was employed as a technical assistant
at the India Museum, where he devised a practical and
cost-effective technique of chromolithography that proved
especially effective in the reproduction of textile designs.
Subsequently, his work was much in evidence within the
Journal of Indian Art and Industry, established in 1884, which
represented the interests of a new generation of British
authorities in the arts and design of South Asia, including
Thomas Holbein Hendley, founder of the Jaipur Museum
and John Lockwood Kipling, head of the Lahore School
of Art. Like *The Grammar of Ornament*, the sumptuous and
detailed designs published in the *Journal* decontextualized
the fabrics from their immediate contexts, translating them
into patterns on the page (pl.145). Alongside this visual
framework, moreover, was added a more specific historical

140
Above: Men working at a gold-embroidery
frame, Delhi
John Lockwood Kipling, (1837-1911)
Pencil, pen and ink with wash on tinted
paper, 1870
V&A: 0929:30(IS)

141
Right: Cream silk-satin skirt embroidered
in chainstitch with red and black rosettes
in silk thread and mirror work, Kutch,
Gujarat, *c*.1880
Purchased by Caspar Purdon Clarke
V&A: IS.2304–1883

142
Right: Vestibule of the Durbar Hall in the Indian Palace, Colonial and Indian Exhibition, 1886
From *Illustrated London News*, July 1886
National Art Library

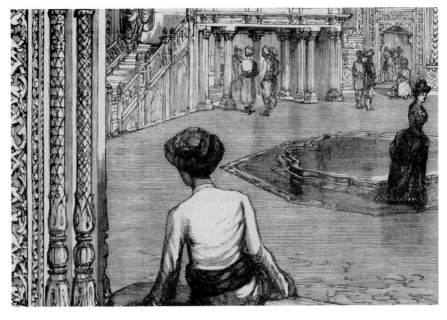

narrative: that of the inexorable decline of Indian craft skills in the face of modern commercial design.

The combination of this idealization of 'traditional' craft production in India with the neo-medievalism of the Gothic revival and its arts and crafts manifestations, provocatively dubbed 'colonial Gothic' by Tim Barringer, proved a potent force in late Victorian design circles.[7] George Birdwood's influential publication entitled *The Industrial Arts of India*, published in 1880, situated the South Kensington Museum's South Asian textiles collection in the context of an idyllic vision of Indian village life and labour. Birdwood had previously worked in the Bombay medical service and then at the India Museum, where he had been responsible for the exhibition of didactic images of Indian labour. Drawings of Indian craftsmen by Lockwood Kipling, including a notable image showing the processes of gold embroidery in Delhi (pl.140), were part of the effort to picture a tradition of skilled artisanship under threat from mass production.

Staging India
The curator of the new Indian gallery at the South Kensington Museum in 1880 (pl.139), Caspar Purdon Clarke, had already proved his credentials as a sort of pageant-master of oriental display. It was clear from his design for the Indian section of the 1878 Paris Exposition that he had an eye for spectacle, and this was again in evidence in his stage-management of the Indian courts at the 1886 Colonial and Indian Exhibition. Many of the items displayed in 1886 were purchased first-hand on a two-year tour of the major cities of India, during which Purdon Clarke had acquired numerous specimens, artefacts and tools (including spinning wheels). The textiles collected during this trip included a variety of kincobs, block-printed cottons of varied quality, numerous articles of worn clothing and a substantial collection of Kashmir shawls (pl.141).[8]

The Indian section of the 1886 exhibition was designed above all to highlight the exoticism of India. At its heart was an unashamedly hybrid 'Indian Palace' with an elaborate 'Durbar Hall', carved over a period of nine months by two skilled craftsmen, Muhammad Baksh and Muhammad Juma, brought over from the Punjab (pl.142). In this highly theatrical setting, textiles were the key decorative element: the Durbar Hall was draped with printed cottons and lustrous, silk-embroidered *phulkari* (or flowerwork), many examples of which Purdon Clarke had acquired on his trip to the Punjab (pls 143, 144). The Vestibule, dominated by an equestrian statue of the Prince of Wales, was also hung, tent-like, with the finest chintzes from Kashmir. A similar approach was deployed in the Provincial Art-Ware Courts and in Thomas Wardle's Indian Silk Court. In this context, as at other late nineteenth-century exhibitions, South Asian textiles were used to create dramatic effects that generally bore no relation to their original purpose, echoing the spectacular techniques of the theatre and department store (pl.131).

The lavish spectacle of the Indian courts in 1886 was accompanied, not always convincingly even to contemporary visitors, by renewed claims to authenticity based on the idealization of craft labour. The exhibition thus included 34 'native artisans' – including carpet weavers and calico printers, coppersmiths, engravers, goldsmiths, potters, and woodcarvers – selected as living embodiments of traditional India. The presentation of these craftsmen was essentially theatrical, the performance of the carpet weavers at their loom attracting much attention in reviews.[9] The underlying message, as anticipated by Birdwood in his 1880 guide, was clear: the crafts of India had to be preserved against modernization itself. The paradox this embodied was reflected in the inclusion within the exhibition of newly-commissioned work, including 12 Ahmedabad kincobs made under the direction of the Bombay School of Art using the purest gold and silver in place of imported materials. The 1886 exhibition was quite literally ornamenting a tradition: where India itself had fallen short of the ideal, the British would make up the difference.

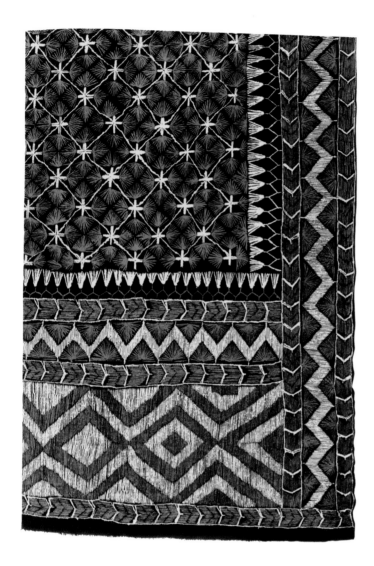

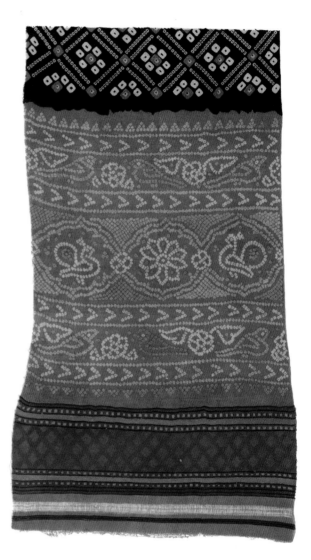

143
Above: 'Phulcari embroidered sari,
Umritsur', exhibited at the Colonial and
Indian Exhibition, 1886
From *Journal of Indian Art and Industry*, 1886
National Art Library

144
Above: 'Bandana work (knot dyeing or tie
and dye work), lent by Diwan Sri Ram,
Prime Minister of Ulwur', exhibited at the
Colonial and Indian Exhibition, 1886
From *Journal of Indian Art and Industry*, 1886
National Art Library

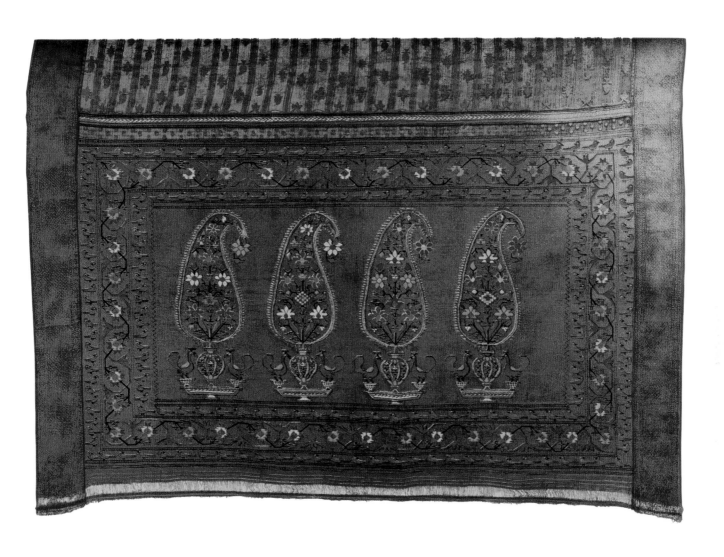

145
Above: 'Ahmedabad kincob'
From *Journal of Indian Art and Industry*, 1892
National Art Library

south asian patterns in urban spaces
by helen scalway

146
Previous page:
Statue of Prince Albert above the main
entrance of the Victoria and Albert
Museum, South Kensington, London,
2009

This contribution is an outcome of my work as an artist on the 'Fashioning Diaspora Space' research project: a collaboration between Royal Holloway, University of London, and the Victoria and Albert Museum, which ran from 2007 to 2009. The project focused on pattern and ornament, looking at South Asian clothing textiles in British culture in colonial and post-colonial times, and exploring the processes of material cultural exchange between Britain and South Asia.

The images that appear here were first shown as *Moving Patterns*, an exhibition at the Royal Geographical Society, London, in May 2009.[1] They came about as a result of my interest in the way ornament surrounds us in the cosmopolitan city, coding people, places and things, filling them with meaning, suffusing them with memory; and in the way that our experience of pattern is always framed, always dependent on context and location.

Ornament as a powerful carrier of meaning and memory, making and marking identities, on clothing or on buildings, is richly manifest in contemporary cosmopolitan British cities, be the city Leicester or London, Manchester, Birmingham or Bristol: each is a palimpsest of ways in which past and present builders have projected messages. Streets, shops, museums, all may narrate the past in ways both conscious and unconscious.

The site as narrative
As part of this series of images I made a pair of 'diagrams' in response to different sites. The first site was a suburban London street, full of British Asian shops selling textiles and clothing, as well as food, music and jewellery (pl.154). The second was the South Asian Textile Collection at the V&A (pl.155). The street inspired *South Asian Textile Retail Outlet: A Diagram* (pl.147), which represents an engagement with the workings of a contemporary, post-colonial British South Asian textile shop. The museum gave rise to the work *Johari's Window Opens on a Colonial Psyche* (pl.148), a

piece offering an interpretation of aspects of a museum department originating in colonial times. If we imagine a museum as the reflection of the collecting impulses of a 'national psyche', in Britain in 1880 this would have been colonial, powerful. The South Asian Textile Collection, as one manifestation of such a psyche, encapsulates national attitudes, aspirations, narratives and desires. This diagram is an attempt to bring such a manifestation into relation with a visual model known as 'Johari's Window', a cognitive psychological tool created by Joseph Luft and Harry Ingham in 1955 in the United States, designed to illustrate the different perceptions that exist of each individual.

The work *South Asian Textile Retail Outlet: A Diagram* plays on the proximity of two conceptual orders: the physical one of a shop – its window display, fitting rooms, counter, store room – and the desires and fantasies it embodies. *Johari's Window Opens on a Colonial Psyche* also slides internally between different conceptual orders, evoking aspects of what might have gone into the making of a British colonial collection of Indian textiles through the use of a visual model more familiar in settings such as self-help groups and corporate training for interpersonal awareness. The model has been exploited here for its evocation of an interplay of perceptions around an identity; here, the identity is imagined as a collective 'psyche' of colonial Britain, a psyche full of colonial attitudes while in the grip of the impulse to collect and archive Indian textiles. (It is not intended as a comment on any one individual in the history of the V&A). Of course, there were nuances of attitude in colonial Britain but I have taken the risk of essentializing such a psyche because letting it stand, even essentialized, within the metaphoric space of the Johari's Window model seems to offer the potential for a fresh view. This diagram plays on the notion of a psyche with different potentials for openness, concealment, blindness and unknowability, intersecting with a historical moment.

These diagrams – the one concerned with shop, the other with museum – co-occupy different kinds of register, seeking to evoke simultaneously both the historic and the physical, and the arena of dreams and emotions.

The site as embodiment of identity

Turning to the other works in the series, the British Asian customers of South Asian textile shops in British cities may be as varied in terms of age, class and style as in more international stores, but they scour the textile stocks imported from Mumbai or Delhi, from Varanasi, Ahmedabad or Islamabad – fabrics embroidered, beaded, printed, brilliantly dyed – as though seeking a nourishment as necessary as food. Clearly these shops, like all clothing stores, are sites for the construction of identities; but sites in which a particularly driven shopping energy pours into the re-creation of memories of distant places and of projections of new contemporary Asian British urban identities (pls 149, 150).

How is the contemporary textile stock proffered by such shops connected to the historic textiles conserved in a British institution such as London's Victoria and Albert Museum? The museum, through its buildings, collections and displays, seems to present an equivalent site of identity-construction. Just like the shop, the museum is a place full of narratives. It is the manner of their telling which varies. Like the shop, the museum proffers its selected treasures behind illuminated glass. British Asian textile shop labelling proclaims, '100% pure silk!' or '20% off!' Museum labelling seems more neutrally informative. It may or may not reveal colonial modes of acquisition. But the largest frame of all, the nineteenth-century museum building itself, unmistakably utters its imperial history, projecting a vision of how Britain desired to see itself and be seen at the height of empire (pls 146, 151). Imperial 'greatness' was predicated on colonial riches. These treasures in turn colonized the British imagination, delighting its taste for colour and ornament.

The site as frame

Like the museum, the shop seems to frame its 'contents', telling us what to notice. The collages titled *Flats near Green Street, E7* and *House near Green Street, E7* (pls 156, 160) play on reframings, using imagery from contemporary British streets. The nineteenth-century V&A museum building and its historic South Asian textile archive also inspired the museum 'views', *At the Museum: Diorama 1, 2* and *3*. These are based on Victorian 'dioramas' and on Benjamin Pollock's toy theatres of the 1880s, and relate to the nineteenth-century interest in creating illusionistic 'other worlds' (pls 161, 162, 163).

These and other works (pls 152, 153, 157, 158, 159) seek to shake some habitual thought-frames and to make visible a glimpse of the centuries-old mutual entanglements, appropriations and inter-colonizations between British and South Asian cultures of ornament. The distinction between frames and their contents is less stable than may at first appear; they challenge each other, transforming themselves into new entities with different meanings. Women wearing their *salwar kameez* in British city streets change the meaning both of *salwar kameez* and British city street. A Paisley silk scarf on sale in the V&A shop bespeaks a history of cultural entanglement and exchange. In such circumstances 'meanings' are necessarily complex and in cosmopolitan London, both in the museum and in the street, new ones are constantly coming into being.

TEXTILE SHOP
GREEN STREET NEWHAM E7

* 'RETAIL OUTLET' IMPLIES FORCE OF PRESSURE TO SELL
* 'STORE' SUGGESTS REPOSITORY (LIKE MAGAZINE: A STORE: A DEPOT)
* 'SHOP' SUGGESTS DESIRE TO BUY: TO GO SHOPPING

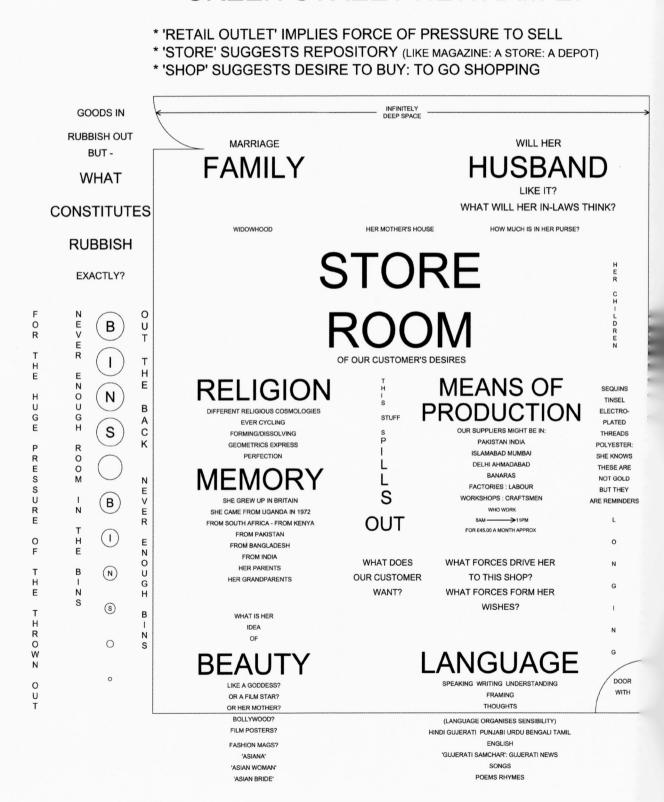

THINGS WE REALLY DON'T WANT TO KNOW ABOUT OR TALK ABOUT OR REMEMBER EVER EVER EVER AGAIN IF WE CAN HELP IT

FOR THE HUGE PRESSURE OF THE THROWN OUT

NEVER ENOUGH ROOM IN THE BINS

B I N S O B I N (s) o o

OUT THE BACK NEVER ENOUGH BINS

GOODS IN

RUBBISH OUT BUT -

WHAT

CONSTITUTES

RUBBISH

EXACTLY?

INFINITELY DEEP SPACE

MARRIAGE
FAMILY

WILL HER
HUSBAND
LIKE IT?
WHAT WILL HER IN-LAWS THINK?

WIDOWHOOD HER MOTHER'S HOUSE HOW MUCH IS IN HER PURSE?

STORE
ROOM
OF OUR CUSTOMER'S DESIRES

HER CHILDREN

RELIGION
DIFFERENT RELIGIOUS COSMOLOGIES
EVER CYCLING
FORMING/DISSOLVING
GEOMETRICS EXPRESS
PERFECTION

MEMORY
SHE GREW UP IN BRITAIN
SHE CAME FROM UGANDA IN 1972
FROM SOUTH AFRICA - FROM KENYA
FROM PAKISTAN
FROM BANGLADESH
FROM INDIA
HER PARENTS
HER GRANDPARENTS

THIS STUFF SPILLS OUT

WHAT DOES
OUR CUSTOMER
WANT?

MEANS OF
PRODUCTION
OUR SUPPLIERS MIGHT BE IN:
PAKISTAN INDIA
ISLAMABAD MUMBAI
DELHI AHMADABAD
BANARAS
FACTORIES : LABOUR
WORKSHOPS : CRAFTSMEN
WHO WORK
8AM ——→11PM
FOR £45.00 A MONTH APPROX

WHAT FORCES DRIVE HER
TO THIS SHOP?
WHAT FORCES FORM HER
WISHES?

SEQUINS
TINSEL
ELECTRO-
PLATED
THREADS
POLYESTER:
SHE KNOWS
THESE ARE
NOT GOLD
BUT THEY
ARE REMINDERS

L O N G I N G

WHAT IS HER
IDEA
OF
BEAUTY
LIKE A GODDESS?
OR A FILM STAR?
OR HER MOTHER?
BOLLYWOOD?
FILM POSTERS?
FASHION MAGS?
'ASIANA'
'ASIAN WOMAN'
'ASIAN BRIDE'

LANGUAGE
SPEAKING WRITING UNDERSTANDING
FRAMING
THOUGHTS
(LANGUAGE ORGANISES SENSIBILITY)
HINDI GUJERATI PUNJABI URDU BENGALI TAMIL
ENGLISH
'GUJERATI SAMCHAR': GUJERATI NEWS
SONGS
POEMS RHYMES

DOOR
WITH

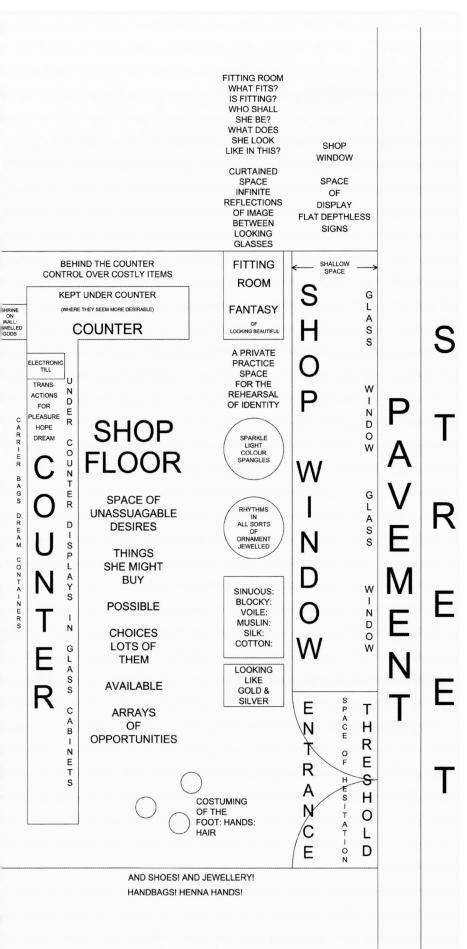

FITTING ROOM
WHAT FITS?
IS FITTING?
WHO SHALL
SHE BE?
WHAT DOES
SHE LOOK
LIKE IN THIS?

SHOP
WINDOW

CURTAINED
SPACE
INFINITE
REFLECTIONS
OF IMAGE
BETWEEN
LOOKING
GLASSES

SPACE
OF
DISPLAY
FLAT DEPTHLESS
SIGNS

BEHIND THE COUNTER
CONTROL OVER COSTLY ITEMS

FITTING
ROOM

SHALLOW
SPACE

KEPT UNDER COUNTER
(WHERE THEY SEEM MORE DESIRABLE)

COUNTER

FANTASY
OF
LOOKING BEAUTIFUL

SHRINE
ON
WALL:
JEWELLED
GODS

ELECTRONIC
TILL

TRANS-
ACTIONS
FOR
PLEASURE
HOPE
DREAM

A PRIVATE
PRACTICE
SPACE
FOR THE
REHEARSAL
OF IDENTITY

SHOP WINDOW

GLASS WINDOW

GLASS WINDOW

GLASS WINDOW

PAVEMENT

STREET

UNDER COUNTER DISPLAYS IN GLASS CABINETS

SHOP
FLOOR

SPACE OF
UNASSUAGABLE
DESIRES

SPARKLE
LIGHT
COLOUR
SPANGLES

THINGS
SHE MIGHT
BUY

RHYTHMS
IN
ALL SORTS
OF
ORNAMENT
JEWELLED

POSSIBLE

CHOICES
LOTS OF
THEM

SINUOUS:
BLOCKY:
VOILE:
MUSLIN:
SILK:
COTTON:

AVAILABLE

LOOKING
LIKE
GOLD &
SILVER

ARRAYS
OF
OPPORTUNITIES

CARRIER BAGS DREAM CONTAINERS

COUNTER

COSTUMING
OF THE
FOOT: HANDS:
HAIR

ENTRANCE

SPACE OF HESITATION

THRESHOLD

AND SHOES! AND JEWELLERY!
HANDBAGS! HENNA HANDS!

147
Left:
South Asian Textile Retail Outlet: A Diagram
Helen Scalway
Digital drawing, 2008–9
This work exploits the cool, quantifying qualities of an architectural plan to hold the unquantifiable desires, reconstructions of memory and presentations of identity contained in a characteristic South Asian textile shop in London.

148
Following pages:
Johari's Window Opens on a Colonial Psyche
Helen Scalway
Digital drawing, 2008–9
This diagram is an attempt to bring a manifestation of a colonial psyche – a collection of Indian textiles of the late nineteenth century – into relation with Luft and Ingham's visual model, known in cognitive psychological practice as 'Johari's Window'. In the open arena is the shared perception that self and others both have; in the façade are the perceptions of self known only to the self, not immediately revealed to others; in the blind spot there is the perception of the self by others, not known to the self; and in the unknown area is the area of self unknown to self or others.

Johari's Window opens on a colonial textile collecting psyche

OPEN

In this window are some perceptions that both the colonial British self, and some others, might share about that colonial self as it organises the India Museum

'The Industrial Revolution has filled our manufacturing cities with noise, chimneys, soot. Some of us are distressed by the loss of our connection to a more natural world.'

'The Great Exhibition of 1851 at the Crystal Palace showed us how awful our design for manufacture has become. We need Beauty.'

'Mechanisation enables the mass production of goods which make some of us rich. The goods are frequently hideous. Where can we find authentically good design for our new industrial world?'

'India is the home of authentic textile design produced in distant rural villages, innocent of big-city wickedness and mechanisation. The India Museum is educational. It exists to raise standards.'

'Items are removed from their contexts the better to study the design principles which they embody.'

'We must classify, we must have order, reason, clarity. This shows our modernity, distinguishing our work from pre-modern superstition and chaos.'

'But we also believe in God, who validates our endeavours. Of course we are divinely called to rule our Empire.'

FAÇADE/ HIDDEN

In this window are some private perceptions that the colonial British self might entertain about itself as it organises the India Museum. It does not share these with others.

'The Empire keeps us rich and India is a huge contributor to Empire. India is a fount of lovely designs which we can appropriate for our manufactured goods and India is also a huge market in which to sell them! How fortunate!'

'We middle class men become anxious ourselves when the lower orders feel times are too hard. We have a right to do anything we can to stimulate British industry.'

'It's such a shame that the effect of our exporting to India seems to have been to destroy the Indian talent for design. Can this be our fault? We fear it might be. Oh dear, oh dear.'

BLIND

In this window are some perceptions of the colonial British self as perceived by others, and to which many British in 1880 are blind.

'British cotton is hated. It is creating starvation in textile communities in India.'

'Those British – they see Indian textiles as part of a pattern of 'oriental' luxury and sensuality – but in this exoticising they are merely licensing their own secret desires and constructing their own imaginary India as an place in which to play out their own fantasies.'

'The British colonial passion for display is a way of asserting their status, and so possessing. Indian princes do the same, they assert their status through lavish ornament. But these British are not Indian princes. They come from far away.'

UNKNOWN

In this window is material which might not yet be consciously acknowledged by the British colonial self, nor is it yet visible to others.

'The industrial world is uncontrollable. It spews forth objects! We are spinning out of control! We must classify, order, archive. We are rational, scientific, modern. We are not like those distant others, such as Indians, whose handiwork we classify, no, no. We must not be! But we are never quite sure…'

'We long for authenticity. So much in our cities is mass-produced in loveless circumstances. Machine-made! Clackety-clack! Our lives are noisy but haunted… We need a memory we can inhabit, but it has gone… We are drawn to visit and revisit these artefacts made by peasants in the rural villages of distant India.'

'And we just adore the ornaments of hierarchy: cloth of gold, rich embroidery, silks, muslins. Makes so much sense within our own class system!'

'Mmm, textile, textiles… silk, airy muslin, fresh cotton… mmm, so tactile. We love touching them with our hands and with our eyes as well.
Perhaps…just perhaps… they will trigger memories of a tactile world we have lost.

'Oh! Those innocent far-off places! So different from Bethnal Green… and Manchester… O, may we be saved from our poor…'

149
*Jewellery Counter, British South Asian Textile
Shop*
Helen Scalway
Pencil and watercolour on paper, 2008–9

150
Shop Fitting Room, British South Asian Textile Shop
Helen Scalway
Pencil and watercolour on paper, 2008–9
Fitting rooms are often mere cubicles
but this one has expanded to house a
mirror reminiscent of a cinema screen
in which reflections suggest Hollywood/
Bollywood glamour.

151
Opposite:
Heraldic lions ornamenting interior
tilework at the Victoria and Albert
Museum, South Kensington, London

152
Right, above:
'British' Lion 1
Helen Scalway
Digital photography, calico, collage,
2008–9
This is an image from Scalway's artist's
book entitled *Some of Albert's Beasts at
the V&A*. A number of the ornamental
heraldic animals, ancient emblems of
hierarchical power found inside and
outside the V&A buildings, are collaged
with various South Asian textiles.

153
Right, below:
'British' Lion 2
Helen Scalway
Digital photography, calico, collage,
2008–9
Another page from *Some of Albert's Beasts
at the V&A*, collaged with various South
Asian textiles.

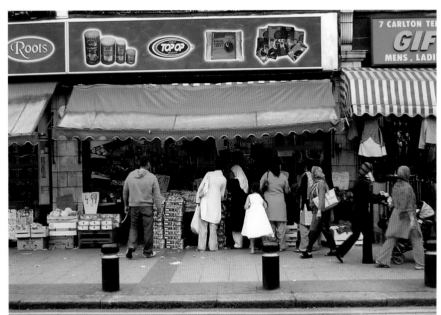

154
Left: Green Street, Newham, London, 2008–9
A suburban London street with British Asian shops selling clothing, food, music, and jewellery.

155
Below: Entrance, Victoria and Albert Museum, South Kensington, London, 2008–9

156
Flats near Green Street, E7
Helen Scalway
Collage, digital photographs, 2009
An image created by juxtaposing a
photograph of severely rational mass
housing, in the international modern
style, with a textile sold in a British Asian
shop nearby, speaking of a quite different
sensibility.

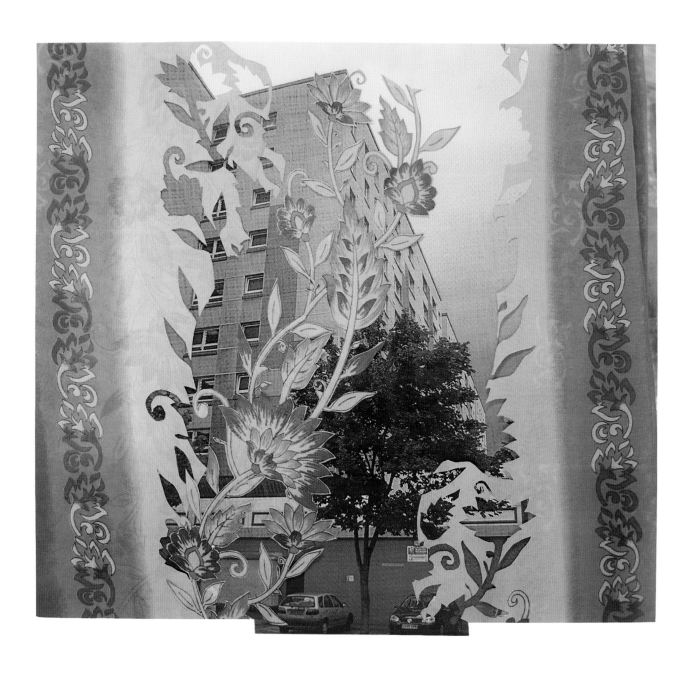

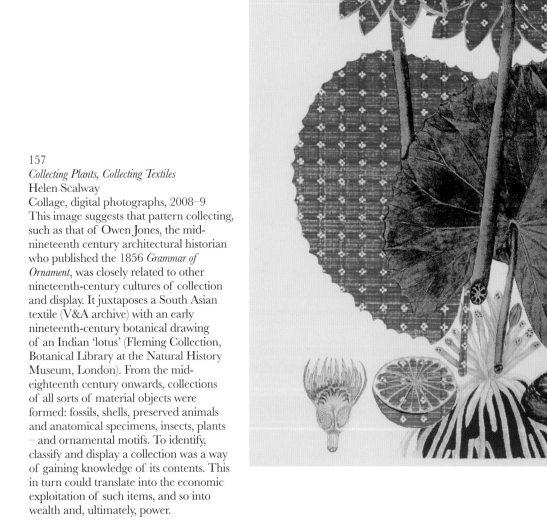

157
Collecting Plants, Collecting Textiles
Helen Scalway
Collage, digital photographs, 2008–9
This image suggests that pattern collecting,
such as that of Owen Jones, the mid-
nineteenth century architectural historian
who published the 1856 *Grammar of
Ornament*, was closely related to other
nineteenth-century cultures of collection
and display. It juxtaposes a South Asian
textile (V&A archive) with an early
nineteenth-century botanical drawing
of an Indian 'lotus' (Fleming Collection,
Botanical Library at the Natural History
Museum, London). From the mid-
eighteenth century onwards, collections
of all sorts of material objects were
formed: fossils, shells, preserved animals
and anatomical specimens, insects, plants
– and ornamental motifs. To identify,
classify and display a collection was a way
of gaining knowledge of its contents. This
in turn could translate into the economic
exploitation of such items, and so into
wealth and, ultimately, power.

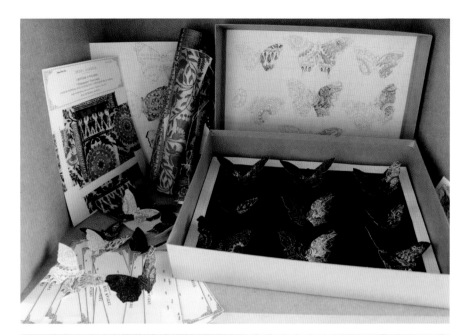

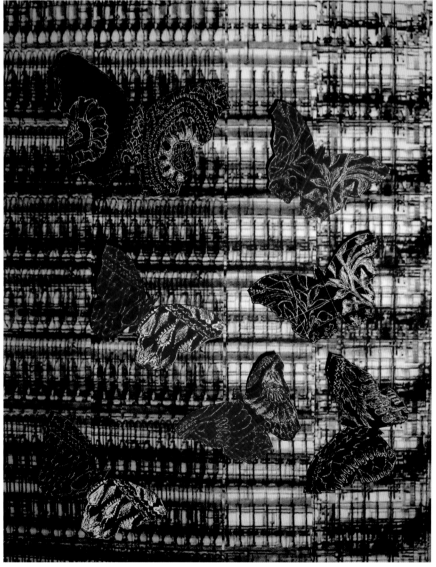

158
Above:
Collecting Butterflies, Collecting Textiles
Helen Scalway
Digital photographs, cardboard box,
2008–9
Nineteenth-century collectors created
systematic displays of insects including
butterflies, housing them in cabinets and
boxes. However, the patterns of each
butterfly in this box are derived from
textile samples gathered by the nineteenth-
century collector John Forbes Watson,
whose sample books are housed in the
V&A archive.

159
Below:
Black Butterflies
Helen Scalway
Digital drawing, digital photography,
2008–9
In the mid-nineteenth century South
Asian textile patterns were often exploited
by the cotton-mill owners of Lancashire,
whose engines blackened the cities of the
North. In this image, textile butterflies find
themselves in a new and unnatural habitat,
the factory, and have turned soot black.

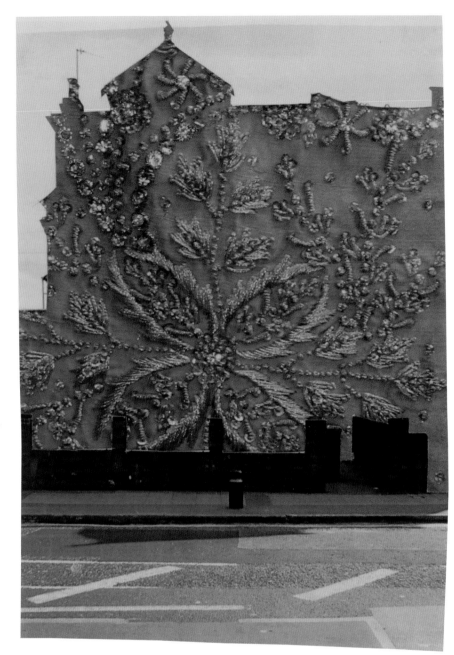

160
House near Green Street, E7
Helen Scalway
Collage, digital photographs, 2008–9
An image created by juxtaposing a
photograph of a London suburban house
with a textile sold in a British Asian shop
nearby.

161
At the Museum: Diorama 1
Helen Scalway
Collage, digital photographs, cardboard
box, 2008–9
In this diorama the imposing Ceramic
Staircase at the V&A is disrupted by a
(hugely enlarged) embroidered flower
on a textile from the V&A's South Asian
Collection in the Nehru Gallery. The
diorama is presented as though in an
archive box, a scene revealed when the
box is opened.

162
At the Museum: Diorama 2
Helen Scalway
Collage, digital photographs, cardboard
box, 2008–9
A diorama in which the National Art
Library, with its suggestions of an
authoritative framing of knowledge, is
disturbed by an ornamental flower on
a textile from the V&A's South Asian
Collection in the Nehru Gallery.

163
At the Museum: Diorama 3
Helen Scalway
Collage, digital photographs, cardboard
box, 2008–9
The V&A's great collection of South Asian
textiles is stored in a severely functional,
rational system of storage units, such as
might also be used in a different institution
to house medical or legal records. This
essentially modernist system, the rationale
for which is efficiency, is disturbed here
by the eruption of an exquisite piece of
South Asian 19th-century beetle wing
embroidery, housed in one of the units
but coming from a culture dominated
by imperatives other than the 'purely'
rational. Ideas surrounding the return
of something repressed are also at work
in this piece: there is a haunting of the
functional storage units by the quite
different world of their contents.

notes

Introduction

1. John Hutnyk, *Critique of Exotica: Music, Politics and the Culture Industry* (London, Pluto Press, 2000) and Graham Huggan, *The Postcolonial Exotic: Marketing the Margins* (London, Routledge, 2001).
2. Joanne Eicher, *Dress and Ethnicity: Change Across Space and Time* (Oxford, Berg, 1995); Margaret Maynard, *Dress and Globalisation* (Manchester University Press, 2004); Parminder Bhachu, *Dangerous Designs: Asian Women Fashion the Diaspora Economies* (London, Routledge, 2004); Robert Ross, *Clothing: A Global History* (London, Polity, 2008); Eugenia Paulicelli and Hazel Clark (eds), *The Fabric of Cultures: Fashion, Identity and Globalization* (London, Routledge, 2009); Giorgio Riello and Prasannan Parthasarathi (eds), *The Spinning World: A Global History of Cotton Textiles* 1200-1850 (Oxford University Press, 2009).

Textiles

The Golden Age of the Indian Textile Trade

1. K. N. Chaudhuri, *The Trading World of Asia and the English East India Company* (Cambridge University Press, 1978), p.282. See also A. Farrington, *Trading Places: The East India Company and Asia 1600-1834* (London, British Library, 2002), p.69.
2. See for example John Irwin and Katherine Brett, *Origins of Chintz* (London, HMSO, 1970); Beverley Lemire, *Fashion's Favourite: the cotton trade and the consumer in Britain 1660-1800* (Oxford University Press, 1991) and Rosemary Crill, *Chintz. Indian Textiles for the West* (London, V&A Publishing, 2008).
3. Anne Buck, *Dress in Eighteenth-Century England* (New York, Holmes & Meier, 1979), p.113. The same complaint – that too wide a spread of society was able to wear fashionable dress – had also been used about imported Asian silks in the early sixteenth century (see G. Riello and B. Lemire, *East and West: Textiles and Fashion in Eurasia in the Early Modern Period*, Working Papers of the Global Economic History Network (GEHN), Number 22/06 [London, LSE, 2006], p.11).
4. John Styles, *The Dress of the People. Everyday fashion in eighteenth-century England* (New Haven and London, Yale University Press, 2007), pp.110–11.
5. Fully published in facsimile by Nathalie Rothstein, *Barbara Johnson's Album of Fashions and Fabrics* (London, Thames & Hudson, 1987).
6. Styles 2007, pp.114–22.

7. See ibid., pls 51 and 52, for two Indian chintz fragments.
8. Jayne Shrimpton, 'Dressing for a Tropical Climate: The Role of Native Fabrics in Fashionable Dress in Early Colonial India', in *Textile History*, vol. 23 (1), 1992, p.60.
9. Ibid., fig.4.
10. John Irwin, *The Kashmir Shawl* (London, HMSO, 1973), p.19.
11. Ibid., plate 12.
12. Monique Levi-Strauss, *The Cashmere Shawl* (New York, Abrams, 1988), p.19.
13. See N. Tromans (ed.), *The Lure of the East. British Orientalist Painting* (London, Tate Publishing, 2008), fig.53.
14. See Veronica Murphy's study of the handkerchief trade in V. Murphy and R. Crill, *Tie-Dyed Textiles of India* (London, V&A Publishing, 1991), and especially figs 67–76 for a selection of British paintings of the late eighteenth century showing people wearing spotted bandannas. See also Susan S. Bean, 'Bengal Goods for America in the Nineteenth Century' in R. Crill (ed.), *Textiles from India: the Global Trade* (Kolkata, Seagull Books, 2006), pp.217–32 and ibid., *Yankee India. American Commercial and Cultural Encounters with India in the Age of Sail 1784-1860* (Salem, MA and Ahmedabad, Peabody Essex Museum and Mapin Publishing Pvt. Ltd, 2001), especially pp.67–77.
15. See for example 'A Striking View of Richmond' of 1810, showing the prize-fighter of that name, in Murphy and Crill 1991, fig.75.
16. John Forbes Watson, *The Textile Manufactures and Costumes of the People of India* (London, Wm. Allen & Co., 1867), p.2.

From Gujarat to TopShop

1. www.katemosstopshop.com (retrieved 6 May 2008).
2. R. Crill, *Chintz. Indian Textiles for the West* (London, 2008), p.8.
3. See V. Elson, *Dowries from Kutch* (Los Angeles, 1979), pp.11–19; J. Irwin and Margaret Hall, *Indian Embroideries* (Ahmedabad, 1973), pp.73–165.
4. Sri Rabari Samaj, *Bandharano ni Thadi* (Anjar, 1995), pp.1–4.
5. D. Eck, *Darsan. Seeing the Divine Image in India* (New York, 1998), pp.10–31.
6. Personal communication, Arjanbhai Rabari, Dhebaria council member, 21.6.97.
7. Pers. comm., Vanka Kana Rabari, 26.6.97.
8. Pers. comm., Arjanbhai Rabari, 21.6.97. At the time of the interview, the average daily wage for a farm labourer – work

done by many Rabaris – was about 50 rupees a day, thus a dowry costing 70,000 rupees represents 1,400 days' work, or over three and a half years' work.

9. W. Menski (ed.), Introduction, *South Asians and the Dowry Problem* (New Delhi, 1998), pp.1–20.

10. T. Veblen, *The Theory of the Leisure Class* (London, 2007).

11. P. Gooch, *At the Tail of the Buffalo: Van Gujjar Pastoralists Between the Forest and the World Arena* (Lund, 1998), p.42.

12. M. Gadgil and Ramachandra Guha, *This Fissured Land: An Ecological History of India* (Delhi, 1992), p.183.

13. Many Rabaris believe that money spent on girls' education is wasted as their future role is that of wife and mother for which formal education is deemed to be unnecessary. The staff at the Ashramshala Anjar have been campaigning for the education of girls since 1993 and girls at that school now represent a third of the student body. Pers. comm., Kantibhai Ros, Principal, Rabari Ashramshala Anjar, 26.12.08.

14. Emma Tarlo describes a comparable change in attitude to embroidery in Saurashtra in the late 1980s; the remoteness of Kutch has meant that the process of change has been far slower. See E. Tarlo, *Clothing Matters. Dress and Identity in India* (London, 1996), pp.202–50.

15. A. McGowan, *Crafting the Nation in Colonial India* (New York, 2009), pp.198–203.

16. GSHDC, *A Note on the Working of the Gujarat State Handicrafts Development Corporation Limited* (Gandhinagar, no date), p.2.

17. Pers. comm., Nazeer Weldingwala, dealer in antique textiles, 18.8.01.

18. E. Tarlo, 'The Genesis and Growth of a Business Community: A Case Study of Vaghri Street Traders in Ahmedabad', in P. Cadene and D. Vidal, *Webs of Trade. Dynamics of Business Communities in Western India* (New Delhi, 1997), pp.53–84.

19. Pers. comm., Sariyaben, embroiderer, 23.8.03.

20. Pers. comm., Pankaj Shah, Kutch Mahila Vikas Sangathan (NGO), 13.7.02.

21. It has proved difficult to obtain precise figures for women working for NGOs in Kutch at any one time as the numbers fluctuate week by week. In 2002 KMVS estimated their membership to be about 4,000; Chandaben Shroff, founder of the Shrujan Trust, said that the Trust's embroiderers numbered over 3,000 but emphasized that over 18,000 women had been trained by the Trust since it was established (1968–9). Pers.

comm., Chandaben Shroff, 12.7.02.

22. C. Kwon and M. Raste, *Through the Eye of a Needle. Stories from an Indian Desert* (Vancouver, 2002).

23. Pers. comm., Prabhat Raja Rabari, teacher, 26.12.08.

Styles

The South Asian Twist in British Muslim Fashion

1. The Arabic word *hijab* has entered popular vocabulary in Britain and Europe where it is commonly used to refer to the headscarves worn by some Muslim women. However, where the word is used in the Qur'an it refers not to a piece of cloth but to a set of ideas about separation, screening and keeping things apart. For wider discussion of the popularization and transformation of the *hijab* in Britain, including discussion of vocabulary, see Emma Tarlo, *Visibly Muslim: Fashion, Politics, Faith* (Oxford, Berg, 2010).

2. I am grateful to Norface for supporting this research as part of a larger collective project on the emergence of Islamic fashion in Europe. My thanks also to research participants who contributed their time and images, and to Elisabeth Scheder-Bieschin for contributing photographs.

Hippies, Bohemians & Chintz

1. *Boteh*: a decorative floral motif, sometimes referred to as a 'cone pattern'.

2. 'Raj': British governance of the Indian subcontinent from 1858, when the government took over from the East India Company, to Indian independence in 1947.

3. Verity Wilson, 'Western Modes and Asian Clothes: Reflections on Borrowing Other People's Dress', *Costume* (2002), vol.36, pp.139–57. See also Emma Tarlo, *Clothing Matters: Dress and Identity in India* (London, 1996) for a fuller account of dress in British India.

4. Nicola Thomas, 'Embodying Empire: dressing the Vicereine, Lady Curzon, Vicereine of India 1898–1905', *Cultural Geographies* (2007), 14:3, pp.369–400.

5. Tony Glenville and Amy de la Haye, 'Bohemian', in *The Cutting Edge: 50 Years of British Fashion, 1947-1997* (London, 1996), p.95.

6. Dianne Sachko Macleod, 'Cross-cultural cross-dressing: class, gender and modernist sexual identity', in Julie F. Codell and Dianne Sachko Macleod (eds), *Orientalism Transposed: The Impact of the Colonies on British Culture* (Aldershot, 1998), pp. 63–85; Elizabeth

Wilson, *Bohemians: The Glamorous Outcasts* (London, 2000), pp.128–9, 169–70.

7. The author thanks Deirdre McSharry for drawing attention to this garment.

8. Richard Martin and Harold Koda, *Orientalism: Visions of the East in Western Dress* (New York, 1994), pp.35–6.

9. Oriole Cullen, *Hats: An Anthology by Stephen Jones* (London, 2009), pp.92–3.

10. British *Vogue*, February 1948, pp.56–9.

11. Martin and Koda 1994, pp.35–49.

12. Debutantes were no longer presented at Court after 1958, but the Social Season persisted.

13. Interview with Jane Ormsby Gore, V&A, March 2006 (retrieved 7.10.09): www.vam.ac.uk/collections/fashion/features/1960s/interviews/ormsbygore_interview/index.html

14. Interview with Robert Orbach, V&A, February 2006 (retrieved 7.10.09): www.vam.ac.uk/collections/fashion/features/1960s/interviews/orbach_interview/index.html

15. British *Vogue*, January 1969, pp.16–27.

16. An example is in the V&A collections: T. 900-2000.

17. Sabine Durrant, 'The Natty Professor', *Daily Telegraph*, 2.12.06.

18. *Mashru*, or 'permitted' cloth, was originally woven for Muslim men who were prohibited from wearing pure silk. The satin weave fabric combines a cotton weft in contact with the skin and silk warp showing on the surface.

19. Interview with designer, 19.9.09.

20. Interview with designer, 22.9.09.

21. www.monsoon.co.uk/page/monsoonhistory (retrieved 7.10.09).

22. Claire Dwyer and Peter Jackson, 'Commodifying Difference: selling EASTern fashion', in *Environment and Planning D- Society and Space* (2003), 21:3, pp.269–91.

23. See War on Want's report, *Fashion Victims II* (2009), retrieved 19.10.09: www.waronwant.org/attachments/Fashion%20Victims%20II.pdf; see also Labour Behind the Label's report, *Let's Clean Up Fashion* (2009), retrieved 19.10.09: www.labourbehindthelabel.org/images/pdf/letscleanupfashion2009.pdf

24. Michiel Scheffer, 'Fashion design and technologies', in Eugenia Paulicelli and Hazel Clark (eds), *The Fabric of Cultures: Fashion, Identity and Globalization* (London and New York, 2009), pp.128–44.

25. See Helen Scalway's account of this practice (retrieved 7.10.09): www.vam.ac.uk/vastatic/microsites/1750_scalway/blog/?m=200804

Banyans, Smoking Jackets & Suit Linings

1. www.pepysdiary.com/archive/1661/07/01 (retrieved 19.02.10).

2. www.pepysdiary.com/archive/1666/03/30 (retrieved 19.02.10).

3. David Kuchta, *The Three-Piece Suit and Modern Masculinity: England 1550-1850* (Berkeley, University of California Press, 2002).

4. Alison Settle, *English Fashion* (London, Collins, 1948), p.48.

5. Peter York, 'Icons of Identity', *Country Life*, 1 February 1996, pp.28–31.

6. Stuart Hall, 'Culture, Community, Nation', in D. Boswell and J. Evans (eds), *Representing the Nation: A Reader* (London, Routledge, 1999), p.42.

7. Karen Hearn (ed.), *Van Dyck & Britain* (London, Tate Publishing, 2009), p.98.

8. Rosemary Crill, *Chintz: Indian Textiles for the West* (London, V&A Publishing, 2009), p.16.

9. Avril Hart and Susan North, *Seventeenth- and Eighteenth-Century Fashion in Detail* (London, V&A Publishing, 2009), p.130.

10. Jason Thompson, 'Edward William Lane', in H. C. G. Matthew & Brian Harrison (eds), *Oxford Dictionary of National Biography* (Oxford University Press, 2004), vol.32, pp.418–20.

11. Christine Riding, 'Travellers and Sitters: The Orientalist Portrait', in Nicholas Tromans (ed.), *The Lure of the East: British Orientalist Painting* (London, V&A Publishing, 2008), pp.48–61.

12. Diane Maglio, 'Luxuriant Crowns: Victorian Men's Smoking Caps, 1850-1890', in *Dress: The Journal of the Costume Society of America*, vol. 27, 2000, pp.9–17.

13. Sukhdev Sandhu, *London Calling: How Black and Asian Writers Imagined a City* (London, Harpers, 2003), pp.71–105.

14. Thomas Burke, *Nights in Town: A London Autobiography* (London, George Allen, 1915), pp.84–5.

15. Helen Callaway, 'Dressing for Dinner in the Bush: Rituals of Self-Definition and British Authority', in Ruth Barnes and Joanne B. Eicher (eds), *Dress and Gender: Making and Meaning* (Oxford, Berg, 1992), pp.232–47. See also J. MacKenzie (ed.), *Imperialism and Popular Culture* (Manchester University Press, 1986).

16. Sonia Ashmore, 'London as Fashion Cosmopolis', in Christopher Breward and David Gilbert (eds), *Fashion's World Cities* (Oxford, Berg, 2006), p.209.

Spaces

From Suitcase to Showroom

1. See P. Bhachu, *Dangerous Designs: Asian Women Fashion the Diaspora Economies* (London, Routledge, 2004).
2. P. Jackson, P. Crang and C. Dwyer (eds), *Transnational Spaces*, (London, Routledge 2004); P. Crang, C. Dwyer and P. Jackson, 'Transnationalism and the spaces of commodity culture', *Progress in Human Geography* 27 (2003), pp.438–56.
3. The research was undertaken as part of a project, 'Commodity culture and South Asian transnationality', funded by the Economic and Social Research Council as part of the Transnational Communities programme (award no. L214252031) and undertaken in collaboration with Philip Crang and Peter Jackson.
4. Mayur Shah, quoted in N. Khan, 'Asian women's dress: from burqah to Bloggs', in J. Ash and E. Wilson (eds), *Chic Thrills: A Fashion Reader* (Berkeley, University of California Press, 1992), pp.61–74.
5. See E. Tarlo, *Clothing Matters: Dress and Identity in India* (London, Hurst & Co. Publishers, 1996).
6. See R. Kumar, *Costumes and Textiles of Royal India* (London, Antique Collector's Club, 2005), second edition.
7. M. Banerjee and D. Miller, *The Sari* (Oxford, Berg, 2003).
8. Bhachu 2004.
9. Khan 1992.
10. Bhachu 2004.
11. S. Hall, 'New Ethnicities', in J. Donald and A. Rattansi (eds), *'Race', Culture and Difference* (London, Sage, 1992).
12. Bhachu 2004; see also C. Dwyer, 'Tracing transnationalities through commodity culture: a case study of British-South Asian fashion', in Jackson, Crang and Dwyer 2004.
13. N. Puwar, 'Multicultural fashion … stirrings of another sense of aesthetics and memory', *Feminist Review* 71 (2002), pp.63–87; J. Hutnyk, *Critique of Exotica: Music, Politics and the Culture Industry* (London, Pluto Press, 2000).
14. Bhachu 2004, p.103.

Exhibiting South Asian Textiles

1. Paul Greenhalgh, *Ephemeral Vistas: The Expositions Universelles, Great Exhibitions and World's Fairs, 1851-1939* (Manchester University Press, 1988), p.62.
2. Ray Desmond, *The India Museum*, 1801-1879 (London, HMSO, 1982), p.94.
3. For further discussion of the India Museum sample books, see Felix Driver and Sonia Ashmore, 'The mobile museum: collecting and circulating Indian textiles in Victorian Britain', in *Victorian Studies*, vol. 52 (2010) [in press].
4. Forbes Watson, in Driver and Ashmore 2010.
5. *Blackwoods Magazine*, in Sonia Ashmore, 'Owen Jones' *Grammar of Ornament*, textile and wallpaper designs, and the V&A's Indian textile collections', *V&A Online Journal*, 1, 2008, p.1.
6. Ashmore 2008.
7. Tim Barringer, *Men at Work: Art and Labour in Victorian Britain* (New Haven, Yale University Press, 2005).
8. See Driver and Ashmore 2010 for an account of Purdon Clarke's trip, and his subsequent orchestration of the Indian displays at the 1886 Colonial and Indian Exhibition.
9. Saloni Mathur, *India by Design: Colonial History and Cultural Display* (Berkeley, University of California Press, 2007), ch.2.

South Asian Patterns in Urban Spaces

1. More information on the exhibition *Moving Patterns* can be found at www.vam.ac.uk/vastatic/microsites/1750_scalway/blog

select bibliography

Ashmore, Sonia, 'Owen Jones' *Grammar of Ornament*, textile and wallpaper designs, and the V&A's Indian textile collections', *V&A Online Journal* 1 (2008).

Banerjee, Mukulika and Daniel Miller, *The Sari* (Oxford, 2003).
Barringer, Tim, *Men at Work: Art and Labour in Victorian Britain* (New Haven, 2005).
Bhachu, P., *Dangerous Designs: Asian Woman Fashion the Diaspora Economies* (London and New York, 2004).
Breckenridge, Carol, 'The aesthetics and politics of colonial collecting: India at world fairs', *Comparative Studies in Society and History* 31 (1989), pp.195–216.

Crang, Philip, Claire Dwyer and Peter Jackson, 'Transnationalism and the spaces of commodity culture', in *Progress in Human Geography* 27 (2003), pp.438–56.
Crill, Rosemary, *Chintz. Indian Textiles for the West* (London, 2008).
Cullen, Oriole, *Hats: An Anthology by Stephen Jones* (London, 2009).

Desmond, Ray, *The India Museum, 1801-1879* (London, 1982).
Dewan, Deepali, 'Scripting South Asia's visual past: the Journal of Indian Art and Industry and the production of knowledge in the late nineteenth century', in Julie Codell (ed.), *Imperial Co-Histories: National Identities and the British and Colonial Press* (London, 2003), pp.29–44.
Driver, Felix and Sonia Ashmore, 'The mobile museum: collecting and circulating Indian textiles in Victorian Britain', *Victorian Studies* 52 (2010).
Dwyer, Claire and Peter Jackson, 'Commodifying Difference: selling EASTern fashion', in *Environment and Planning D- Society and Space* 21:3 (2003), pp.269–91.
Dwyer, Claire, 'Tracing transnationalities through commodity culture: a case study of British-South Asian fashion', in P. Jackson, P. Crang, and C. Dwyer (eds), *Transnational Spaces* (London, 2004).

Eicher, Joanne, *Dress and Ethnicity: Change Across Space and Time* (Oxford, 1995).
Entwistle, Joanne, *The Fashioned Body: Fashion, Dress and Modern Social Theory* (Cambridge, UK and Maryland, US, 2000).
Eck, Diana, *Darsan. Seeing the Divine Image in India* (New York, 1998).
Elson, Vicky, *Dowries from Kutch* (Los Angeles, 1979).

Fryer, Peter, *Staying Power: The History of Black People in Britain* (London, 1984).

Gadgil, Madhav and Ramachandra Guha, *This Fissured Land: An Ecological History of India* (Delhi, 1992).
Gilroy, Paul, *There Ain't No Black In The Union Jack* (London, 1987).
Glenville, Tony and Amy de la Haye, 'Bohemian', in *The Cutting Edge: 50 Years of British Fashion, 1947-1997* (London, 1996), pp.92–113.
Gooch, P., *At the Tail of the Buffalo: Van Gujjar Pastoralists Between the Forest and the World Arena* (Lund, 1998).
Greenhalgh, Paul, *Ephemeral Vistas: The Expositions Universelles, Great Exhibitions and World's Fairs, 1851-1939* (Manchester, 1988).
GSHDC, *A Note on the Working of the Gujarat State Handicrafts Development Corporation Limited* (Gandhinagar, no date).

Hall, Stuart, 'New Ethnicities', in J. Donald and A. Rattansi (eds), *'Race', Culture and Difference* (London, 1992).
Huggan, Graham, *The Postcolonial Exotic: Marketing the Margins* (London, 2001).
Hutnyk, John, *Critique of Exotica: Music, Politics and the Culture Industry* (London, 2000).

Irwin, John and Margaret Hall, *Indian Embroideries* (Ahmedabad, 1973).

Jackson, Peter, Philip Crang, and Claire Dwyer (eds), *Transnational Spaces* (London, 2004).

Khan, Naseem, 'Asian women's dress: from burqah to Bloggs', in J. Ash and E. Wilson (eds), *Chic Thrills: A Fashion Reader* (Berkeley, 1992), pp.61–74.
Kriegel, Lara, *Grand Designs: Labor, Empire and the Museum in Victorian Culture* (Durham, NC, 2007).
Kumar, Ritu, *Costumes and Textiles of Royal India* (London, 2005), 2nd edition.
Kwon, Charlotte and Meena Raste, *Through the Eye of a Needle. Stories from an Indian Desert* (Vancouver, 2002).

Macleod, Dianne Sachko, 'Cross-cultural cross-dressing: class, gender and modernist sexual identity', in Julie F. Codell and Dianne Sachko Macleod (eds), *Orientalism Transposed: The Impact of*

the Colonies on British Culture (Aldershot, 1998), pp.63–85.

Malik, Sarita, *Representing Black Britain: Black and Asian Images on Television* (London, 2002).

Martin, Richard and Harold Koda, *Orientalism: Visions of the East in Western Dress* (New York, 1994).

Mathur, Saloni, *India by Design: Colonial History and Cultural Display* (Berkeley, 2007).

Maynard, Margaret, *Dress and Globalisation* (Manchester, 2004).

McGowan, Abigail, *Crafting the Nation in Colonial India* (New York, 2009).

Menski, W. (ed.), 'Introduction', in *South Asians and the Dowry Problem* (New Delhi, 1998), pp.1–20.

Mitter, Partha and Craig Clunas, 'The empire of things: the engagement with the Orient', in Malcolm Baker and Brenda Richardson (eds), *A Grand Design: The Art of the Victoria and Albert Museum* (London, 1997), pp.221–37.

Paulicelli, Eugenia and Hazel Clark (eds), *The Fabric of Cultures: Fashion, Identity and Globalization* (London and New York, 2009).

Puwar, Nirmal, 'Multicultural fashion … stirrings of another sense of aesthetics and memory', *Feminist Review* 71 (2002), pp.63–87.

Riello, Giorgio and Prasannan Parthasarathi (eds), *The Spinning World: a Global History of Cotton Textiles* 1200–1850 (Oxford, 2009).

Ross, Karen, *Black and White Media: Black Images in Popular Film and Television* (Oxford, 1996).

Ross, Robert, *Clothing: A Global History* (London, 2008).

Samaj, Sri Rabari, *Bandharano ni Thadi* (Anjar, 1995).

Scheffer, Michiel, 'Fashion design and technologies', in Eugenia Paulicelli and Hazel Clark (eds), *The Fabric of Cultures: Fashion, Identity and Globalization* (London and New York, 2009), pp.128–44.

Swallow, Deborah, 'The India Museum and the British-Indian textile trade in the late nineteenth century,' *Textile History* 30 (1999), pp.29–45.

Tarlo, Emma, *Clothing Matters: Dress and Identity in India* (London, 1996).

Tarlo, Emma, 'The Genesis and Growth of a Business Community: a Case Study of Vaghri Street Traders in Ahmedabad', in P. Cadene and D. Vidal, *Webs of Trade. Dynamics of Business Communities in Western India* (New Delhi, 1997), pp.53–84.

tarlo, Emma, *Visibly Muslim: Fashion, Politics, Faith* (Oxford, 2010)

Thomas, Nicola, 'Embodying Empire: dressing the Vicereine, Lady Curzon, Vicereine of India 1898–1905', *Cultural Geographies* 14: 3 (2007), pp.369–400.

Veblen, Thorstein, *The Theory of the Leisure Class* (London, 2007).

Wilson, Elizabeth, *Bohemians: The Glamorous Outcasts* (London, 2000).

Wilson, Verity, 'Western Modes and Asian Clothes: Reflections on Borrowing Other People's Dress', *Costume* 36 (2002), pp.139–57.

Woodward, Sophie, *Why Women Wear What They Wear* (Oxford, 2007).

acknowledgements & picture credits

The Editors would like to thank the Arts and Humanities Research Council for its support of this publication, completed as part of the Diasporas, Migration and Identities Programme. We are grateful to all the contributors for their insightful work. Particular thanks go to the publishing team, Anjali Bulley, Denny Hemming, Christina Borsi and David Bothwell who have produced an engaging and innovative book in extraordinary circumstances.

author biographies

Sonia Ashmore is a design historian. As a Research Fellow at the Victoria and Albert Museum, London, she has published research on its South Asian textile collections.

Christopher Breward is Head of Research at the Victoria and Albert Museum. He was a member of the Arts & Humanities Research Council's Fashioning Diaspora Space research team and has published widely on the history and theory of fashion.

Philip Crang is Professor of Cultural Geography at Royal Holloway, University of London (RHUL). Between 2007 and 2010 he directed the Fashioning Diaspora Space research collaboration between RHUL and the Victoria and Albert Museum.

Rosemary Crill is Senior Curator in the Asian Department at the Victoria and Albert Museum. Her recent publications include *Chintz: Indian Textiles for the West* (2008) and *The Indian Portrait 1560–1860* (2010, with Kapil Jariwala).

Shivani Derrington is a PhD student at Royal Holloway, University of London, funded by the Arts and Humanities Research Council. Her doctoral research focuses on South Asian women's dress practices in Britian.

Felix Driver is Professor of Human Geography at Royal Holloway, University of London. He is the author of *Geography Militant* (2001) and co-editor of *Imperial Cities* (1999) and *Tropical Visions in an Age of Empire* (2005).

Rajinder Dudrah is Head of Department of Drama and Senior Lecturer in Screen Studies at the University of Manchester. His publications include *Bollywood: Sociology Goes to the Movies* (2006), *Bhangra: Birmingham and Beyond* (2007) and *The Bollywood Reader* (2008). He is one of the founding co-editors of the journal *South Asian Popular Culture*.

Claire Dwyer is a Senior Lecturer in Social and Cultural Geography at University College, London, where she is Deputy Director of the Migration Research Unit.

Eiluned Edwards is a Senior Lecturer in Design and Visual Culture at Nottingham Trent University. She was previously a Senior Research Fellow at the Victoria and Albert Museum/London College of Fashion. The author of *The Textiles and Dress of Gujarat* (2010 forthcoming), her current research focuses on the textiles and dress of western India.

Gavin Fernandes is a photographer, stylist and Senior Lecturer at London College of Fashion. He has exhibited in London at the Victoria and Albert Museum (1994); Photographers' Gallery (2008); Whitechapel Gallery (1999) and Institute of Contemporary Arts (1997).

Susan Roberts is a journalist and campaigner. She specializes in working with vulnerable groups that are difficult to access, creating platforms from which they can express their views and sense of identity. In 2003 she set up Bridging Arts, an organization that tackles difficult issues in society through art, design and photography.

Helen Scalway is a London-based visual artist with interests in ornament, memory and the cosmopolitan city. Trained at Chelsea College of Art, London, she has been associated as an artist with the Geography Department at Royal Holloway, University of London for several years.

Emma Tarlo is a Reader in Social Anthropology at Goldsmiths, University of London. Her publications include *Clothing Matters: Dress and Identity in India* (1996) and *Visibly Muslim: Fashion, Politics, Faith* (2010).